Digital Photography Made Easy

Taking, fixing, printing, and scrapbooking

Digital Photography Made Easy

Taking, fixing, printing, and scrapbooking

Ivan Hissey

Roger Pring

Jerry Glenwright

Grange BOOKS

First published in the UK in 2006 for Grange Books
an imprint of Grange Books plc
The Grange
Kingsnorth Industrial Estate
Hoo, nr Rochester
Kent ME3 9ND
www.Grangebooks.co.uk

By arrangement with THE ILEX PRESS LIMITED

ISBN 184013928-5

This book was conceived by
ILEX
Cambridge
England

Printed and bound in Thailand

CONTENTS

An Introduction to Digital 6
Clicking the Light Fantastic 8

Hardware Made Easy 12
Bits and PCs 14
Building Blocks 16
Files and Formats 20
Feature Packed 22
Digital Storage 24
Make the Connection 26
Which Computer 28
Silicon-free Photography 30

Point and Click 32
Groundwork 34
Get a Grip 36
Vital Statistics 38
Clear and Close Up 40
Digital Color 42
Quick as a Flash 44
The Human Experience 46
Getting the Outside In 52
An Inside Job 60
Up Close and Personal 62
How Your Garden Grows 66
Pets and Other Animals 70
Sporting Chance 74
Planes, Trains, and Automobiles 76

The Digital Darkroom 78
Software 80
Sharpen and Contrast 82
Selective Focusing 84
Cleaning Up the Image 86
Adjusting Color 88
Adjusting Brightness 90
Color Casts 94
Altering Image Size 96
Selective Retouching 98
Cropping 100

Masterclass Tips 104
Combining Images 106
Distorting Images 108
Adding Texture 110
Motion Effects 112
Vignettes 114
Adding Effects 116
Creating Panoramas 120
Creating Soft Focus 124
Altering Backdrops 126
Adding Words 128
Framing 130
Coloring 132
Airbrushing 136
Deleting Red-Eye 140

The Projects 142
A Holiday Album 144
The Family Event @ Home Page 154
A Pet Calendar 164
Let's Move House! And Home Page... 172
Small Office, Home Office... 182
Wedding Bells: Online or Video 192
Kidz @ Play Multimedia 208
Bear Necessities: Record a Collection 212
Growing a Family Tree 226

Output Ideas 240
T-Shirts 240
Water Slip Decals 244
Email Your Photos 246
Trimming, Mounting, and Sticking 248

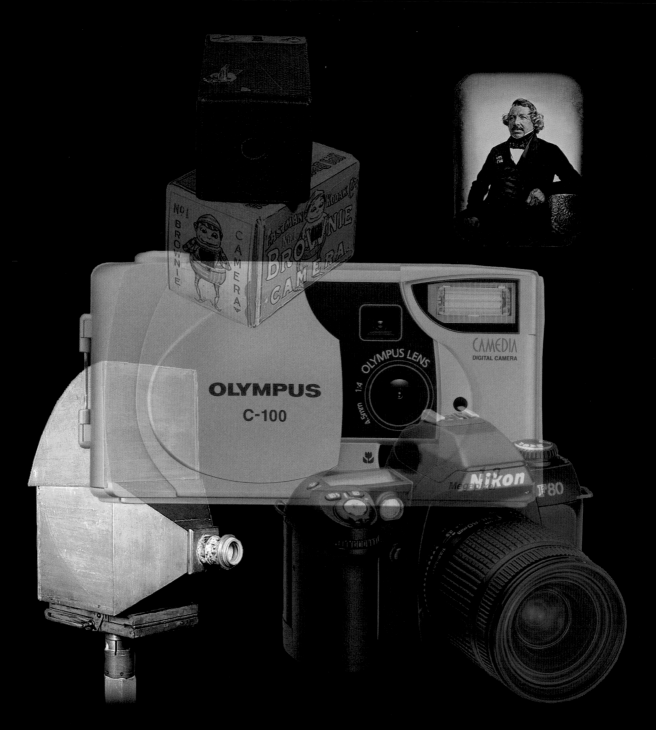

An Introduction to Digital...

Digital photography is the remarkable realization of a 150-year photographers' wish-list. It offers instant gratification allied with complete mastery over the results, combined with an affordable and portable technology in an easy-to-use package. And yet digital photography is, simply, photography, just like the Daguerreotypes of yesteryear and the medium-format photos of today. Whether you take a picture using light-sensitive paper in a camera fashioned from a pinhole in a shoe box, or hold in your palm the latest hi-tech digital wonder, the end result is the same: a picture that hopefully will strike an emotional note. The difference is that with digital photography you can do what once required expensive equipment and complete darkness: manipulate images however you want...

CLICKING THE LIGHT FANTASTIC!

A photograph—conventional or digital—is a fleeting moment captured for ever. In 1839, on viewing a demonstration of the process of picture-taking, the astronomer Sir John Herschel described it as "a miracle!" And that power to amaze, inspire, and excite continues to strike a chord even today.

The 19th century was a time of great invention. In Britain and America scientists, civil and marine engineers, architects, and experimenters in every field were developing technology for ever bigger buildings, bridges, ships, and locomotives, while surgeons too were making incredible advances in medicine. It was a time of upheaval and change, though with the emphasis firmly on the industrial rather than the cultural.

In the midst of these great endeavors, in 1826, French inventor Joseph Nicephore Niepce attempted to find a practical use for-the recent discoveries made with light-sensitive chemicals, known as silver halide compounds. By marrying the artists' tool and the fairground novelty *camera obscura* (see panel) with a small square of pewter coated with silver halides suspended in a solution of asphalt, Niepce succeeded in taking the world's first photograph, an eight-hour exposure of a farmyard.

Photographs from Niepce's camera required extremely lengthy exposure times, during which the asphalt hardened and the image was captured, and for this reason the process was essentially useless for all but inanimate subjects. What's more, the images were

A SHOT IN THE DARK

A phenomenon known to the ancient Greeks, the *camera obscura* (from the Latin for "dark room") projects an outdoor scene by admitting light through a hole and recreating the scene on an opposite wall, or on a table. Unlike the camera as we know it, no means existed for recording the projected image, although artists once used small *camera obscuras* to copy from life by sketching over the projection as an aid to accurate reproduction.

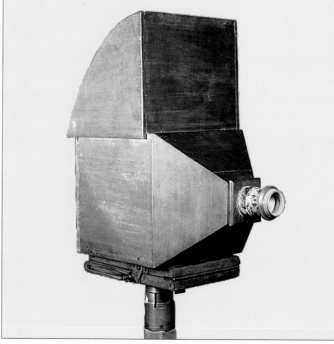

dim and fuzzy; but for all their faults they were recognizable and available for others to view—they were photographs.

After some years' experimentation, Niepce met up with fellow Parisian Louis Jacques Mande Daguerre, who hit upon the idea of "developing" the photo after it had been exposed rather than as a part of the exposure itself. Developing an image in this way shortened exposure times significantly. Daguerre also discovered that images could be fixed by immersing the developed photograph in a salt solution. In 1839 (several years after Niepce's death), Daguerre announced to the world the first practical photographic process. The pictures from this process, known as "Daguerreotypes," became extremely popular, as did the little tin photos they produced.

Daguerre's photos were "one-shot" positive pictures. That is, the captured image was developed as a positive image (the equivalent of a print in a package of photographs) without a negative step in the process. While this might at first appear to be a perfectly reasonable approach, the only way to make a second photograph of the same image was to take an identical picture again!

Early Negatives

Briton William Henry Talbot solved the problem. In 1840, Talbot announced his "Calotype" process. This added a negative stage to picture-taking (an image in which the light areas are dark and the dark areas light). Talbot's Calotype negatives could be used to make an unlimited number of positive prints on specially prepared, chemically treated paper.

One disadvantage of Talbot's paper negatives was that the imperfections in-the paper produced correspondingly fuzzy images. A cousin of Niepce's, however, had the solution. Abel Niepce de Saint-Victor coated glass plates with light-sensitive chemicals embedded in the albumen of eggs. The glass negatives produced very fine pictures, but exposure times remained comparatively slow. Building on Saint-Victor's work, Frederick Scott Archer refined the chemicals in the coating and devised an

EXPENSIVE MANIA

Daguerreomania, as it was known at the time, was only for the rich. A single Daguerreotype cost about a guinea (£1.05)—a week's wages for the average manual worker.

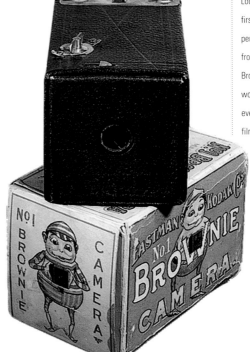

Small and fuzzy maybe, but Daguerreotypes (*above*)—the little tin pictures created using the process devised by Louis Daguerre—were the first commercially available permanent images captured from life. The Kodak "Box Brownie" (*left*) was the world's first camera for everyone. Containing enough film for 100 exposures, the camera was simply returned complete for processing. Suddenly, photography was a hobby almost everyone could pursue.

improved processing method ("Collodion"), which reduced exposure times to two or three seconds and substantially reduced the cost to about a shilling (5 pence) for each print.

Pictures on a Plate

One final difficulty remained: managing glass negatives was a "wet process," that is the plates had to be coated, exposed, and processed while wet. This cumbersome process led Dr. Richard Maddox to experiment with gelatin coatings, and by 1871, Maddox had perfected a "dry-plate" process. And when, in 1884, US bank clerk George Eastman combined lengths of the recently invented celluloid with gelatin-based photographic coatings, modern film and modern photography were born.

Amazing though photography was, the invention met with hoots of derision from artists and critics, who dismissed the process as one that was largely mechanical with little creative input. It was worthless, they said, or at best easily mastered. The truth,

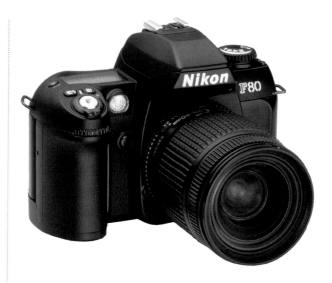

of course, just as much then as it is now, is that the mechanics of photography are indeed mastered relatively easily, but the eye of the photographer is as potent a conduit for artistic expression as any painter's brush.

While the cultural elite remained skeptical, the public took photography to their hearts. Early equipment was cumbersome and the chemical processes complex and delicate, but

Single-lens reflex (SLR) cameras such as this high-quality Nikon use a folding mirror to project the image from the lens to a viewfinder. This arrangement enables the photographer to see exactly what the camera sees thereby sidestepping the possibility for parallax error.

Digital

Conventional film

When shown greatly enlarged, the visible pixelation of a good-quality digital image is comparable with the grain of conventional film.

photography could be learned by anyone who set their minds to the task.

The Pocket-sized Miracle

The same George Eastman dreamed up the notion of a camera that could be held in the hand and carried everywhere, and which used a roll of film. The camera would then be simply handed over for processing at appointed agents, such as pharmacies, and returned with the photographs and ready-loaded with fresh film. Eastman's invention underwent further refinement when Oskar Barnack, head of design and development at camera manufacturer Leitz of Wetzlar, Germany, combined 35mm cine film with a specially designed, pocket-sized camera that really could be taken anywhere.

The Digital Leap

Little more than a decade after Barnack developed the pocket-sized 35mm camera, John Von Neuman in the US and Alan Turing in Britain were busy laying the foundations of modern computer science. By the 1950s, computers were room-sized monsters, but the machines established the principles of binary computing. The arrival of transistors, solid state electronics, and, eventually silicon and miniaturization, finally paved the way for today's pocket-sized digital devices.

The first digital cameras began to appear at the end of the 1980s, along with crude image scanners and low-resolution laser printers. Resolution was abysmal, memory quotients shameful, and prices astronomical. But the companies experimenting with digital cameras continued to develop the

POWER VISION

The first electronic computers filled rooms, consumed megawatts of electricity, sported just a few dozen bits of memory and had a "brain" capacity that an intelligent food processor would put to shame. By comparison, your digital camera has a memory quotient measured in Megabytes and processing power beyond the wildest dreams of the early computer scientists, and all contained within a case you can keep in a shirt pocket!

technology and by the mid-1990s, affordable cameras became available that offered reasonable resolutions at sensible prices.

Today, you can buy a multimegapixel digital camera for less than an average week's salary. Most will provide photorealistic images in a package that will slip easily into the pocket. You can manipulate those images on a personal computer, print them, and enjoy near-professional results with remarkable ease.

Compact digital cameras like this smart little Olympus make picture-taking easy. The camera calculates the exposure, automatically focuses the lens, and captures a high-resolution image when you fire the shutter. All you have to do is point it at a suitable subject!

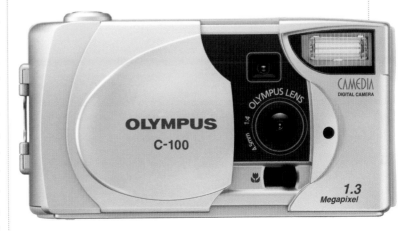

2

Hardware
Made Easy

Pixels, CCDs, firmware, digital this, digital that, resolution, and connectivity... and all you wanted to do was take a picture! The camera has, without a doubt, moved firmly into the 21st century. But understanding the technology and making use of that new-found knowledge of hardware and software to get the best from your digital camera and produce fantastic photographs seems elusive. If knowledge is power, then understanding your camera is the most powerful way to perfect its use and produce images that will not only please you, but all who see them...

BITS AND PCS

"Digital camera"—the name is at once fascinating and a little frightening. It conjures up daunting lists of associated jargon. So exactly what is "digital" and what effect does it have on picture-taking?

The word "digital" has been common currency for 30 years and is used to describe everything from watches and calculators to, more recently, radios, televisions, and cameras—but few understand what the term really means. While understanding the technology isn't a prerequisite for using a digital camera, some knowledge *will* enable you to maximize the opportunities the hardware offers. And, what's more, it isn't that complex.

The Future is On or Off

Turn to the dictionary for a definition of digital and you'll be rewarded with the stark description: "of digits;" not terribly helpful, but nevertheless that's the nub of what we're trying to understand. Digital technology relies on acquiring and manipulating picture, audio, or other information as a sequence of binary digits—the numbers 1 and 0—where 1 represents the presence of data, and zero its absence. The beauty of these 1s and 0s is that they can be represented by anything which has two states (hence binary), on and off: a switch, a light bulb, or a transistor (which is, after all simply a switch) on an integrated circuit (IC).

Let's apply the binary concept of "ons" and "offs" to musical recording. A traditional vinyl-based recording is captured within, and

CAPTIVE IMAGES AND RESOLUTION

A digital camera works much like a conventional model, in that light passes through a lens and is recorded inside. However, in place of film, the digital camera has at its heart a chip known as a CCD (charge-coupled device). This, essentially, is a matrix of tiny light-sensitive cells. The tinier and greater the number of cells, the better the resulting image—the higher its "resolution." The CCD passes varying electrical charges to a device called an analog-to-digital converter. These are transformed into 1s and 0s (binary data), and from there sent to a memory device for storage.

The CCD and its cells are similar to conventional film and its silver-halide grains, in that each captures the light that makes up the resulting picture. But unlike a conventional camera, you can't change a digital camera's CCD as you can a conventional camera's film.

recreated from, a continuous groove in the vinyl, which, when fed through a transducer (a device for converting one kind of energy into another, in this case the movement of the needle into an electrical signal), produces a continuous, varying signal—one which has peaks and troughs. There is no "on" and "off" state, except where the music itself begins and ends. This is a called an analog signal.

By contrast, a CD recording has no such grooves. Instead, the music is "sampled" (examined) by a device, usually a computer, during which it is broken into a stream of tiny chunks of ons and offs, 1s and 0s. Just how tiny is vitally important, as we'll discover later on, but suffice to say that early CD recordings did not break the data into small enough bits ("binary digits"), so the quality was, for a short time, inferior in some ways to vinyl.

The Orchestra Pits

Quality issues aside, the stream of 1s and 0s is recorded as microscopic pits "burned" onto the surface of the CD. To recreate the music, a laser scans the pits, noting where

the 1s and 0s ("pit" or "no pit") fall. After a certain amount of interpreting by clever computer programing, the CD player recreates the music. Although the sound from the CD player starts out as a sequence of ons and offs, the listener hears continuous music.

Digital Pictures

Similarly, light and shade entering a camera is divided into a stream of 1s and 0s which, when manipulated by software, reproduce the original image. Enlarge the image sufficiently and you'll see that it is in fact a series of blocks ("pixels"—of which more later), but the overall image is generally of sufficient quality to fool the eye.

Pixel

When light enters a digital camera, it is directed into a matrix of sensors that generates a variable electric charge. This charge is transformed into a binary data stream. Enlarge a digital image and eventually you'll see the tiny blocks of picture data which fool the eye into seeing a continuous image.

BUILDING BLOCKS

Resolution, pixelation, and interpolation—although they sound complicated—are the stuff of which digital images are made. Understanding what they are will assist you in buying and using a digital camera.

On the previous pages, you were introduced to the basic concept of resolution. A simple equation describes what's required: tinier samples (and therefore more of them) equal higher-quality audio, pictures, or whatever it is that's being sampled. This is called a high sampling rate. But why should more equal better? Think of it this way. Draw a circle with a pencil around the base of a tumbler. There are two ways to find the length of the circle's circumference. The precise mathematical formula $\pi \times D$ (3.14 times the diameter) will provide the figure, or you can use a ruler and try to measure bits of the circumference. It follows that the tinier the bits of circumference you measure, the more accurate will be the final measurement. Big bits give a loose approximation, smaller bits, a closer one.

Digital Approximation

So it is with pictures, sounds, and anything else that's digitized (rendered into bits of data). Greater resolution results in a digital sample that is more convincing to the eye or ear. However, it is a paradox of the digital world that whereas accuracy to the last bit is essential for correct operation (for example, a single bit of bad data can bring even a supercomputer to its silicon knees), a digital

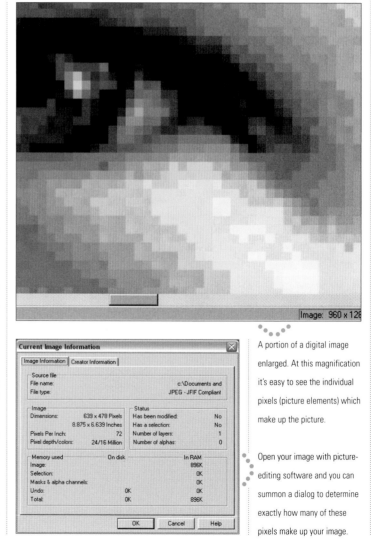

Image: 960 x 128

A portion of a digital image enlarged. At this magnification it's easy to see the individual pixels (picture elements) which make up the picture.

Open your image with picture-editing software and you can summon a dialog to determine exactly how many of these pixels make up your image.

representation of an analog occurrence from the real world is never anything better than an approximation!

Elementary Pictures

If you've shopped for a digital camera, it's certain that you've encountered the word "pixel." Even if you have no idea what a pixel is, it probably became clear to you quite quickly that more is definitely better as far as pixels go, hence the buzzwords, "megapixel" and "multimegapixel."

Pixel is another one of those contractions of words favored in the hi-tech world and which, in this case, is a contraction of the words "picture" and "element." Pixel refers to the smallest addressable element of a picture—that is, the smallest block of a picture that can be switched on or off to represent light and shade.

The earliest digital cameras provided a typical resolution of 320x240 pixels. An image at this resolution will appear crude and "blocky" when viewed onscreen or printed, because there aren't enough pixels to fool the eye into seeing a "continuous" flow of light and shade. Advances in technology soon led to cameras that were able to capture images at 640x480 pixels—matching the best in PC computer screen resolutions of the time. Images at this resolution appear smooth onscreen but still look crude when printed, unless the picture is very small, say,

Examine the pictures below and you can see why buying a camera with the highest possible resolution is preferable. The images on the left were taken with a one megapixel camera (the close-up shows how the image decays under close scrutiny), while with the images on the right—taken with a four megapixel camera—even the close up shows remarkably good resolution.

2 x 1.3 inches. Any bigger, and each pixel must be enlarged to the point at which it becomes clearly visible and the image is said to appear "pixelated."

By the late 1990s, the first megapixel cameras became available. These offered a height by width resolution that adds up to more than a million pixels. The introduction of megapixel cameras moved digital photography into the fast lane because images could at last be reproduced at the standard enprint (150x100mm) size, and yet be "photorealistic" (supposedly indistinguishable from a real photograph).

If you're choosing a digital camera, and unless you're on a very tight budget or will

ALL-SEEING EYE?

Today's "hobbyist" multimegapixel cameras offer resolutions of between 2 and 3.5 megapixels. The latest professional digital cameras can provide a staggering 16 million pixels per image. But the human eye has the equivalent of 230 million pixels—digital cameras have some way to go yet!

only view your images onscreen, choose a camera with at least one megapixel capacity. These will swiftly become standard on even cheap cameras. Today, even mid-range cameras offer multimegapixel resolution—between 2 and 3.5 million pixels—which is more than enough for quality prints and enlargements.

FILES AND FORMATS

As digital image capture and manipulation have evolved, so too have increasing numbers of formats in which to represent and store the results become available. Each has its merits but all is not equal in the backing storage stakes.

Users of conventional cameras "store" their pictures as negatives or transparencies. For digital camera users too, storing an image is a distinct step in the process of creating a picture—the image is captured and stored within the camera, possibly transferred to a computer as a picture file before being edited and printed. But the intermediate stage—storing the image as a file—is an important step, and a number of formats have been devised to store digital information as efficiently as possible.

It's this drive for efficiency and accuracy, however, which has caused so many file formats to be devised. Raw picture data takes up a relatively large space within your camera and so a certain amount of compression—squeezing of the image data—is applied in order to pack more pictures into the ever-limited "backing storage" in the camera.

The Compression Problem

But compression isn't a cure-all, and many compression techniques result in degraded image quality. Some formats are rather less able than others, and which one you choose depends on your application—whether your pictures are intended to be viewed as prints or only in webpages, for example. Generally, file formats target one of two areas: color accuracy at the expense of file size, or vice versa.

BIT PART PLAYERS

Colour depth is often expressed as a binary factor: 8-bit, 24-bit and so on. Bit is a contraction of the words 'binary digit', and a bit represents one of two states (hence 'binary'), on or off. It follows that 8-bit colour (that is, 2^8 or 2x2x2x2x2x2x2x2) has a maximum depth of 256 colours. 16-bit has a colour depth of 64,000 colours, and 24-bit, 16.7 million.

There are many file formats for storing digital images and each is geared to a particular application. GIFs, for example, are generally used for relatively low-resolution images intended for the Web whereas the TIFF format is ideal for storing photorealistic pictures with high color definition.

GIF

TIFF

The Formats

JPEG: (pronounced "jay-peg") The most popular format for images taken with digital cameras today is the JPEG, and there's a good reason for this. JPEG is an acronym that stands for the (International Standards Organization's) Joint Photographic Expert Group, which created the format and devised it specifically for digital photographs. JPEG files offer 24-bit color representation—that is, they can contain up to 16.7 million colors, which is more than enough for photorealistic pictures. Compression is high too resulting in small picture files (though size is relative in file formats) and the supreme advantage of the JPEG is that it only stores data for pixels that have color—white pixels require no data.

The downside is that JPEGs use "lossy" compression. Redundant picture information is actually discarded to reduce the file size. Obviously, throwing away information from the picture will degrade it. What's more, compression is applied every time the JPEG is opened and saved (though not when opened, viewed, and closed without saving).

GIF: The other major picture file format and certainly the most widespread on the Web is the GIF (Graphics Interchange Format). GIFs are ideal for "portable" pictures that are likely to be viewed only on a computer screen (for example, those you want to post on a website). Compression is very high and generally, the same picture rendered as a GIF will be far smaller than in any other format but at the expense of color—GIF only allows a maximum of 250 colors.

JPEG, maximum quality JPEG, maximum compression

Compression techniques enable you to store high-resolution images with a small cost in backing storage but use with care—many compression systems are "lossy" which means picture data is discarded in favor of file size.

TIFF: In professional publishing, the TIFF reigns supreme. TIFF (Tagged Image File Format) offers 16.7 million colors and uses a "lossless" compression equation, which retains picture data, but results in files that are larger than some other compressed picture formats.

PNG: Newcomer PNG (Portable Network Group) is a Web-oriented format designed to retain picture integrity and produce small files. Lossless compression, 24-bit color and meta-tags (indexing text for Web search engines contained within the picture) make the format ideal for Internet use.

FEATURE PACKED

All digital cameras come bristling with features, some of which you'll use every time you take a picture. Resolution is paramount, but LCD screens, self timers, and on-board special effects can make picture-taking more fun and ease you gently into the world of digital editing.

Between the writing and the reading of this book, prices for digital cameras will have fallen considerably and specifications increased significantly.

Until relatively recently, 640x480 pixels was considered a reasonable working resolution, and then along came affordable multimegapixel cameras, and now 640x480-pixel cameras are considered acceptable only for pictures intended for the Web. So if your idea of digital photography is as a replacement for a conventional camera and your pictures will be printed, a multimegapixel camera is a must.

Specifications

All digital cameras have a lens (fixed and plastic, in the case of cheaper offerings), viewfinder (low- and mid-range cameras are "compacts," and the viewfinder is separate from the lens), and a body which houses the electronics and perhaps a removable storage option. Digital compact cameras are usually equipped with a lens that is the focal length equivalent of the 35mm to 50mm lens of a conventional 35mm film-based camera, and provide a field of view broadly comparable to the human eye's.

The very cheapest cameras have a fixed-focus lens (don't confuse this with auto-focus)

which, combined with aperture and shutter speed, will focus everything from about 1.5 meters to infinity. Most digital cameras offer auto-focus and a macro facility for close-up pictures. Many better-quality cameras sport a zoom lens that novice photographers generally think of as a tool for getting closer to

This Nikon digital camera is capable of taking high-quality digital images. It is a 5 megapixel camera, and features a 35–280mm motorized zoom lens.

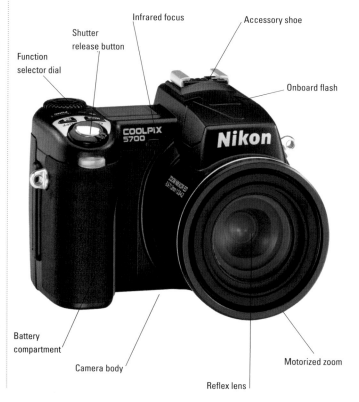

Infrared focus

Accessory shoe

Shutter release button

Function selector dial

Onboard flash

Battery compartment

Camera body

Motorized zoom

Reflex lens

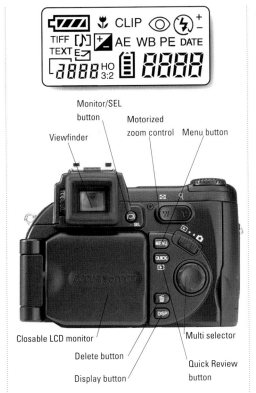

Monitor/SEL button

Viewfinder

Motorized zoom control

Menu button

Closable LCD monitor

Delete button

Display button

Multi selector

Quick Review button

available. FireWire is another variation on the serial theme, but exponentially faster than USB. FireWire ports are built into more recent Macintoshs (such as the iMac) and PCs.

Digital Slideshow

Connectivity doesn't stop at linking your camera to a computer. Some cameras offer a "video out" function, which enables you to connect the camera to a television set or VCR and view your pictures as a slideshow.

But the most obvious feature that sets the digital camera apart from its conventional cousin is an LCD screen for reviewing, editing, and deleting pictures, configuring the camera and selecting options. All but the cheapest cameras have an LCD, which can also double as a viewfinder. The LCD generally gives access to other features too, such as setting resolution, compression, and file type, and the result of applying an onboard effect, say, sepia toning, can also be viewed on the LCD screen.

The back of the same camera showing its various control features, and above it, a typical control panel. These indicate battery life, file format, exposure, macro, red-eye, and flash settings, among other things.

distant action. However, the zoom lens is more useful as a framing device, letting the photographer remain outside the "personal space" of the subject.

All digital cameras can download pictures to a computer. Early examples were equipped with a serial connector. Although slow, a serial connector is available on virtually every PC (and many Apple Macs, in a slightly different guise) on the planet. USB (Universal Serial Bus) is a modern variation on the serial theme. It's faster, hot-swappable (the computer recognizes your camera as soon as it's connected and launches the appropriate software, there's no need to reboot), and standard on new PCs and Macs. More recently, Apple's FireWire has become

CONSUMER CHOICE

Digital camera manufacturers fall into two camps: those from traditional camera companies such as Nikon, Canon, and Olympus, and those from companies that are principally involved in the manufacture of consumer electronic goods, and which make everything from computers to microwave ovens (Sanyo, Samsung, Hewlett-Packard, and Casio). The traditional camera manufacturers tend to produce digital examples that are familiar in size, shape, and operation to anyone who has used a conventional camera, whereas the latter group often approach digital camera manufacture in more novel and interesting ways. Take each on merit and make your choice on features and price.

DIGITAL STORAGE

So you thought you'd seen the last of film? Think again! Just as conventional cameras require conventional film, digital cameras need digital "film," but the advantage is that it can be used time and time again.

Digital pictures are big! A high-resolution photograph might require as much as 5 or 6 Megabytes (Mb) of storage within the camera. The first digital cameras had fixed internal storage that was gradually filled as pictures were taken. When the camera was "full," the pictures had to be transferred to a computer or erased. Today's multimegapixel cameras produce images at stupendous resolutions, and with truly enormous file sizes as a result. Not for them the fixed internal storage scheme. Instead, storage cards—"digital film"—are used. Typically, manufacturers have thrown their weight behind competing formats. The popular cards are for the most part standard memory cards, such as might be found in an electronic organizer. Making use of removable cards enables photographers to keep spares in their camera case and plug in a fresh one when necessary. Of course, there's nothing remotely like conventional film within the case of the card. It is simply an electronic device which features memory chips and a means by which information can be stored and retrieved.

The End of Floppies

For a time, Sony persevered with cameras that used floppy disks as their storage medium. The cameras were slightly cumbersome, but the floppy disks made a lot of sense. They're cheap, widely available, portable, and reliable. However, the advent of megapixel cameras and large picture files spelled the end for the floppy. What's more, economies of scale equate to ever-cheaper storage cards as digital cameras become more widespread.

At present, two major contenders vie for your camera's card slot: CompactFlash and SmartMedia. Despite the name, CompactFlash cards are physically larger than SmartMedia

DIGITAL DILEMMA

Any memory card designed for your camera can be used to store any kind of picture—low- or high-resolution, color or black and white, compressed, or as raw data. The card is simply a store, much like the memory in a computer, and what you choose to fill it with is entirely up to you!

SmartMedia cards (*right*) are cheap, readily available, and tiny, which means you can carry spares for those outings where you intend to take a lot of pictures.

Memory cards are available in generic formats such as the CompactFlash card (*right, above*) or proprietary as with this IBM Microdrive (*right, below*).

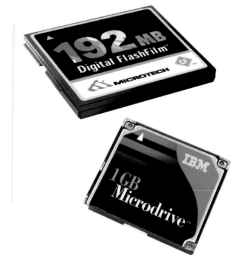

CAPACITY				
SIZE OF CARD	**NUMBER OF IMAGES**			
	Typical JPEG basic	Typical JPEG normal	Typical JPEG best	Typical 3-megapixel TIFF uncompressed
8Mb	26	11	6	1
16Mb	53	22	12	2
32Mb	106	45	24	4
64Mb	213	91	49	8
128Mb	426	182	98	16

ones, and they offer greater storage space. You can buy SmartMedia cards ranging from 8Mb to 64Mb, but CompactFlash is available up to 128Mb. If you plan to take a lot of high-resolution images for printing, CompactFlash is probably the best choice, but don't be put off a camera simply because it uses SmartMedia. A 64Mb SmartMedia card will store a lot of

pictures, SmartMedia cards are cheaper, and unless you're trying to capture pictures of unrepeatable events, the seconds it takes to swap a card are not really a problem.

SmartMedia cards can be plugged into special adapters and then inserted in a computer and accessed in the usual way. This negates the need for cables and software links to a computer to transfer pictures.

Sticks

Sony offers a proprietary card called a "Memory Stick," which can be used with other Sony equipment, and there are also PCMCIA memory cards that are occasionally used in cameras. Credit card-sized PCMCIA cards originated in the computer world, where they're used to house everything from modems and network adapters to hard disks within their cases. Cameras use standard Type II PCMCIA memory cards (there are three "types" of PCMCIA, each with slightly different dimensions and varying power requirements).

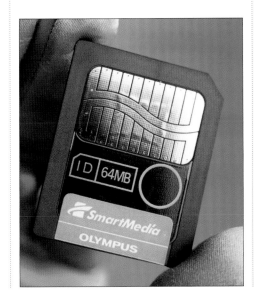

Sony's Memory Stick is a proprietary format that is relatively expensive when compared with CompactFlash and SmartMedia. It can, however, be used in other Sony products, which might mean a saving if you're already a user or a fan!

MAKE THE CONNECTION

Taking a picture is just the first step—you must get the image into your computer and printer before it becomes the print that your friends and relatives would recognize as a photograph.

All digital cameras are equipped with a means by which they can be connected to a computer, so that you can transfer ("download") your pictures for storage, manipulation, printing, emailing, and so on. The legacy option, certainly the slowest, and arguably the least reliable, is the RS232 serial connection. Serial transfers are very slow compared with, say, USB and, despite being around for many years, RS232 has a strong potential for problems.

Going, going...

Problems arise because there are so many ways to configure an RS232 connection and setting one up can be a minefield for even the most technically aware. As well as configuring the connection, it must be established manually too. Unlike USB, the computer doesn't know when you've connected your camera. You must link the camera and the computer, launch the necessary software, and instruct it to begin the transfer. In short, serial connections are yesterday's technology.

Why then, does RS232 continue to be used? Principally, because all PCs have a serial port of some description, and the majority of Apple Macs have one too. And until relatively recently, nothing else had come along to take the technology's place.

Older cameras and very cheap examples offer serial transfers. However, some mid-range cameras, alongside a USB port, also provide RS232 as a legacy option; this can be useful if you're away from your desktop machine and only have access to an older laptop or palmtop for example.

Universally Superior

In the mid-1990s, some of the major players in the computer world got together to establish a new "standard" for serial connections. Compaq, DEC, IBM, Intel, Microsoft, and others created the Universal Serial Bus (USB), which is to RS232 what a Ferrari is to a Model T Ford. USB is "hot-swap-

When you connect your camera to your computer, the screen will tell you that you have "created" another drive (i.e., your camera) and will list the files (your pictures) on that drive.

WHAT'S IN A NAME?

In computer speak, a data connector on a computer is known as a "port."

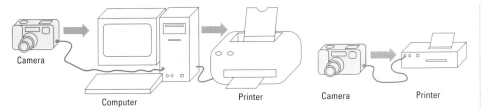

Camera

Computer

Printer

Camera

Printer

pable," which means that when you attach a camera, the computer knows it's connected, automatically invokes the necessary software and establishes a (usually) reliable link. You don't have to switch off, reboot, or manually launch software.

The speed of transfer is orders of magnitude beyond legacy serial connections, and furthermore there's no need to mess around with the technicalities of a serial connection. Almost all new PCs over the past couple of years (and certainly all brand new ones) have one or more USB ports, as do Apple Macs, and USB is standard across platforms—the same cables work with any machine that has USB ports. The connectors themselves are small and easy to use.

Fly by Wire

Not for nothing is Apple a leader in the professional media world. In 1995 the company launched a new serial transfer scheme known as "FireWire." Capable of truly blistering transfer speeds (400 megabits per second (Mbps), compared with USB's 12Mbps), FireWire languished for a time as a poor second to USB because no suitable application existed. Then Sony included a FireWire port on its newly launched digital video camera, and suddenly the potential for FireWire became clear. Where digital photographs produce large files, digital

video generates memory-defying files of breathtaking proportions. Transferring them required the incredible muscle of FireWire. All G4 and G5 Apple Macintosh computers have these ports, and so do many new PCs. FireWire is generally reserved for high-end multimegapixel professional digital cameras, which generate large file sizes.

Computers use two types of data transfer connection: serial and parallel. Serial data transfer involves sending each piece of data one after the other along a single connection between communicating devices. A parallel connection is one in which multiple bits of data are sent at the same time along several connections, and each piece of data has its own line.

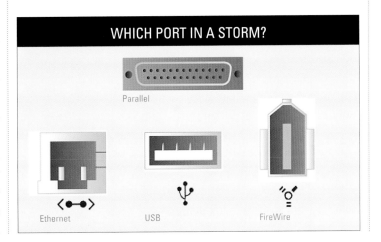

WHICH PORT IN A STORM?

Parallel

Ethernet

USB

FireWire

WHICH COMPUTER?

Though it isn't absolutely necessary, chances are you'll want to connect your camera to a computer to store, edit, and print your pictures. Two distinct types of computer dominate the marketplace, and which you choose depends on a number of factors.

"No-one ever got fired for buying IBM," ran the advertising slogan, and in the early 1980s it was true. IBM's personal desktop computer (as opposed to the mini and mainframe computers that IBM also manufactured back then) quickly came to dominate the market; and in the PC's wake followed an avalanche of clones. Indeed, so successful were these lookalike computers that sales of them eventually exceeded those of IBM, and PC-compatible manufacturers such as Hewlett-Packard ousted IBM as the number-one sellers.

PC Versus Mac

When it was launched, the PC came with a command-line driven operating system (that is, you typed in obscure commands such as DIR, DEL, MD, and so on) created by a little-known Seattle software company called Microsoft. Then Apple launched its Macintosh computer, which featured the world's first truly commercial point-and-click graphical interface. "Windows," icons, a mouse, and pointers passed into common currency, and Microsoft wanted its share. The Seattle company launched Windows, which was treated as something of a joke for several years in its earlier guises. However, with the launch of Windows 95,

Microsoft hit paydirt and computer users around the globe bought and installed the system, while Apple failed to license its own products to other developers (its key error).

So successful is Microsoft's system that today a PC and a Windows computer are generally thought of as one and the same thing. However, publishing professionals use the Apple computer almost exclusively, and with the launch of fast new Intel-based Macs (and the irresistible iPod), Apple are gaining

Although a computer is a welcome friend in the digital darkroom, there's no need to plump for large and ugly boxes! Today's PCs (*left*) and Macs (*above*) are esthetically pleasing in their own right.

market share again. Which one you choose—PC or Mac—depends on who you are and what you want to do. If digital photography is a pastime, and your pictures will be stored on a computer that is also shared with your family, it's almost certain that you'll choose (or probably already own) a PC.

A Very PC Solution

PCs are generally cheaper than Macs and more widely available. All PCs use off-the-shelf plug-in components that are easily swapped when repairs are required, there's a wealth of quality software of all kinds to support the machine, and finding help is as easy as asking a friend or work colleague—every second person is familiar with PCs and Windows.

The Mac, on the other hand, remains relatively unknown outside pro-media circles, although the iMac has changed that to an extent. But that doesn't mean Macs aren't an excellent choice for digital photographers. Macs offer excellent graphic options as standard across the platform (no grappling with video driver software from third-party graphic card suppliers), a robust operating system, which is arguably better integrated, smoother, and more intuitive than Windows, and some very high-quality, image-manipulation software, some of which can be found nowhere else.

All new Macs and PCs feature plenty of RAM, large hard drives and fast processors; each offers USB ports as standard (and sometimes FireWire), and each provides access to CD- writers, easy Internet access, and a lot more to broaden your horizon.

SOFT OPTIONS

Though a comparatively large investment, a computer is simply the means to an end: using image-editing software. This software is a primary reason why digital photography is so much fun. Once the pictures in your camera are transferred to your computer, image-editing software enables you to view and manipulate them in ways that previously required an entire darkroom's worth of expensive equipment and years of experience. Image editors are available in many guises, some aimed at beginners, some at media professionals. Prices vary enormously too, from free (that is bundled with the camera) to hundreds of dollars. However, software is one of the few products about which "you get what you pay for" can't be said. A relatively cheap image editor such as Jasc Paint Shop Pro for the PC is packed with features, it's easy to use, and you can download a try-then-buy version from the Internet before actually spending your money. At the other end of the scale, Adobe Photoshop has every feature imaginable and is available for both PC and Mac—but at a hefty professional price!

SILICON-FREE PHOTOGRAPHY

Digital photography means "instant" pictures and no more processing costs. You've side-stepped film, but have you had to acquire a computer instead? And what are the options if you don't own a computer?

Don't let the lack of a computer put you off buying and using a digital camera. Computers have certainly entered millions of homes over the past 10 years or so, but not everyone owns one. Just because you're a digital photographer doesn't mean you want to be a computer programer too!

Computer or Printer?

Of course, the first thing to realize is that manipulating digital images calls for as much or as little technical expertise as you're willing to acquire. With no more knowledge of computers than switching them on and plugging in cables, you can download your pictures and save them to disk. A chapter or two of this book, and half a day invested in experimenting, and you'll be cropping, re-sizing, and toning your pictures, burning CD picture albums, and sending images to friends over the Internet like an old hand; and after that, the digital darkroom is yours to command.

But let's assume for a moment that you don't have a computer, and prefer instead to invest in the best camera your money can buy. Back to that "household penetration" quotient.

You might not have a computer, but it's certain that a relative or a friend has one, and while they probably won't want you spending hours poring over their machines with your pictures, an hour here and there while you download them and file them to a CD ought to be okay.

Orphans who shun friendship aren't altogether stymied either. Those who work usually come into contact with computers, those who don't can probably gain access to silicon at a public library, and students of all ages can petition their schools and colleges

If you don't have space for a full-sized desktop computer consider a laptop. These have the processing power of many desktop machines in a compact and convenient format. Be aware though, that you'll pay more for equivalent features to a PC.

for time on a machine (but always remember to ask permission before you make free with someone's computer).

In the Hand

If not owning a computer is an issue of space, consider a palmtop or laptop. These handheld and portable computers offer processor speeds, hard-drive space, and RAM memory that's on a par with the desktop computers, but they occupy far less space. All will enable you to connect to the Internet too, so you can post your pictures (that is, insert them into a webpage) or send them to others via email. Despite their convenience and incredible miniature technology, palmtops and laptops are not that much more expensive than a comparable desktop computer, and have many advantages. There are also good deals to be had on second-user and end-of-line machines.

Your Prints Will Come

Those who truly don't want a computer of any sort don't have to have one. Many inkjet printers sport a built-in card slot as standard. Fill your camera with pictures, withdraw the storage card, plug it into the printer's slot, select from a range of printing options on the printer's LCD menu panel (enlargements and reductions, color or mono output, and so on), and go ahead and print. You'll get good results, and all without a computer. And many cameras offer basic editing features right in the camera so you can even crop and compose your pictures before printing them.

Shop Smart

Some conventional photography outlets and pharmacies also provide a print-from-card option. Take your pictures as before, eject the card, and pop it along to the store much as you would a conventional film. The result is a package of prints and an empty card ready to use again.

With no computer or printer (*above*), you can take your digital camera storage card to a main street processing outlet (almost all conventional camera and film outlets offer this service), or email your image files to an online processor (*below*) . It's easy!

Point and Click

3

Point and Click

The world of photography is littered with casualties! There are no bandages or medicines and the only bruising is an ego or two, but they are casualties nonetheless, as the small ads of photography magazines fill up with hi-tech camera equipment, sold off cheaply as people's interest wanes. Why does it happen? Because the wise photographer realizes that a top-of-the-range digital camera produces box-brownie pictures in the "wrong" hands. And what are the wrong hands? Those that skip this chapter; it contains old—it's true!—but exceedingly valuable advice for budding picture-takers. Covered here is composition, lighting, positioning, and the half dozen or so other techniques which, while simple in themselves, turn good photographs into great ones.

GROUNDWORK

The basic rules of photography exist to guide and hone your talent, not to stifle it. Learning and mastering these simple techniques will equip you with all that's required for truly gorgeous pictures—the rest is up to you.

Guitar players spend much of their time worrying about whether learning to read music will spoil their musical intuition—that indefinable "something" that ensures their playing is inspired. It's a worry that could apply equally to photographers. After all, many of the world's most famous images were taken on the hoof with little regard for the rules of composition and lighting, or else these rules are abandoned on purpose to create a particular effect.

But what conclusion have seasoned guitarists and photographers reached? That to throw away the rule book, you have to have one first! It's a cliché but it's true, the best camera in the world won't make you Diane Arbus or David Bailey, but the cheapest disposable compact would enable either photographer to produce marvelous pictures. Photography is about looking and seeing, and good photography is about composition, balance, lighting, and tone.

Composing

Arguably, the principal factor that sets an interesting picture apart from a dull one is composition—not the subject itself, but the way in which you choose to present it. Whether as a journalistic record of an event or an artistic representation of what you see, the appeal of any photograph can be strengthened by training your eye to see a composed picture. When you survey a scene your eyes take in everything and your brain picks out what it perceives as the important details. The camera, however, isolates just one part of the scene, framing and flattening it into a two-dimensional representation that can be dramatically different from the way you perceived it.

The "rule" might be expressed as: don't aim, frame. Build a picture rather than simply

A common mistake is to position the strongest point of interest at the center of the picture. Add greater impact by composing your picture using the "rule of thirds," an age-old technique designed to build in balance and add drama.

The seasons have a great impact on light quality and availability. In the winter months, stark reflected light from snow will tend to fool your camera's metering system, and the result could be a poor exposure.

point the camera. Assess the scene and decide where its interesting highlights lie. Allow your eye time to scan the subject in the viewfinder. If you're unsure, use the LCD screen to supplement the framing. Practice observing what's around you as potential pictures, isolating and framing portions to make subjects. Of course, the advantage of a digital camera is that you can take a picture many times while you practice this technique without wasting film.

Lighting Effects

Second only to composition is lighting. Stark lighting (such as strong flash) can have a very dramatic effect, especially in portraiture, by stripping a subject of personal space, while sympathetic soft or natural light enhances and is kind to subjects. Low-key lighting suggests reflective moods, while high-key lighting, and lighting filters and effects, can produce a party atmosphere. Although your eye might not notice it, the time of day, seasons, and weather all have a significant effect on light. Try setting your camera on a tripod and taking the same exposure at two-hourly intervals throughout the day—the difference in light is dramatic.

Balance is important to composition. Ensure the horizon is level and alter your vantage point so you can build surrounding features such as trees into the picture to support the composition.

GET A GRIP

Holding your camera, tilting and twisting it, getting up high, or crouching low—all have significant impact on your pictures, and form the basic techniques forcreating more dramatic photographs.

It's likely that your digital camera is what's known as a "compact." Unlike a single-lens reflex (SLR), which uses the same lens to view and take the picture, the compact's lens and finder are separate—you look through one and capture the scene with the other. The system works perfectly well (indeed some of the world's most famous photographs were taken using rangefinder cameras—a variation on the compact theme), but there is potential for problems. The most obvious is that you leave on the lens cap or otherwise obscure its view with a finger without realizing.

Learning to handle and hold your camera will help you to avoid these simple problems. Of course, with a digital camera, obscuring your picture with a finger or the lens cap costs only time and effort while you erase the picture

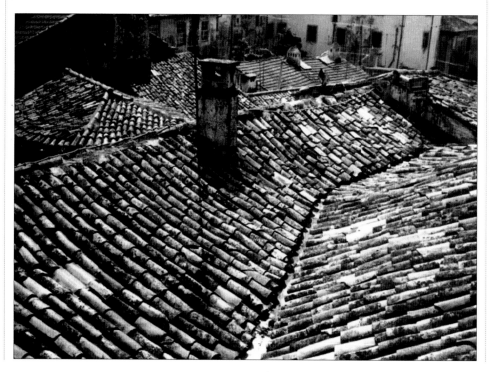

Interesting vantage points breathe life into your photographs. Look for shapes and textures to catch the eye and engage the interest of all who see your pictures. Here, the gutter between these glorious roof tiles leads the eye into the picture.

and make another exposure—there's no film to waste, and you're aware of the problem immediately. But where you are in relation to your subject matter is what will make a good picture into a great one!

Handheld

Hold your camera with a firm but gentle grip. The shutter release will almost certainly be positioned on the right- of the camera, so whether you're right or left-handed, cup the camera snugly in the palm of your left hand and curl the fingers of your right hand around its right- hand edge so that your index finger falls naturally over the shutter button—the classic landscape position. Keep your elbows tucked in and your feet slightly apart. Simply turn the camera through 90 degrees for a portrait format. Held like this, the camera will be largely immune from shake (and blurred pictures) and your fingers are out of the way.

Getting above your subject adds perspective, depth, and drama, and will enable you to frame more effectively—especially with a group portrait such as a wedding picture or a sporting event—and crop out unwanted detail. Effort made at this stage of the picture will reduce the work required during the editing process.

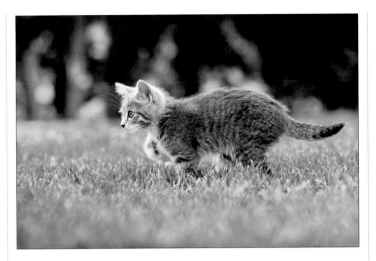

The Lowdown

Children are smaller than adults, and so are family pets, yet so many pictures of kids and animals are taken looking down at them. Better by far to get down low where you can see the world the way they see it.

Up Close

Enlarging digital images is easy, but it has a cost in resolution. How many times have you seen or taken pictures which lacked impact because the point of interest in the picture was a little blob in one corner? Getting in close to your subject will tease out the interesting aspects, and produce appealing pictures.

Never work with children and animals… unless you can get down to their eye view. Seeing what this kitten sees conjures its world rather than yours in what might otherwise be an ordinary picture.

VITAL STATISTICS

Aperture, shutter speed, and focal length are a camera's vital ingredients, and each combines to produce your picture. The same is true of digital cameras though the way these are expressed can be different.

An exposure is the result of two factors: the speed at which the camera's shutter opens and closes; and the width of the aperture through which light passes. The same is true whether you're using a conventional or digital camera. Shutter speeds are usually measured in fractions of a second: 1/30th, 1/60th, 1/125th, 1/250th, 1/500th. Aperture is measured in f-stops: f/2, f/4, f/5.6, f/8, f/16. Each stop admits half the light of the previous setting.

A slow shutter speed allows more time for the light that is passing through the aperture to reach the CCD. Similarly, a wider aperture allows more light to pass through. It follows that combinations of the two enable the same amount of light to reach the CCD.

With many mid- to high-end digital cameras, the photographer has complete control over the way these two factors are combined to produce a picture, and all but the most basic digital cameras offer some degree of control. The question is, why and when to favor aperture over shutter, or shutter over aperture? The answer lies in depth of field

The result of incorrectly combining aperture and shutter speed is an under- or overexposed picture. It's possible to compensate for poor exposures using image editing software, but, inevitably, detail will be lost (crucial when working with a finite quantity of pixels).

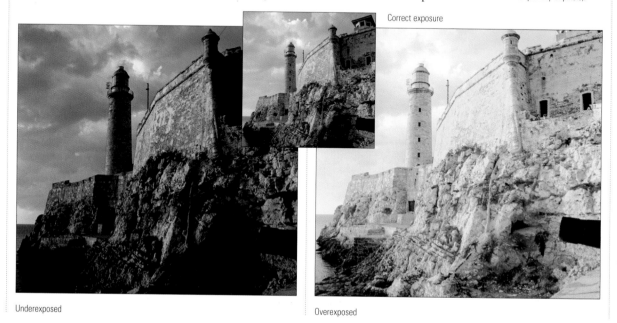

Correct exposure

Underexposed

Overexposed

and movement. A narrow aperture allows more of the picture to be in focus. That is, a picture exposed at say 1/60th of a second and f16 will focus everything between a yard and infinity (described as "depth of field"), ideal for landscapes. But 1/60th is slow, and if there's movement in the scene, it could be blurred.

Light, Camera... Action!

So when taking an "action" photo a fast shutter speed of say, 1/500th of a second, and a correspondingly wider aperture of perhaps f/2.8 are used. This lets enough light enter the camera for your subject to be in focus, while other details will be blurred.

What does all this mean to digital cameras, which have a CCD rather than a shutter? Much

the same. A digital camera fired at 1/500th of a second makes an exposure just like a conventional camera. The difference is that the CCD is turned on and off for 1/500th of a second rather than the plates of a shutter passing across a film frame. The control you have over the aperture settings of digital cameras depends on the camera. Mid-range cameras allow manual aperture settings, but most have a "motion" setting for taking action photographs.

A wide aperture allows effects such as "panning." The camera is focused before the subject appears and the camera is moved as it sweeps through the scene while the shutter is released. The out-of-focus background gives a dramatic indication of speed.

Looking out over vegetation, a narrow aperture and slow shutter speed keeps everything in focus, and is an ideal combination when photographing a landscape.

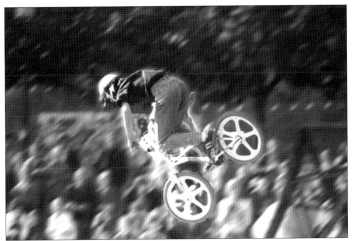

CLEAR AND CLOSE UP

A blurred image can provide dramatic impact, but more usually, your aim will be to capture scenes in perfect focus—especially important when working within the finite resolution of a digital camera.

On the previous pages you learned that focusing is as much a factor of aperture as it is of dialing in the correct distance between the lens and its subject. When light passes through a narrow aperture, it undergoes a kind of "natural" focusing. This property enables camera manufacturers to build cameras that are described as being fixed-focus—there is no way to change the focusing distance of the lens. Instead, a relatively slow shutter speed is combined with a narrow aperture to ensure that on sunny days or when using flash, everything between about 4 feet and infinity will be more or less in focus. Fixed-focus cameras are cheap and work, but they're creatively limiting.

Ghostly Images

Manual focus cameras—generally either rangefinders and SLR types—rely on the photographer to set the lens to the correct distance between camera and subject. This is achieved with the aid of a focusing tool rather than by measuring or guessing. Rangefinder cameras resemble compacts in that they have a separate lens and viewfinder, but these two lenses are linked in such a way that turning the distance ring on the lens causes a "ghost" image in the viewfinder to move. When the ghost image and main viewfinder image are aligned—the one transposed over the top of the other—the lens is focused.

SLRs generally offer a combination of aids such as a split screen and a fresnel screen. The split screen shows a divided image which is aligned as the lens is focused. When the divided image joins up, the lens is in focus. A fresnel screen resembles a pixelated digital image which is made to grow gradually less pixelated as the lens is brought into focus. The fresnel screen is used widely with twin-lens reflex cameras.

During the 1980s, auto-focusing became widely available. As you squeeze the shutter button, the camera fires an infrared (or occasionally a sonic) beam at the subject which is reflected back to the camera. The distance is calculated from the delay between sending and receiving and the shutter focused accordingly. All mid-range digital cameras feature autofocus as standard. Professional cameras

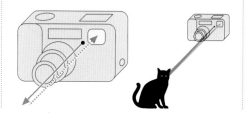

Autofocus cameras fire an infrared beam at the subject, which is then reflected back to the camera, letting its onboard sensors judge the distance and pull the lens into focus accordingly.

often feature a manual override to enable experienced photographers to choose.

Though autofocus works well, there is a small delay between pressing the shutter, focusing the camera, and the shutter firing. This can be a problem if you're trying to capture a moving target but there is a way around it known as "locking" the focus. Aim the camera at something which is at a similar distance, squeeze the shutter to focus the camera and hold the shutter button. You can now recompose the picture and fire the shutter at the required time. You can also use this method to focus on subjects outside the center of the frame but pointing the camera momentarily while you focus, then back again to take the picture.

UP CLOSE AND PERSONAL

Zooming is one of those gimmicks that camera and lens manufacturers make much of because they know that getting close to the action holds an immeasurable appeal for novice photographers (digital video cameras which offer 800x zoom lenses). However, unlike some gimmicks, zooming offers many possibilities. Certainly you can "get closer" to distant subjects, but the real value lies in the way a zoomed lens tends to flatten depth of field, tightly packing the "layers" (see composing) of a scene. This flattening effect is perfect for portraiture because it flatters the subject, and enables the photographer to get in close without making the model uncomfortable. Perhaps most importantly, zooming helps you to fill the frame with the subject, lending greater impact, and helping to avoid the classic mistake of cluttered pictures with what should be the point of interest lost in a corner.

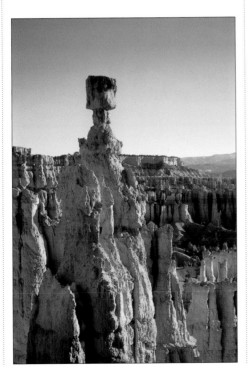

Used even on a landscape picture, zooming in on a detail—such as this almost human-looking rock formation— flattens the background and flatters the subject to create a striking image.

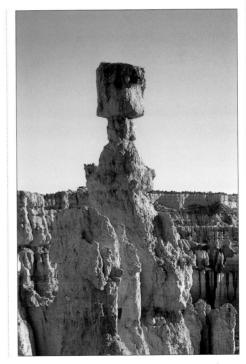

DIGITAL COLOR

During its early years photography was a monochrome process and color was the Holy Grail. But the advent of color processing brought with it the realization that black-and-white photographs can be every bit as striking.

Color stirs the emotions in a way that transcends the relative simplicity of composition and technical application. Color can convey tension, it can comfort, it can inform, or it can be simply abstract, the artistic value of the picture derived from the-combination of colors within and the subject itself without recognizable form. Paradoxically, where color can convey emotion, a lack of color can have an equally potent effect. Used carefully, a grayscale treatment will bring great beauty and impact to an image.

Color Variations

It's important to realize at the outset that in photography, there is no true color. The same scene shot at the same time with the same camera but on different film, will result in photographs that are very different tonally. Digital cameras vary even more so. Manufacturers tend to weight one color over another and by its very nature the digital process itself is incapable of anything more than an approximation (albeit a pretty good one!) of the range of colors in a scene. Though 24-bit color offers a remarkable palette of more than 16 million hues the human eye can distinguish almost infinitely subtle variations which can be lost in a digital

This scene is brought to life by-the availability of color which gives reason to the composition and delights the-eye.

sample. Time of day, the seasons, and artificial lighting all have an impact too.

Some digital cameras provide a white-balance option as a counter to the color

COMPLEMENTARY COLORS

Color is the result of mixing one or more hues. Where there are no hues the result is black, and all hues together are white. To represent this mixture artificially, on the printed page, for example, or on a television screen, several color "models" have been devised and two are used most frequently: RGB and CMYK. RGB stands for the primary colors red, green, and blue, and mixtures of these in various degrees makes the other colors. RGB is used for television and computer screens, cameras, scanners, and binary devices. The CMYK model (which stands for cyan, magenta, yellow, and key plate—the plate that carries the black) is used for color printing. This model is used because ink cannot reproduce the range of colors provided by the simpler, but tonally more subtle, RGB model.

Fortunately, when you come to print your RGB digital image, it is converted to CMYK color automatically by the image-editing software or the printer's firmware (which accounts for the differences in the printed and onscreen image). RGB is said to be an "additive" model because the colors are added together to create others. CMYK is a "subtractive" model, the colors are removed by degrees to provide the required hue.

(*above*) If your camera provides red and yellow filters, they can be used to powerful effect in black and white photographs. In this image a red filter has deepened the contrast between sky and clouds

(*right*) Color conveys information which, though important, is sometimes second to mood as in this scene. The grayscale and added noise gives a gritty realism to the picture.

casting that artificial light can create. Some cameras offer red and yellow filters which profoundly affect the tones of black and white photographs. However, these effects can be simulated using image-editing software.

QUICK AS A FLASH

Light is your medium, but working with light can tax even the professionals. Too much and a picture's detail disappears into uniform whiteness, too little and there is no photograph. Your aim is to balance the available light to build your pictures, to create highlights, mood, and tone.

All but the very cheapest fixed-focus VGA digital cameras sport a flash unit. But it's fair to say that these usually tiny electronic flash systems are often underpowered and the results when using them disappoint many digital photographers. The unit is charging from tiny batteries which are also powering the camera. You can expect a built-in flash unit on a compact camera to have a maximum working distance of about fifteen feet. The manual that accompanies your camera will tell you the unit's working distance.

Most digital cameras offer several flash modes: autoflash, in which the camera

Night photography can produce beautiful results, but you must mount the camera securely to avoid the blurring that is inevitable with the long exposures required.

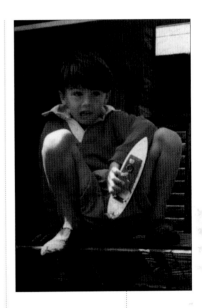

(*left*) The bane of low-light photography (when pupils are wider to admit more light), red-eye occurs when flash is reflected from the retina at the back of the eye. Many cameras offer a red-eye reduction flash mode which fires the flash fractionally ahead of the shutter so that the subject's pupils contract before the picture is taken and red-eye is avoided (left image).

decides whether to deploy the flash unit based on the exposure reading; and flash always on or always off. Switching on the flash yourself is useful when you need to light a subject that might otherwise be underexposed or thrown into silhouette, such as when shooting into bright light (this is known as "fill-in" flash). In these circumstances the camera's exposure meter reading would almost certainly indicate that flash wasn't required. Switching off the flash is necessary if you want to take time exposures—at night, say, with the camera mounted on a tripod and using very long exposure.

Reflected Glory

Wherever possible make the most of available natural light. If your camera's metering tells you that flash is required, try using a reflector (a large piece of white card will do) to direct light onto your subject. A reflector placed horizontally beneath a head and shoulders portrait will direct light up into the face,

softening shadows, smoothing wrinkles, and minimizing prominent features. Close-ups work better with reflectors too where flash might burn out detail. Indoors, position your subject near a window (one that admits indirect light), so that your back and the subject's face is turned to the light.

Blocking Noise

Outdoors, shoot your pictures mid-morning or mid-afternoon to avoid the deep shadows thrown by the overhead midday sun. In dim light use a tripod or position the camera firmly on a steady surface and use the timer to fire the shutter and avoid camera shake. Though digital cameras generally work well at long exposure times, some "noise" will begin to creep into the picture, though you can use fill-in flash to avoid it. If the camera features an EV or white balance option, use them to expose backlit scenes correctly in which the point of interest might otherwise be silhouetted or when shooting in artificial lighting conditions.

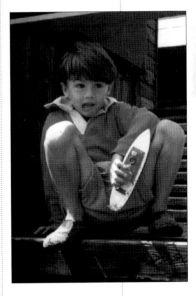

Fill-in flash helps to light a subject that would otherwise be underexposed and lacking detail. This is when flash comes into its own.

THE HUMAN EXPERIENCE

Photographing people makes for an inexhaustible supply of potential subjects, and the picture-taking starts right in the home with family and friends. With a new camera, a fresh set of batteries, and an empty data storage card you have the potential for some truly great people pictures.

People are endlessly fascinating, and pictures of people provide a truly irresistible fascination. Our brains are "trained" from childhood to recognize faces, to pick friendly or familiar faces from crowds, and to make a connection with faces and human form that is without parallel. For photographers, people provide an inexhaustible supply of material for interesting pictures, and for most of us that means we can find fantastic photos without even leaving the house. A good portrait picture preserves the moment enabling us to see beyond the obvious form and somehow glimpse the essence of a subject—though it's fair to say that the subject may not always like being preserved!

Pose the Question

During photography's early years, portraits were necessarily formal. Long exposure times required sitters to remain quite still for several minutes or more, effectively ruling out candid photography. The introduction of the Leica 35mm "miniature" and similar small cameras freed the photographer from the formal subject, and allowed pictures to be taken in all kinds of interesting situations. Candid shots—those without the subject's knowl-edge—are explored elsewhere on these pages, but there is a mode of photography which falls between the rigidity of "formal" and the voyeur-like approach of the unobserved and more "candid" shot.

Informal pictures capture people in natural poses—which may or may not in fact be rigidly posed by you. A storekeeper leaning over the counter, a traffic policeman

Formal or informal, a portrait is a magnet for the eye. You want to see what, why, and when, who and where. Carry your camera and look for the moment that defines an experience, one in which the subject is contextualized within the confines of the image. It isn't easy and you'll discard far more images than you'll keep, but when it happens, you know you've got a great picture.

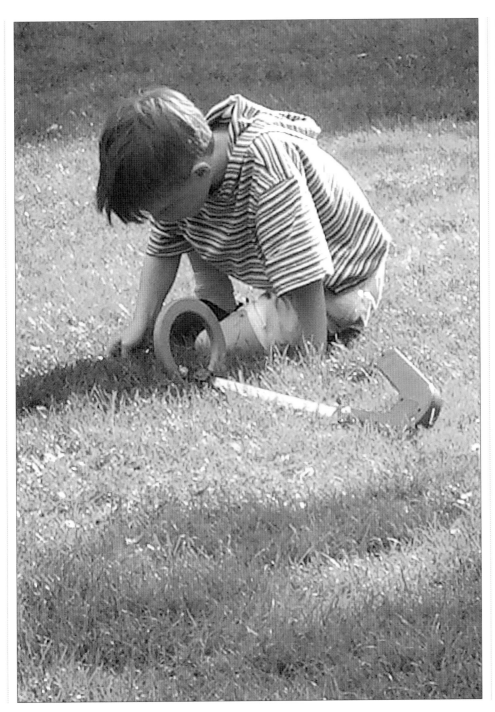

Children are endlessly fascinated by their world and it's that interaction with what's around them that makes for a compelling image—we want to know what it is the boy is about to dig up. Take lots of pictures of your kids so that they become impervious to the camera letting you capture the moment.

caught mid-gesture, the sentry in his box, family pictures of people sitting at the kitchen table, on sofas, or enjoying the deck all reveal something about the subject which is at once interesting and compelling.

Even today, when the majority of people are completely familiar with the camera, it remains relatively difficult to capture people at ease. They become edgy and nervous, unable to relax, or else wooden and stiff. Give your subject something to do to focus their mind away from the camera. A prop is a good way to help relax your sitter, suggest perhaps they hold a book, stroke a cat, or some such.

If you're photographing someone who isn't sitting for you, side-step potential hostility and ask permission! Most people will agree after a token show of objecting. By gaining

Proof that a snap of a family group for the album can be every bit as interesting as the "art" shot. Here the people are arranged in such a way that the eye is drawn into the picture. Height in the arrangement also plays a part and creates interest.

permission you can direct the subject into a "pose" that justifies your interest.

If you're taking a vacation picture of a friend posed alongside a landmark, try to create distance, and work up some drama between the two. Use the lens" widest setting, move far enough away from the landmark so that it isn't cropped, and stand the subject close to the camera. This will provide depth and enable both the person and the landmark to create their own space within the picture. Alternatively, keep your camera primed and ready and take the picture when your subject is animated, but with the landmark as a back-drop—effectively a frame—to the movement. Use depth of field and selective focusing (a technique described elsewhere in this book) to draw out your subject.

Eye to Eye

There is no greater impact than that of the subject making eye contact with the photographer. The effect can be dramatic, poignant, inviting, or starkly rebuffing, but you can be sure that those who see the picture will feel the impact whatever its apparent message.

TWICE THE PICTURE

Here's a tip for a tense subject. Take your picture but then, immediately as the subject relaxes (because the moment has passed), take another picture. This second one could well be the picture you imagined in the first place.

Ask the subject to look directly at the camera. This might be difficult if your subject is self-conscious and shy, and even those who aren't will find it difficult to stare into the lens for longer than a few moments. You can over-come the problem by speaking to the subject just before you fire the shutter, ask again for them to look at the camera, or else capture their attention by making a noise or saying something unexpected.

If a face forms part of your picture and unless you're after a particular effect, always focus the lens on the eyes for maximum impact. Looking into the lens doesn't necessarily mean the subject should smile (though a glare might not be what you're looking for either!). Try to determine what it is about your subject that you and others might find interesting and arrange the face to tease out that particular element.

When palm-sized cameras became a reality in the 1930s, all kinds of truly amazing

Get up close when taking portraits and fill your image with the subjects (or else crop closely). There's nothing worse than squinting to make out a tiny pair of figures way off in one corner of the picture!

pictures were taken of the rich, famous (and infamous)! Where people were familiar with, and aware of photographers lumbering about with unwieldy box cameras, they were caught off-guard by the new wave of photographers shooting candid pictures.

The Name is Bond...

Today the same is true. Your digital camera is probably smaller again than any conventional device you've previously owned. What's more, it'll either be silent, or can be silenced at the touch of a button. The potential for candid pictures is immense!

The first rule of candid picture-taking is simply to let you and your camera become familiar. If you're almost invariably seen holding a camera, no one will think twice when you use it, thereby enabling you to capture the moment.

If you find yourself in a one-off situation where familiarity isn't an option, then try using various blinds: misleading aiming, waist-level viewfinding, wide-angle framing,

CHOOSE YOUR VIEW

A high viewpoint narrows but slightly lengthens the nose, draws attention to the hair and forehead, and gives the face a triangular appearance. A low viewpoint tends to strengthen the chin, broadens but shortens the nose,-and emphasizes the eyes and brows—but beware of nostrils!

WANTED!

Avoid head and shoulders portraits with the subject turned to face the camera unless your intention is to create a passport snap or a "wanted" poster. Instead, turn the subject so the picture captures a three-quarter perspective, narrowing the body. Tilt the head slightly so that the subject looks down the line of the shoulder into the picture. A pose like this will breathe life into a portrait and give it movement and interest.

or even a mirror turned at 45 degrees to the lens will get you the picture without the subject being aware. Misleading aiming involves your focusing at a point similar in distance to the subject. Hold the focus by retaining pressure on the shutter button, then turn to the subject and fire the shutter quickly before the victim is aware. Snap a second shot if your subject notices and decides to glare or confront you!

Candid Camera

With a preview LCD screen you can often frame and focus a picture away from eye height, enabling you to neatly conceal the fact that you're taking a photograph, or else a small mirror held at 45 degrees to the lens will turn your pictures through a right angle—you'll be pointing ahead but photographing to the side. Setting the lens to its widest wide-angle setting will enable you to

The classic head and shoulders pose with the subject's shoulder drawing the eye into the picture and up to the face. Here, a longer focal length has blurred the background and flattened depth to really lift the subject out of the picture.

point the camera away—ostensibly—from the subject you want to capture but while actually including them in the picture.

Interaction between several subjects equates to interest in a picture. When working with a group of people, arrange them so that there is a variety of angles and heights—even if that means someone kneels. Avoid a straight line-up treatment which makes for dull, flat pictures. Couples make great subjects. Let them touch to heighten the human interest, which is the essence of what you're attempting to capture.

Arrange multiple subjects so that they're framed by something solid—tree trunks, steps or stairs, a doorway or window. This will have the effect of joining and fixing the group in its own space, and provide a focus for the picture. Use your camera's wide-angle setting and exploit the lens' ability to fill the frame.

Little and Large

It's a sure bet that most of the children you meet and photograph will be smaller than you. Yet time and again you'll see photographs of kids who all but disappear into a corner of the picture because the photographer is towering over them. The secret, if there is one, is to get down where the action is (unless you're trying to make a virtue of a child's relatively diminutive stature to give impact and poignancy to a picture). Allow your camera to see the world as children see it. Look for unusual child-eye view angles, use a fast shutter speed (if your digicam lets you choose), and flash for action-stopping pics.

Try shooting from a low viewpoint—that is one lower than that of the child subject, so that you're looking up into the child's face, or else exaggerate the height difference by standing close and photograph the child from almost directly overhead.

If you have kids, accompany them to a birthday party and take your camera with you. Better still, take them to the park on a sunny afternoon, let them run off to play with others, and wait for the picture to emerge…

And here again we can see the potential for drawing the eye into a picture. While the subject is but a tiny part of the overall image, there's interest in the "layers" that arc horizontally across the scene, dividing it and heightening the visual impact and interest.

GETTING THE OUTSIDE IN

Step outside and you step into a world of possibilities, picture-wise. Landscapes are everywhere you look, even in cities, and buildings old and new are a joy to explore with a camera. And let's not forget the humble family seaside vacation, ice creams, donkey rides, and all!

From the moment you leave your home you're surrounded by landscapes that are potential pictures. A landscape can be the archetypal rolling countryside and scenes of farm buildings or a shot of distant office towers outlined against a dramatic sky.

If there's a secret to shooting landscapes, it is in rejecting the notion of including all that you can see into the picture in a bid to capture what you perceive as its breadth of scale. Instead, find a focal point that leads the eye into the scene and try to isolate a section of what you see—in a landscape, composition is vital, but by trying to incorporate the widest possible scene, you'll find that when the photograph is printed the lack of focal point results in a dull and empty picture. Try to avoid the obvious viewpoint. Raise yourself above the scene or get down low to tease out an interesting perspective.

The Light of Day

Time of day and the elements play a substantial part in the appearance of the landscape which is otherwise fixed. Patience will result in the picture you're looking for, and you may have to return to a subject when the light or the weather is better suited to the scene. Midday sun—the time when the sun

This picture (*left*) is a fascinating interplay of textures, light, shapes, reflections, and shadows; look for contrasts like this in any landscape shot, and you'll have a stunning image.

By focusing and exposing
for the scene outside, then
standing back from the
window, this picture has a
perfect frame. To achieve the
same effect, stand close to the
window and point your camera
outside, squeezing the shutter
release to enable the camera
to focus on the scene and
correctly determine a suitable
exposure. Hold the shutter to
"lock" the settings, then take
a step or two back and release
the shutter. You may need
to crop superfluous window
material from the picture

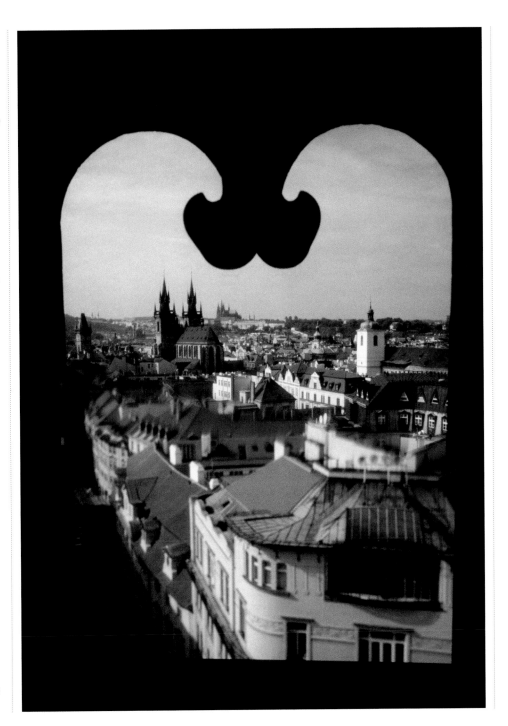

A delightful scene such as
this-(*left*) demands the rule
of-thirds for a balanced
composition, but all the
rules of exposure have been
abandoned in order to capture
the magnificent light.

is more or less directly overhead, results in few shadows and flat pictures. Morning and late afternoon sun casts deep shadows which reveal the texture in a scene and help you to build layers which draw the eye from the foreground to the background.

As you might expect, the seasons play an important part in the quality of light. During the summer months, your pictures will be well lit, but the light can be harsh, whereas in spring and fall, the sun is lower in the sky, shadows are deeper and the natural world is alive with color! Winter sunshine is thin and bright but beware of inaccurate exposure meter readings (and that includes automatic exposure digital cameras as well as those over which you have

Any device that will draw the eye into the picture will create interest. Here though, the railing has become almost abstract and yet it's the main source of interest within the photograph.

The wintry trees in this scene are, again, almost abstract. What matters in the image are the colors and textures which strike a chord in the viewer.

control). Snow scenes especially can easily fool your camera into overexposing and it may be necessary to make EV and white balance adjustments accordingly.

Second only to weddings, vacations present ideal opportunities for taking pictures. Simple snaps of families gathered together on the beach, kids making sandcastles, donkey rides, and brightly colored buckets and spades. Pictures like these are perennial favorites. They evoke lovely memories of endless summer days and strike a chord that virtually everyone can relate to. No day at the beach is complete without your camera and far from being clichés, these classic shots will live as pictures long after your attempts at high art have stopped embarrassing you!

Edifying Edifices

Photographing buildings is in many ways like photographing any landscape, the difference lies in the combination of attraction with purpose. All buildings have a function and a reason for their existence. Architects design buildings with a dominant aspect and by photographing this you capture the essence of what it is that makes the building interesting. Let your eye seek out the dominant features, and then move on to, and over, the supporting elements. A low viewpoint and a wide-angle lens setting will exaggerate these features and make for a very striking picture.

Opening the lens to its widest possible setting has resulted in wildly distorted angles in this picture of a windmill. However, the distortion emphasizes the mill's sails and points the eye to the second windmill on the hill at the right of the image.

CLOSE QUARTERS

Photographing buildings, it's natural to imagine that the best pictures will be those which include all or at least a substantial amount of-the building in the picture using a wide-angle lens (or the wide-angle setting of your camera's zoom lens). But much of what good architecture is about is texture. Often getting up close and making an abstract of some small part of a building—worn bricks, scared stonework, an old rusted lock, or some such—will capture the flavor of a building in a way that shooting it as a whole never could. See pp. 62–65 for details of how to use your digicam up close.

Buildings can be impressive in their own right, or because of the way they fit into or contrast with their surroundings. Those constructed on an impressive scale can be difficult to work into a picture in their entirety and you might have to think of alternative ways to shoot them. Look for a reflection in a store-window, a car's side mirror, or even a puddle for a different perspective.

Scale and Elevation

Alternatively, photograph the building from afar, filling the frame as far as you are able with your camera's zooming function and cropping out unwanted material when the picture is downloaded to your image-editing software. Work your way around the building, taking pictures that reveal interesting nooks and crannies. Consider how light falls and is reflected against its elevations; study the space around the building; use street furniture and passers-by to provide a measure of scale. Now move in close and pick out the building's details. Doors

Don't overlook a simple picture-postcard scene such as this one. Careful framing will help get all relevant detail into the image.

The distorted angles in this picture are what is known as "converging verticals." A wide-angled setting makes the building "lean" backward.

Although there's quite a bit of "noise" in this night scene of lit buildings (*right*), the artificial colors add emphasis to the hues from the-buildings themselves and the whiff of steam from the center building is the frosting on the cake! The Arc de Triomphe (*left*) appears a see of calm and solidity among the bustling traffic in this long night exposure.

and windows, steps and stairs, eaves, and the material of the building itself—bricks, stone, concrete, or whatever.

Landmarks are all very well, but it's the unfamiliar which makes an interesting picture when overseas. Street furniture such as road signs, electricity and telephone line poles, vending machines, mail boxes and phone

Textures and colors again. But with a longer exposure, they have created a softened tone for this image of pebbles on the shore.

SAND IN THE MACHINE

In the course of regular use, a camera will come into contact with all kinds of potential contaminants, but none is quite as bad as sand. Fine grains will work their way into every thread and combine with the grease intended as a lubricant to form an excellent grinding paste! It's possible to buy protective cases. Alternatively, save the clear plastic bags which wrap fruit, tying the bag tightly to keep out the sand.

A mixture of the natural and incongruous here makes for a splendid composition. The fact that the brash yellow of the sign contrasts splendidly with the intense blue of the sky squeezes extra value from a great image.

(*Right*) An adjacent building to the leaning Tower of Pisa, has deliberately been included in this photograph to make a comparison and show just how much the tower actually leans!

booths, quirky delivery vehicles, public transport (trams especially), and street markets with exotic fruit all create a picture of things which are—literally—foreign to our experience.

All Abroad!

Of course, when in Paris, take pictures of the Eiffel Tower; in London, Tower Bridge, the Houses of Parliament, Nelson's column and Buckingham Palace; in San Francisco, the Golden Gate Bridge, and in New York, the Empire State Building and the Statue of Liberty. But don't dismiss the everyday stuff. Look into a potential scene and try to isolate what it is that makes it different from your

own home territory, and then take a picture that emphasizes that difference.

Even the light itself can be different. If you live in a northerly clime and visit a region that's hotter, the light will be very different and will in some measure dictate the way that you approach pictures which might otherwise be familiar to you.

Like the photograph of pebbles on the opposite page, it is the soft tones and textures in this delightful picture of a rock pool that make for a worthy photograph.

AN INSIDE JOB

With a new camera and an eye for subject matter take a look around you: the home and backjard offers interesting shapes, colors, and textures, and the potential for a peek into the daily lives of your family and friends...

It isn't only charity that begins at home. With a new digicam fresh out of the box, your home becomes a veritable Aladdin's cave of picture-taking potential. Interiors, either "straight" or viewed from unusual angles (from-the foot of a stairwell, for example), create interesting photographs, and the possibilities for lighting effects are many and varied. Outdoors, the fabric of the building can also provide plenty of potential.

Arguably more important than all of these is that the home is the focus of everyday life—your life, and that of your family. And there are few photographs more compelling than the simple act of people, young and old, going about their daily routines.

These Four Walls

Taking pictures inside your home can be difficult. There are extremes of light and space. If the sun is shining brightly into a room, it's easy to fool your camera into making the wrong choice of exposure, and using flash often results in harsh shadows, color casts, and red-eye if there are people in the shot.

Inside, try to look for ways to frame your pictures. By using say, a doorway or a window to frame the subject, you'll strengthen the overall composition and create an illusion of

Even a subject as simple as a-few dishes on a table can catch your eye and attract your lens. Wander through your home looking for interesting shapes and arrangements—especially when shot from an unusual angle.

WIDER THAN WIDE?

Most compact digicams sport a lens that is the equivalent of a 35mm SLR's 50mm lens. This has a field of vision that roughly matches the human eye. However, pointing a 50mm lens into an average room will cause much of it to appear outside the frame. If your camera has a wide-angle setting, use it to include more of the interior. Equivalent focal lengths would be 35 (the largest focal length that is-considered to be wide-angle) or 24mm (generally wide enough for most situations indoors). If your camera can swap lenses and you plan to shoot interiors, plump for a 24mm or even a 20mm lens.

depth. It's important too, to ensure that the vertical surfaces in the room remain upright. Put the camera on a tripod and/or use its LCD preview screen if you find it difficult to keep everything upright using the viewfinder.

Placing people in a room will help provide a degree of scale, and if a person is seated, the room will appear to be larger. Position your subject midway across the room for the best effect. Take your picture from waist height; a shot taken at eye-level will include a lot of ceiling, and will unbalance the picture. Aiming the camera downward will cause the walls to lean into the frame. Take your picture from a corner to get in the most detail, or point the camera through an open door.

Unless your camera is equipped with a wide-angle setting, it can be difficult to include much detail into a shot of a room. Try squeezing yourself into a corner and shoot from waist height to provide scale and balance.

UP CLOSE AND PERSONAL

Zoom in to the world of the microscopic and see things from a different viewpoint with close-up picture-taking. Most digicams offer close focus of some sort and there are add-on lenses for those that don't.

Taking close-ups is easy if your camera has a macro mode—and many do. Macro photography is what close-up picture-taking is properly called. In this context "macro" is a focusing attribute which enables the lens to correctly focus an image inside the normal limit for its focal length. Sometimes this is achieved using an add-on macro lens, sometimes with on-board trickery but whatever the method,

close-ups enable you to take a "sideways" look at a subject, exploring it in an interesting new way which might otherwise be missed.

Of course, it's entirely possible simply to download an "ordinary" picture to your image-editing software, isolate a small section, and enlarge it but the results would not be anywhere near as effective as a true close-up picture. The reason, as those who have read

Getting in close, without disturbing your subject is only part of the secret of taking a picture like this one. This is where a good zoom or close-focus lens really comes into its own: not pulling distant objects into focus, but homing in on a near object and knocking its surroundings out of focus. The stunning effect is accentuated by the out-of-focus flower in the foreground. But when using autofocus, check carefully that the correct subject is sharp.

Using a powerful zoom or close-focus lens, a similar but equally striking effect to the butterfly image (*opposite*) can be achieved by knocking even some of the subject out of focus, and just focusing tightly in on the face, or the eyes. This technique is useful for human portraits too.

HOW CLOSE IS CLOSE?

Close-up (or macro) lenses aren't measured in focal length in the same way normal lenses are. Instead a "diopter" rating is used. Diopter is a measure of magnification and usually diopter lenses are rated on a scale of between +1 and +10. +10 is used for really close-up work.

a close-up facility (though even at this end of the camera spectrum most do) and those at the other end of the scale, some of the expensive "pro" cameras offer close-up photography at focusing distances of just a few inches.

this book in sequence are by now aware, is that a digital image is constructed from pixels—a finite number of them. Enlarge a picture and you simply enlarge the pixels. Enlarge beyond a certain factor and the detail is lost—all that can be seen are pixels. In other words, there is no "hidden" information in a digital image—what you see is what you get.

No Soft Solution

So, true close-ups are generated by your camera, not your software. And just how close you can get depends upon the make and model. A mid-range camera aimed at the hobbyist market will generally offer a close-up facility focusing between one and two feet. Some cameras adjust the flash output too so that a subject focused at such a critical range will be properly lit and exposed. Cheap cameras or older models may not have

ADDING VALUE

If you want to get really close, you'll need to acquire add-on close-up lenses. Even if you're using a fixed-lens (not fixed-focus which is something else) compact camera—one which has a lens that can't be removed—you can probably buy and use one or more close-up lenses to suit. Many third-party accessories manufacturers offer lenses for digital cameras. Visit your camera manufacturer's web pages for details of add-ons, or use a search engine and search for something like-+lens+closeup+digital. Close-focus lenses look very like magnifying glasses without a handle (because that's just what-they are!) and as well as fitting to the camera they can be attached to each other to sum their diopter values. That is,-if-you add a +10 and a +5 diopter lens you'll get a +15-diopter lens. Be aware that combining lenses in this way-may result in some small degradation in the results.

One thing is certain, whether the distance is one foot or just one inch, if you're using a point-and-shoot compact camera, what you see in the viewfinder will be far removed from what the lens is seeing. This phenomenon—known as "parallax"—occurs because of the distance between the position of the viewing lens and the exposing lens. The few inches that separate these lenses on non-SLR cameras have little or no effect on framing when you're taking normal pictures, but draw near to the subject and the effect increases the closer you get.

Extreme Measures

Almost all compact cameras provide opaque framing guides (also known as correction, parallax, or close focus marks) visible in the viewfinder to help you frame at various distances. However, these might not assist in extreme close-ups. Instead, you must resort to the LCD preview screen to see what the lens is seeing and frame accurately (indeed, many cameras switch on the preview screen as soon as you enter close-up mode). Use the framing guides to position your subject within the view-finder, so that the resulting picture shows the subject more or less where it should be.

Cameras with a "macro" (close-up) feature let you to get very close a subject, but the "depth of field" will not be great (the foreground and background will be out of focus).

The zoom feature won't let you get very close but the depth of field will be greater—although enlarging the picture to get the same subject will not yield the same detail as with a macro feature.

Nearest and Dearest

1 Good lighting and sharp focusing is essential for a quality close-up picture. Lighting can come from the camera's own flash or from external lamps—a couple of anglepoise lamps perhaps (though compensate for the tungsten bulb by using your camera's white balance function).

2 Mount the camera on a tripod. Switch on its close-up mode and position it so that the subject is framed in the way that you want. Position external lights if you're using them. Switch on the camera's timer function. This will enable an exposure to be made without inducing camera shake from the shutter button.

3 Squeeze the shutter release to lock focus, then fire the shutter. Move back so that your shadow doesn't obscure the subject, then stand still so that camera is affected by vibration (which will appear in the picture as fuzzy focusing).

4 Sharpen the image once it's downloaded to your image editor using the techniques covered elsewhere in this book.

FIELD TRIP

When using a close-up lens the depth of field will be reduced dramatically—possibly to as little as 15mm. This can have a significant impact on your picture. If you're shooting, say, a flower at close quarters, the depth of field may not even be sufficient to keep the whole flower in focus. You might find that while the petals at one side are pin-sharp, those at the side are a complete blur. This can make for creative interest but it can also be simply irritating! To partly overcome the problem, use lots of light to enable you to use as small an aperture as possible. If possible, position your subject on a stiff sheet of white paper to throw light up and on to it. If you're shooting outdoors, in a meadow for example, you can use a piece of stiff white paper as a light deflector by locating it to the side and at an angle to the subject.

If you follow the steps outlined on this page carefully, you should achieve high-quality, close-up shots that give sharp detail and accurate color.

HOW YOUR GARDEN GROWS

As the seasons shift and change, you'll have limitless possibilities for imaginative and stunning photographs. But each new season will present fresh challenges, as well as new blooms and fauna.

The garden is a great hunting ground for photographs. Obviously, the seasons will largely dictate what's of interest in any garden, but also provide a shifting, ever-changing backdrop to your photographs. During the summer, there's fauna and flora in abundance, children playing on the grass, older family members dozing in chairs, and pets frolicking. Avoid the midday sun which casts few shadows (and results in flat, lifeless pictures), and shoot your photographs in the morning or late afternoon when the sun is at an angle in the sky and you can discover interesting nuances of light and shade.

Snowdrops and F-stops

During winter, and especially in the snow, the landscape of the garden is transformed dramatically. Snow reflects and boosts the available light. Your camera will expose incorrectly, and it's important to adjust using its EV (Exposure Value) function (for more information see pp. 44–45) which manually compensates for over- or underexposure. Adjust by two EV stops to ensure that snow appears white; otherwise it will be captured as a mid-gray. Similarly, mist and fog requires EV compensation of up to two stops to expose correctly and retain the white of the mist.

Using the macro feature on your camera lets you capture the splendid colors of nature; and of course in any image-editing software those colors can be further enhanced.

This photograph of a typical meadow uses the brook to lead the eye to the focal point of the image. Note also how the branches in the foreground add drama to the composition.

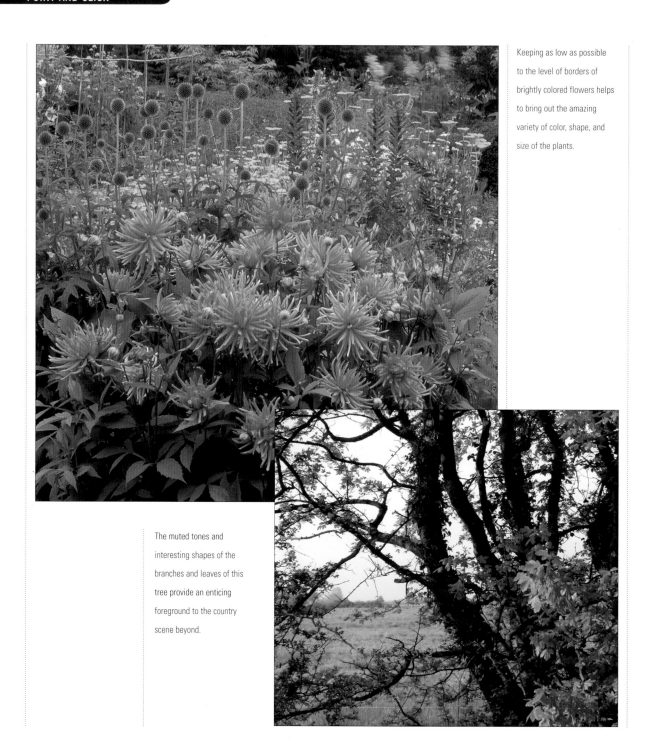

Keeping as low as possible to the level of borders of brightly colored flowers helps to bring out the amazing variety of color, shape, and size of the plants.

The muted tones and interesting shapes of the branches and leaves of this tree provide an enticing foreground to the country scene beyond.

White Out

Indoors, it's more than likely that you'll be shooting under artificial lights: either fluorescent striplights or conventional tungsten bulbs. Either will add an unwanted color cast to your pictures, in this case reds or greens. Preview a shot with the on-board LCD and, if you find that it has a blueish or greenish cast, use your camera's white balance functions to compensate for the artificial lights. This function of your camera is also particularly useful in very white sunlight or in snowscapes. If your camera is without a white balance option, you can simulate the effect using image-editing software once you have downloaded the images onto your computer.

Shots of landscapes covered in a blanket of snow are often disappointingly gray (*above*) when you see the results. Most mid-range digital cameras feature white balance adjustment. This makes an allowance for the amount of white light, so that the image becomes less gray and the whites purer (*left*).

PETS AND OTHER ANIMALS

Animals provide great potential for photographers and those using a digital camera have an added advantage: no film to waste while taking the endless shots required to capture the "right" picture! Start by practicing with family pets and work your way up to bigger and wilder animals.

Everyone's heard the old thespian saying about "never working with children and animals," and there's a good reason for its passing into common currency (especially when applied to the latter category): animals are unpredictable! Even photographing loveable and friendly pets can be fraught with the unexpected. But photographing animals is fun and their behavior can provide magical pictures—which is why actors dislike working with them so much—no actor wants to be upstaged!

So haul out your digicam, switch on the flash, and get to work around the house photographing your family pets. You know by now that, as a digital photographer, you have an automatic head start—you can shoot as many pictures as batteries will allow without wasting film, and continue until you get the picture you're after.

Good Behavior

Start by watching the animal in question—say, a cat or dog—and note the details of their

Even a pet cat can be chivvied from his lair as a subject for a photograph! Invest time watching your pets in the home and garden so that you can determine their habits. Mount your camera on a tripod and settle yourself for a wait. When the picture comes along, you'll be prepared.

Dogs can make excellent subjects for photographs. Unlike humans, they're not aware of the camera and therefore don't exhibit any self-consciousness—they just strike a perfectly natural pose.

behavior, where and why they come and go. Both cats and dogs have favorite spots where they like to curl up for a nap. Cats generally prefer to raise themselves off the ground and choose somewhere warm, though many will also come and sit on a piece of paper for no apparent reason if you put a sheet down on the floor. Dogs (if they are allowed) enjoy sofas, beds, or a big cushion, a spot on the hearth before an open fire, or a stretch beneath a warm radiator.

Know Your Prey

Get to know their favorite places and you have a likely stalking ground for great pics. Choose your location, sit quietly with your camera, and wait for the picture to hove into view. Wide-angle and zoomed lenses work equally well for different reasons, and you can always crop to compensate for weak composition afterward. The effort will be in capturing your pet at his most endearing, when he's displaying a human-like trait or action.

Caught in the Act

Many animals enjoy performing tricks, cats like to catch small items that you throw for them, and will endlessly chase a bobbin or some such attached to a length of string. Dogs are altogether easier creatures to train, and will happily sit down, rollover, hold out a paw, or balance a square of chocolate on their

noses while you take a picture. Some dogs (especially the smaller breeds) will even do spectacular tricks like walking on hind legs.

The Right Way

Remember though that the secret of a great pet picture lies in encouraging your pet to do whatever catches his personality. Tricks are fun, but unless they say something about the pet, the potential for poignancy is lost. If you're trying to photograph small animals, fish, or reptiles—essentially those that are housed in glass or plastic tanks—beware of reflections from the tank, especially if you're using flash. A good idea is to set the camera on a tripod at a slight angle to the tank, and use the camera's timer to take the picture for you once you've checked for composition and focusing to avoid catching your own reflection. Also, a polarizing filter will cut glare (hold it in front of the lens if your camera can't use filters).

There are super shots to be had outdoors too, but to find them you'll have to monitor the animal's behavior. Patience will reward

you with the best picture, and your camera's zoom will get you closer to the action.

Open Forum

Zoos and animal parks are perfect starting points for larger (and possibly wilder!) animals. Photographers often struggle to shoot zoo pictures without including the cages in the shots. Digital photographers have no such problems. Using the photo editing techniques discussed later, it's possible to remove cage bars and other artificial obstructions, which would otherwise ruin a great photograph.

A photograph like this is all about simply being in the right place at the right time—often entirely by accident. Be sure to carry your digicam with you wherever you go with fresh batteries and free space on its memory card so that you never miss a picture.

On the other hand, a simple trip to your local zoo or wildlife safari park will turn up lots of photographs like this. The inmates are entirely used to having strange people point cameras at them! And of course with some deft image manipulation any annoying artificial artifacts (*left*) can easily be removed (*right*).

But conventional techniques will work too, so position the camera as close to the cage as is practicable. Depth of field will ensure that it "melts" into the shot. Use your camera's zoom lens function to enable you to span the safety barriers between you and the wilder inmates. A wide-angle setting is useful when photographing creatures indoors. And don't forget that the zoo is full of watchers as well as the watched and some of the visitors are every bit as rich a hunting ground as the inmates.

A fast shutter speed will stop action and enable you to capture birds in flight, though you might shoot many pictures before you get the "right" one.

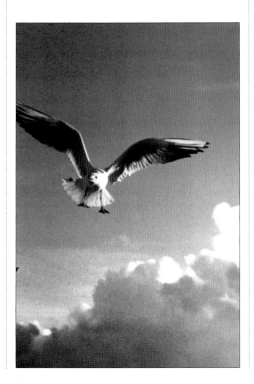

These ducks have become almost abstract shapes within the picture, which makes it an intriguing composition.

SPORTING CHANCE

Next time you go to watch a football match or cheer on your children at the school sports day, don't forget to take your digital camera. There's a wealth of picture-taking possibilities at every event.

Sporting events present fabulous opportunities for picture-taking. Indoors or out, solo, in teams, behind the wheel, mounted on horseback, with a bat and ball, a rod, or whatever, there are people, there is interaction, moments of high drama followed by periods of extreme concentration—all grist to the photographer's mill.

You can approach sports pictures in two ways: if you're a fan of a particular sport, say, football, take along your camera whenever you set out to watch a match and log the game as it unfolds; alternatively, and for those who aren't great sports fans, think of sporting

If you've ever noticed professional photographers at a sports event, you'll have seen that they use very long lenses in order to get closer to the action. Many digicams offer a zoom of some description and though these are usually very modest compared with the professional models, they can help fill the frame and magnify the subject matter.

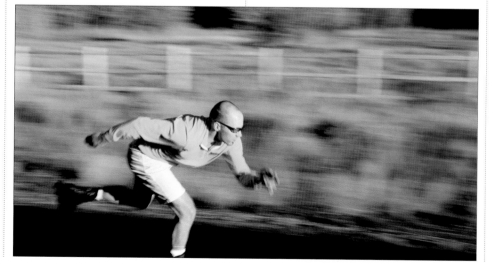

Panning a picture—moving the camera in time with the movement of the subject heightens the impact and makes for a dynamic picture. The technique isn't difficult but requires practice. As a digital photographer you have a distinct advantage: you're not wasting film! If the results don't please you, discard them and take some more.

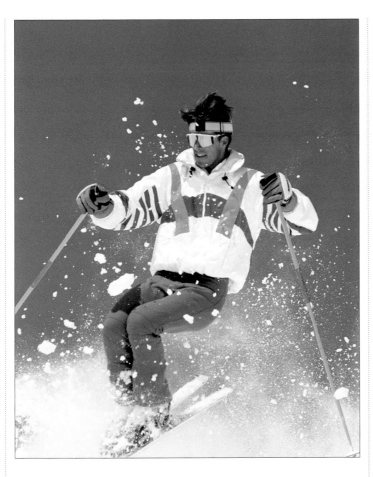

Mount the camera on a tripod, lock the focus on a point at which the subject(s) must pass through, and take a several pictures either one immediately after another or at intervals. The result is a striking action and time sequence, which truly conveys the atmosphere of the event.

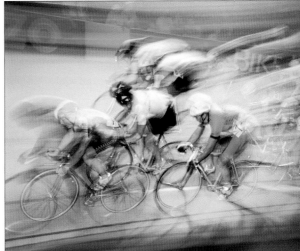

events simply as opportunities for taking great pictures of people. In fact it's almost certain that you've already taken pictures at sports events as a way to record the event for posterity—school sports day perhaps—but without really considering what you're doing as "photography." Now, you can combine the amazing features your digicam provides with your burgeoning skills as a photographer to record these events for your family and friends but while also taking pleasure in getting the best picture you can.

Unless you're photographing a chess match in which case no one will be able to tell, a fast shutter speed will stop the action and capture some truly amazing pictures. This type of picture is especially effective at events at which capturing the natural grace of the body would otherwise be missed.

Using a slow shutter speed or moving the camera as you fire the shutter will result in a blurred picture. However, this can be used to dramatic effect.

PLANES, TRAINS, AND AUTOMOBILES

We are surrounded by public and private transport of all kinds some of which—arguably—is attractive enough to warrant a picture! Your own vehicles, a vintage motorcycle perhaps, a steam train, or a yacht in full sail are all excellent subjects.

Endless pictures of a customized Ford, with gleaming paint work and whitewall tires, may bring back some memories for you, but they're very definitely best kept private! If you absolutely must take pictures of your motorized pride and joy, then now (i.e., putting into practice what you've learned in this book) is the time to do it with artistic aplomb. That way if the pics fall into the hands of those who might otherwise be entirely uninterested (your wife/children—and no apologies for assuming that it is the male who might be tempted!) they will have at least have some esthetic merit…

In fact pictures of cars, airplanes, steam trains, and all kinds of other weird and wonderful vehicles account for the bulk of professional photography sales around the world and, with care, you can ensure that transport pictures are interesting to look at for their own sake as well as, in future years, being a hideous reminder of your youthful taste in cars!

Bring out the Best

The key with photographing inanimate and sometimes overfamiliar objects is to look at what makes them familiar, or attractive, and to find ways of accentuating those unique features. Try different viewpoints, close-up details of radiator grilles and badges, waist-high shots along the hood, or with a single

Smile, please: the gorgeous curves and smiling radiator of this classic car are ideal subjects for the imaginative photographer. A flattering setting looks good in both, but the image on the left benefits from the viewpoint and the use of a wide-angled lens to draw out the most prominent feature.

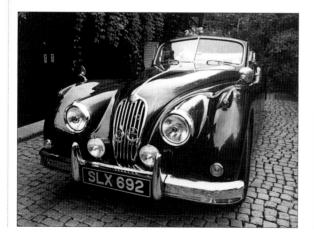

detail—such as a headlight—in focus. Or try using different lenses or settings: a wide-angle lens to distort the view from close up, a zoom to emphasize a detail from close up. A stunning location helps: an English stately home would make a fitting setting for a vintage Jaguar or Rolls Royce; as would an urban setting for a classic sports car. And with the editing techniques we'll explore later, you could add some motion blur for extra dynamism!

LONG AND WIDE

The standard 50mm-equivalent lens is geared to everyday tasks, but lenses of longer and shorter focal lengths—or digicams sporting zoom lenses—are often better suited to particular tasks. So it is when taking pictures of vehicles. Interiors require the widest possible wide-angle settings to capture as much detail as possible. Exteriors also benefit immensely from a wide-angled lens setting which tends to exaggerate angles and can make an otherwise dull "three-quarter" shot of our motor car (*opposite*) for example, look far more dynamic.

Long lenses too have their part to play. Zooming will fill the frame for a more dramatic picture and it will get you closer to the action—from an airport observation area or railroad platform for example.

Boats make ideal pictures, with a little imagination and good composition. Their elegant curves and variety of textures (wood, rope, sail cloth, and peeling paint) will look great contrasted with waves, reflections, and harbor scenes.

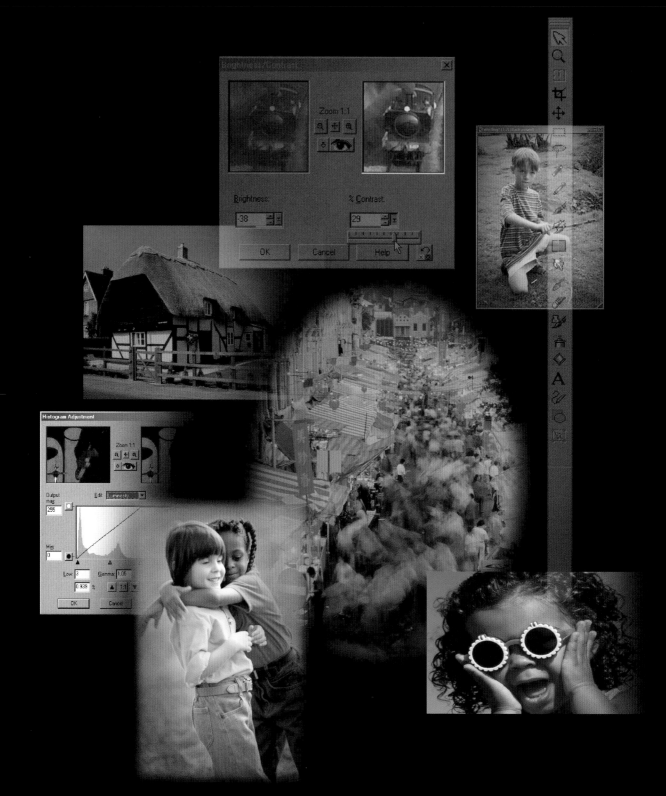

The Digital Darkroom

Time was (and it was not so long ago) when photographers were required to carry around a heavy wooden camera on an unwieldy tripod, boxes of delicate glass plates, bottles of crude and sometimes dangerous chemicals, and a special tent that doubled up as a darkroom for developing "in the field." Fortunately Kodak's box cameras ("You take the picture, we do the rest") simplified picture- taking, and the digital cameras of today continue that tradition, freeing your attention so that you can capture the picture you want without being overly concerned with the mechanics of exposing, developing, and printing. A desktop computer is your digital darkroom. You work in complete daylight, and enjoy instant results, but your mastery over the resulting images is absolute.

SOFTWARE

The digital darkroom is, in reality, image-editing software running on a computer. Your pictures are already "developed" inside the camera, but download them to your computer, fire up your image-editing software, and your "darkroom" is ready...

Until you print a picture from a digital camera, it exists as a digital file, just like a wordprocessor or spreadsheet document. And, just like those other computer files, dedicated software is available to manipulate, edit, enhance, and print the file. All but the very cheapest cameras come with editing software for you to install on your computer. Sometimes this software will include the software for linking the camera and the computer to transfer the files; but it is rarely as sophisticated as third-party software.

Shop Smart

The leading image-editing software by far is Adobe Photoshop. Available for the Apple Macintosh and Windows PCs, Photoshop is a feature-packed program which, in experienced hands, can produce truly amazing results.

The disadvantages, however, are that many of Photoshop's features are confusing for novices, the interface is anything but intuitive, and the price is way beyond what the majority of home users might consider paying. Indeed, you can buy a good-quality, mid-range camera and editing software for what you'll pay for a copy of Photoshop. The program is absolutely without parallel in the marketplace, but unless you're a professional, or an amateur with a large bank balance, it might be better to look elsewhere.

One alternative to Photoshop is Adobe's cut-down version, Elements. It is the latest addition to Adobe's range of image manipula-

Photoshop Elements' tool kit hides an amazing array of options beneath each of its buttons.

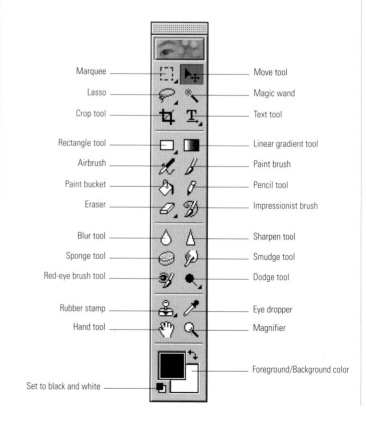

Marquee	Move tool
Lasso	Magic wand
Crop tool	Text tool
Rectangle tool	Linear gradient tool
Airbrush	Paint brush
Paint bucket	Pencil tool
Eraser	Impressionist brush
Blur tool	Sharpen tool
Sponge tool	Smudge tool
Red-eye brush tool	Dodge tool
Rubber stamp	Eye dropper
Hand tool	Magnifier
	Foreground/Background color
Set to black and white	

tion software. Photoshop Elements uses similar tools to its big brother.

It's Elementary

Targeted at the keen amateur, Photoshop Elements is geared to getting the most from digital camera images and among the tools and filters used to correct the kinds of problems you're likely to encounter, are features such as color correction, red-eye correction, merging backgrounds, constructing panoramas, straightening skewed pictures, and there's an integrated image browser too. The program also features a real-time compression option that enables you to squeeze the size of the file while viewing the effect on the image.

Pro Plus

For the PC only, one of the better-known programs—certainly the best value—is Paint Shop Pro, by Jasc Software. Similar in many ways to Photoshop, Paint Shop Pro (PSP) offers a complete range of image-editing tools allied with an easy-to-use and intuitive interface. The program began life as a shareware offering, and you can still download, install, and run the latest version for 30 days before deciding to buy it. PSP is also often available on the CDs that accompany digital photography magazines.

The program features many dedicated digital photo tools including a scratch filter, red-eye removal tool, and auto contrast and color balance enhancement. You can import pictures directly from your digital camera, and there's a built-in image browser.

Magnifier — Move tool
Crop tool — Deformation
Rectangular marquee — Move tool
Magic wand — Lasso
Paint brush — Eye dropper
Color replacer — Clone brush
Palette knife — Smudge tool
Picture tube — Eraser
Paint bucket — Spray can
Pencil — Text tool
Object selector — Preset shapes

And the Rest

If you have an Internet connection, try searching the Web for free downloads and shareware offerings. Many digital imaging and computer hobbyist magazines feature demo software on their cover-mounted CDs, too. Experiment until you find an image editor that suits you—when you do, you'll be amazed at the possibilities!

Paint Shop Pro has most of the tools the novice or semi-professional user will need. However, Mac users beware, this image-editing software is only available for PCs.

81

SHARPEN AND CONTRAST

It's time to open the door to your digital darkroom. Start with some simple editing—enhancing sharpness and adjusting contrast—and you'll soon be creating complex photomontage images, and exploring time-lapse picture-taking!

As you now know, digital images consist of many thousands of pixels and each one is individually addressable. What that equates to is the ability to edit at the pixel level—the most basic—and enjoy complete control over your images. If you were a skilled artist, you could actually "paint" whole new features into your pictures a pixel at a time—people, buildings—whatever! For the rest of us, those with modest artistic ability, you can improve sharpness, enhance contrast, correct flaws in lighting and composition, tweak composition, edit out unsightly or unwanted "features," crop for best effect, and much, much more using the tools provided by image-editing software.

Tools for the Job

A program such as Photoshop Elements or Jasc's Paint Shop Pro provides incredible control over an image with comprehensive software toolboxes which pre-empt your requirements, and require little effort to get good results. So let's start by using, say, Paint Shop Pro (hereafter PSP) on the PC, to sharpen and adjust the contrast of a typical digital photograph. You won't believe how easy it can be!

Sharpening

1 Fire up PSP by double-clicking its shortcut on the desktop or selecting it from the *Start* menu. When the program is running, press *Control > B* to summon the image browser. Navigate to the image you want to enhance using the folder on the left, then double-click the image thumbnail in the right-hand window to open it.

2 This picture of a train has the potential to become a very nice photograph. The wall creates a baseline from which the train leads the eye into the picture, and the tracks beyond continue the theme. The train bends slightly to the left, drawing the gaze into, rather than away from the image. But the nondescript sky and the slight fuzziness in some areas, together with late afternoon lighting is spoiling the overall effect.

3 Pull down the Image menu, and from the *Sharpen* submenu select *Sharpen*. The image is sharpened slightly.

4 At the *Sharpen* submenu again, select *Sharpen More*. This time, the sharpening effect is dramatic. What happens if you apply the filter again? Try it. The image becomes almost pixelated. Press *Control-Z* once to undo the last edit (the second *Sharpen More*). Though the sharpened image appeals to the eye, the train is beginning to lose resolution, its once-smooth edges are now noticeably jagged. Fortunately, you can selectively sharpen an image. So let's start again.

5 Select *Revert* from the *File* menu to abandon all changes. Without selecting anything, apply the *Sharpen* filter to the entire image. Click on the *Freehand* tool and draw around the wall and apply *Sharpen More*. This throws the wall into relief, giving it an almost organic appearance. Applying even this simple filter has markedly improved the picture.

Contrast

1 The camera has captured smoke trails from the engine but the-late afternoon sun has produced a hazy effect. Fortunately, this can be improved with a little contrast tweaking. Make sure the picture is selected (by clicking it), pull down the *Colors* menu and, from the *Adjust* sub-menu, select *Brightness/Contrast* (or simply press Shift-B). The *Brightness/Contrast* dialog box appears.

2 Experiment with the slider bars. The thumbnails above each will change as you make adjustments. Click the *Auto Proof* arrow (to the left of the "proof eye" between the preview windows). Now when you move the sliders, the picture itself will change. Here, a couple of notches of brightness and contrast is enough to cut the haze and help give the picture some zing. Click OK.

3 Back at your picture, press *Control-Z* to undo the adjustments if you decide you were too aggressive with the filters (which is easy). The secret is to experiment. Nothing is altered irrevocably until you save and even then, many image editors will allow you to undo changes. Now all that's needed is a bit of blue and some clouds in that sky. We'll get to that later!

SELECTIVE FOCUSING

Almost all hobbyist digital cameras offer autofocusing as standard—you simply squeeze the shutter button and the camera does the rest—but it's surprising just how often the camera can be fooled. However all is not lost with a poorly focused image if you have access to image-editing software.

While today's digital cameras are light and compact, and many feature complex software algorithms to counterbalance external camera shake (i.e., caused by you as you hold the camera), it's still entirely possible to produce images that are not abso-lutely pin sharp. Earlier we looked at a simple method to improve the sharpness of your pictures, but there are many ways to counter the problem of poor focusing and we'll now look a little more closely at the tools on offer in image-editing software.

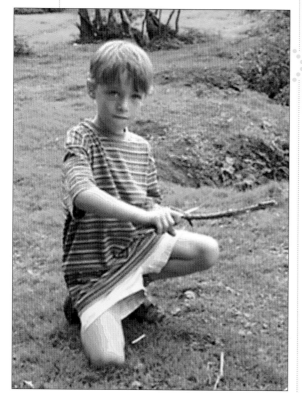

Hazy Routes

1 Along with the *Sharpen* and *Sharpen More* filters, which merely increase the intensity of pixel tones where light and dark edges meet, Most image-editing software features *Unsharp Mask* (or something similar). This feature can work wonders with fuzzy, hazy images. Here we've opened the image in PSP.

2 Summon the *Unsharp Mask* dialog box by pulling down the *Effects* menu and selecting it from the *Sharpen* submenu.

3 The preview windows show "before" and "after" effects. There are a number of settings on the dialog that you can adjust (play with!), gauging the effect of each in the preview windows (and on the original image if you click the *Auto Proof* arrow).

Further Clarification

1 Another excellent tool for enhancing sharpness also provided by Paint Shop Pro is the *Clarify* tool. Open your fuzzy picture in PSP.

2 Pull down the *Effects* menu and, from the *Enhance* menu, select *Clarify*. Picture sharpness is enhanced in a way that sometimes (depending upon the picture) even image-editing software experts would find hard to match using "traditional" tools such as the *Unsharp Mask*.

3 Of course there's a downside: *Clarify* works only across an entire image; you can't apply it selectively. Also it will only work with grayscale and images with a 24-bit color depth, although there is a way around this...

4 Simply increase the color depth of the image. Apply the *Clarify* tool and reset the color depth, if required. This quick fix would be appropriate for images with low color depth, intended for the Web.

4 *Unsharp Mask* is a filter that increases further the intensity of contrast between mid- and high-contrast pixels. The *Radius* field specifies the number of pixels affected at an edge. *Strength* and *Clipping* denote the measure of intensity applied and the break-off point for pixels that are not affected by applying the filter.

5 Play with the controls until you become familiar with the effect each has on your image. Generally, a *Radius* of around 2.00, together with a *Strength* of 100 and *Clipping* set at 5 (i.e., the default settings) will give good overall results. Click the *Reset* button at the right of the *Help* button to return to the filter's defaults. The finished result should be an image like this, (*above*).

CLEANING UP THE IMAGE

A vanishing act is easy when you manipulate your pictures with image-editing software. Remove noise, artifacts, and even undesirable features with the swish of a mouse and the click of a button...

Remarkably, digital images can be blighted (and sometimes enhanced!) by noise—not anything you can actually hear, but speckles in the picture caused by (among other things) low light levels. These appear as pixel-sized spots of color throughout the image. Removing noise (or even adding it for effect—more of which later) is straightforward, and many image-editing packages provide specific tools to do just that. It's a bit like deliberately generating a grainy photograph in conventional photography.

Stepped Edges

Artifacts occur in JPEG pictures which have been edited and saved many times. During every save the JPEG compression algorithm is applied, and eventually the picture begins to deteriorate and the edges of the subject matter appear become increasingly jagged—these are known as artifacts.

Speckled Image

1 With a yen to remove noise speckles, open the troubled image (here in Paint Shop Pro) pull down the *Effects* menu and select *Despeckle*.

2 PSP automatically removes detectable noise within the image. Some noisy images respond very well to this algorithm, others poorly. If the latter holds true in your case, try this...

3 Access the *Effects* menu again and select *Edge Preserving Smooth*. A dialog is displayed.

5 Sometimes, applying noise filters can have unexpected results (severe filtering can remove desirable information from a picture). Use *Control > Z* to undo the effect and try again using less smoothing until the balance is just right.

4 Use the buttons to increase or decrease the amount of smoothing according to the result in the preview window. Click *OK*.

BANISHING JAGGIES

1 Jaggies appear in digital pictures that have been overly compressed. JPEGs are especially vulnerable to this side-effect (known in JPEG parlance as "artifacts"). To reduce JPEG artefacts using Paint Shop Pro first open the image you want to correct.

2 Pull down the *Effects* menu and, from the *Enhance Photo* submenu select *JPEG Artefact Removal*.

3 Undo (*Control > Z*) will restore your image if the result is not to your liking, otherwise *Save As* to make a new copy.

Time for Change

1 The *Clone* (or *Rubber stamp* in Elements) tool is ideal for removing unwanted features from an image, in this case an unsightly television aerial on the thatched roof of this cottage.

3 Select the *Clone stamp* tool. Right-click (or shift click) an inch away from the aerial to specify a source for the *Clone* tool. Now move to your target, in this case the aerial, and press and hold the left mouse button. Crosshairs appear at the source point.

2 Open your picture and zoom in on the aerial. Don't get too close however; otherwise it becomes difficult to see how the cloning is blending in with the surrounding picture.

4 Move the *Clone* tool over the aerial so that it is covered by the material from the image picked up by the crosshairs. Continue until the aerial is "removed."

5 If it becomes obvious you've cloned from a specific area, try selecting a different source, clone, select again, and so on, to break up the result.

ADJUSTING COLOR

Our eyes are alive to the possibility of color, and a lustrous, color-saturated image captures a subject like nothing else can. Colors create mood, and colors imbue digital images with a reality that they might otherwise lack...

Unlike conventional photographs, the color in digital images can be manipulated in order to tease the most from a picture. You can correct color casts from artificial lighting and selectively increase color saturation to add emphasis to a picture.

That's All, Folks

It's important to realise though, that making corrections to color cannot add detail where none existed before. With a conventional negative, dodging and burning techniques (exposing more or less of sections of a print to the projected negative image) can uncover detail previously lost in shadow. A digital image has no secrets—what you see is what you get. The advantage is that each pixel can be changed to improve the image. The disadvantage is that unless you're skilled at drawing, you can't add features where none exist.

So improving color starts with the camera and the exposure—use the features of your camera such as white balance and exposure compensation, review each picture taken immediately, and reshoot where possible. That way, you'll have the best possible exposure which can be enhanced further in the digital darkroom.

Saturate to Accumulate

1 Contrast adds vitality to colors, but it's also possible to increase their intensity too much (just as you can turn up the color on a TV). Open your image (here in Photoshop Elements), pull down the *Enhance* menu and, from the *Color* submenu, select *Hue/Saturation* (or press *Control > U*). The *Hue/Saturation* dialog is displayed.

2 Ensure that *Master* is selected from the pop-up *Edit* menu at the top of the dialog. Grab the *Saturation* slider and move slowly to the right to increase the color intensity. Selecting *Master* means that the saturation of all the colors is increased.

3 You'll find that while some colors respond well to this adjustment, others such as skin tones don't. Access the *Edit* pop-up again and select *Reds*.

Add Life

1 Breath life into flat, washed-out images by making simple adjustments to the contrast. It's an easy tweak in almost all image-editing software, and the first point of call to brighter colors.

2 Open the picture with an image editor (here PSP). Pull down the *Colors* menu and select *Brightness and Contrast* from the *Adjust* submenu (or press Shift-B).

4 The preview windows on the dialog box give a flavor of what to expect, but it's back at the image proper where you'll see the effect of the changes. Use *Control > Z* to undo overly zealous adjustments and *Shift > B* again to summon the dialog for another go.

4 Use the *Saturation* slider to make skin tones more natural by moving to the left slightly. As you adjust, you'll see the picture itself change (if the dialog's *Preview* checkbox is selected). Click *OK*.

5 As always, use *Control > Z* to undo changes and return to the *Hue/Saturation* dialog to try again if you need to. Play with the colors until you begin to get a feel for balance—remember: the image remains unchanged until you save!

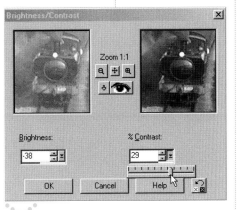

3 Make small adjustments to contrast by typing a new figure into the *Contrast* field or click on the pop-up slider and move left or right to suit.

ADJUSTING BRIGHTNESS

From simple overall brightness and contrast adjustments to the delicate tweaking of midtones, shadows, and highlights, image-editing software will enable you to save pictures that otherwise would be ruined by poor exposure...

How many pictures have you taken that were spoiled by being under- or over-exposed? Although it's possible to manipulate conventional negatives at the processing stage in order to lighten or darken them and improve contrast, and also to edit the resultant prints using dodging and burning techniques, the processes require that you do your own developing and printing and that means a darkroom, enlarger, and lots of other expensive and unwieldy equipment!

All Change

Digital images of course, are far easier to manipulate. Every pixel can be changed. They can be brightened, made darker, and changed in color to suit your requirements and improve the resulting picture. In fact, improving exposure begins at the camera, where EV compensation and exposure locking (controls that enable you to alter the camera's exposure settings relative to its metered measurements) are a significant aid in correctly exposing a picture.

Comprehensive control, however, begins when the picture is opened in an image-editing program such as Photoshop Elements. Everything from simple changes in overall brightness and contrast to complex histogram-based adjustments are available.

Filling Station

1 Because it's oriented toward digital photographs (rather than digital images that have been drawn or scanned), Photoshop Elements provides camera-like lighting tools and filters which echo those available in the real world.

2 Launch Photoshop Elements and open a poorly exposed image.

3 First step is to darken the background slightly in order to strengthen detail. Select the *Lasso* tool and carefully draw around the subject. Try to keep the marquee either on or inside the subject's edges. Press *Shift > Control > I* to select the background.

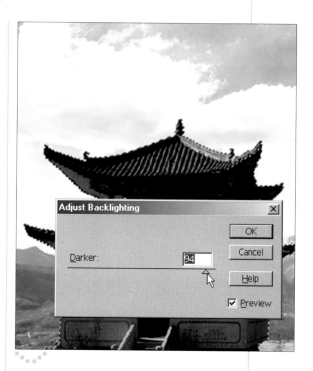

4 Pull down the *Enhance* menu and select *Adjust Backlighting*. Click on *Preview* to select it, and use the *Darker* slider bar to deepen the tonal range of the selected background. Make gradual adjustments. Click *OK*.

EV ADJUSTMENT

Before making an exposure, the metering system within a digital (or conventional) camera assesses available light and sets the aperture and shutter speed accordingly. This happens in a fraction of a second as you squeeze the shutter release button and, if there are subjects of strong contrast in the scene, the camera can easily be fooled into under-, or overexposing. To provide a degree of manual control, many digital cameras provide exposure compensation known as the EV control. By adjusting the EV control up or down, the camera can be made to increase (or decrease) the exposure by one stop (that is, from 1/125 to 1/160 say). Some cameras provide half-stop adjustments.

To use the EV control, take a picture in the usual way. Compensate for poor exposure by adjusting the EV control up or down and make another exposure. Review using your camera's LCD screen and adjust again as necessary.

5 Press *Shift > Control > I* again to select the foreground/ subject. Select *Fill Flash* from the *Enhance* menu. Use the *Lighter* slider bar to increase the brightness of the selected subject. Make sparing adjustments—a little goes a long way!—so that you don't bleach out detail. Click *OK.* Save the result.

6 With just a few simple adjustments, you should end up with a corrected image that looks something like this.

Gamma Correction

1 Adjusting the overall brightness and contrast of an image can work well... or result in the extremes of dark and light being bleached out. If this is the case, the result could be a washed-out and "thin" picture.

2 The solution is to adjust the midtones (aka the "gamma")— the portions of the picture that feature tones falling between the extremes. By singling out these tones, blacks remain black and whites, white, while the intensity of everything else is increased.

3 Launch Paint Shop Pro and open an image you want to edit. Pull down the *Colors* menu and, from the *Adjust* submenu, select *Gamma Correction* (or press *Shift > G*). The gamma correction dialog is displayed.

4 Make sure the *Link* box is checked so that all the hues are affected equally, click and hold one of the sliders, and move it gradually to the right. As you do so, the preview window shows how the image is lightened. An adjustment of no more than about 1.1–1.5 should be enough to improve the picture. Click *OK*.

KEEPING STANDARDS

Gamma is a standard measure of the shift in contrast in an image, though it's usually used to refer to as "midtones."

Table Tops

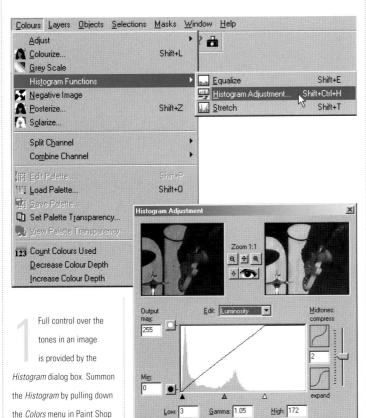

1 Full control over the tones in an image is provided by the *Histogram* dialog box. Summon the *Histogram* by pulling down the *Colors* menu in Paint Shop Pro (or from the *Image* menu in Photoshop Elements) and selecting *Histogram Adjustment* from the *Histogram Functions* submenu.

2 Daunting, yes, but easy when you know how! First step in brightening an underexposed image is to examine the graph (don't worry, it isn't mathematics!). If the majority of peaks fall to the left of the graph, the image is too dark and must be lightened. If the majority fall to the right, the image is too light. If all the peaks are in the middle and there are few or none to the left and right, the midtones of the image are out of step with the highlights and shadows.

3 Ensure the *Edit* pop-up menu (above the graph window) is showing *Luminosity*, then click and hold the highlights grab-handle (the rightmost triangle beneath the graph) and move it to a point just to the left of the point at which the values fall off. This whitens the white values in the image.

4 Is there a gap between the left edge of the graph window and the point at which the leftmost values begin to rise? This means the deepest shadows are not truly black. Click and hold the shadows grab-handle (the leftmost triangle) and move it just to the right of the point where they rise.

5 Click and hold the *Gamma* grab-handle (the triangle in the middle) and nudge it fractionally to the right. Repeat as required but bear in mind that only very slight changes will be required.

6 If the majority of peaks in the original graph fell at the edges, the midtones can be compressed slightly using the *Midtones* slider at the right of the *Histogram* dialog. Expand the midtones if the majority of peaks fall in the center of the graph. Adjust gradually and preview the image frequently using the *Proof* button. You'll quickly get the hang of it and get good results.

COLOR CASTS

Color photography was once an expensive luxury. Today's digital cameras provide color images that positively sing with vibrant, saturated colors—but they're not always entirely accurate.

Almost invariably, the camera balances color more than adequately and your snapshots are rendered in bright, beautiful colors that bring the pictures to life. But occasionally, and especially in adverse lighting conditions, the camera gets it wrong. If you were committing a picture to film, there'd be little that you could do to rescue it, but digital images lend themselves to extremes of manipulation, and image-editing software provides just the tools necessary for correcting inaccurate color.

1 Color casts occur principally when you shoot with flash under artificial lighting conditions. The light from tungsten bulbs blends with the flash and tints the picture with an overall yellowish or greenish hue. Similarly, fluorescent lights give a blue tinge to a picture. All good image-editing packages provide automatic color balance controls to correct color casts.

2 Launch your favorite program (here we've used Paint Shop Pro) and open the image you want to correct. Color cast correction works only with 24-bit color images (images that contain 16.7 million colors). If yours is less than this, increase it by selecting *Increase Color Depth* from the *Color* menu.

Casting Color

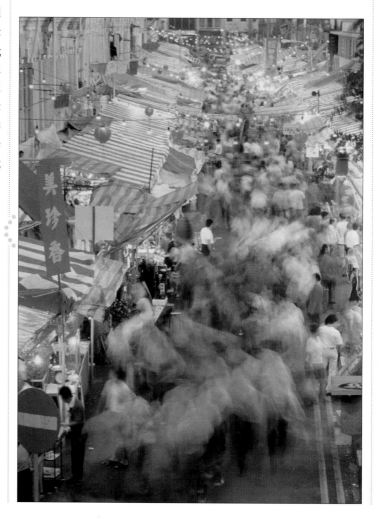

3 Select the *Automatic Color Balance* dialog box by clicking its icon in the *Photo* toolbar (switch this on if it isn't already by selecting *Toolbars* from the *View* menu and then checking the *Photo Toolbar* option). The filter is also available from the *Enhance Photo* submenu under the *Enhance* menu.

4 When the *Automatic Color Balance* dialog is displayed the program immediately changes the image according to the default settings and updates the preview window on the right (move the image around in this window by clicking and dragging).

5 Ensure the *Remove Color Cast* check box is selected (and click it if it isn't). The *Illuminant Temperature* is a measure of the conditions the picture was taken in—outdoors in moderate sunlight, indoors under fluorescent lights, and so on. The default is 65000K, sunlight. Use the slider to select the conditions the picture was snapped. Now click *OK*.

6 The image is automatically color balanced and the cast removed. This filter works exceptionally well at the default settings but badly color cast pictures might need some experimentation. Increase the *Strength* using the slider provided until you arrive at tones that look right.

ALTERING IMAGE SIZE

Conventional photographs are almost always enlargements of the original negatives. Using image-editing software digital photographs can be enlarged (or reduced) too, but just as in conventional photography, there's a small price to pay.

As you now know, digital images contain a finite number of pixels. Enlarge the image significantly and somehow the pixel count must be increased too; otherwise there'd be gaps where the original pixels were pulled apart.

Image-editing packages use a technique known as "interpolation" to increase the pixel count. Sophisticated equations determine the properties of a new pixel based on those around it. Interpolation can be surprisingly accurate over small size increases, but larger increases soon lead to inconsistencies.

Small is Beautiful

But resizing images isn't always about making them bigger—often you'll want to reduce a picture. Images captured with multimegapixel cameras produce huge pictures—far larger than can be comfortably downloaded from the Web for example. A multimegapixel image viewed on screen will be too big to see complete because digital pictures are reproduced pixel for pixel on a screen. For the most part, the Web is geared to work at screen resolutions of 800x600ppi (pixels per inch) and a big image will require sideways scrolling on the part of the recipient! But reducing the pixel count to a value of something less than 600ppi wide will enable the picture to be displayed comfortably.

Digital Enlarging

1 To see the current image size (and other information), click and hold the *Image Information* box in the lower left corner of the Photoshop Elements window or press *Shift > I* in PSP.

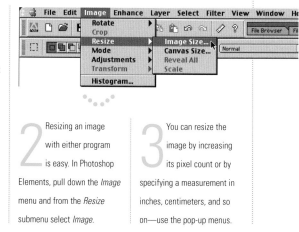

2 Resizing an image with either program is easy. In Photoshop Elements, pull down the *Image* menu and from the *Resize* submenu select *Image*.

3 You can resize the image by increasing its pixel count or by specifying a measurement in inches, centimeters, and so on—use the pop-up menus.

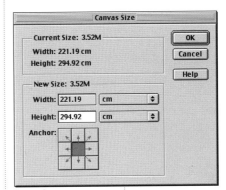

5 Check the *Resample Image* box, and choose a resampling. *Nearest Neighbor* is a fast algorithm but less accurate than *Bicubic*. However, it produces good results with subject matter that has hard edges. *Bicubic* is better for organic subjects. *Bilinear* falls somewhere between the two. Click *OK*.

6 It's a good idea to Save As (*File* > **Save As**, or *Shift* > *Control* > *S*) so that you have the original to return to if you decide against the resized image.

4 Checking the *Constrain Proportions* box ensures that the photograph retains its correct aspect ratio (height to width), and that the image editor recalculates height or width based on your new figure for one or the other. The next thing to do is to resample the image by one of the options in the drop-down menu...

Canvas Size

1 As well as resizing the image, you can resize the canvas. It's the easiest way of joining two or more images into one big one.

2 Increase the canvas size of one image and copy and paste the other, cropping waste canvas when the images are aligned.

Reducing

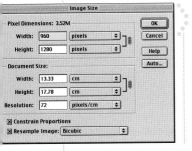

1 Open your image with your chosen image-editing software.

2 From the *Resize* sub-menu under the *Image* menu, select *Image Size*.

3 Ensure the *Constrain Proportions* check box is crossed in the *Image Size* dialog, and type 600 into the *Width* field in the *Pixel Dimensions* section of the dialog.

4 Click *OK* and save the resized picture using *Save As* from the *File* menu. Not only will the physical dimensions of the image have been reduced, so will the file size.

Distorting

1 And this is what happens if you don't use the auto constrain function... scary!

2 The resized picture is distorted. *Control* > *Z* returns the image to its former size, and then start again with the *Image Size* dialog. However, in some cases, distortion can add a desirable impact to a picture.

SELECTIVE RETOUCHING

There are two areas in which photographs—conventional or digital—can go wrong: focus and exposure. We've looked at focus earlier in this chapter so now let's turn our attention to the knotty problem of correcting poor exposures...

Correctly exposing a picture can be fraught with difficulties. Difficult lighting conditions, moving subjects, and automatic metering systems can all have an adverse affect on your pictures. Almost all modern cameras have built-in metering systems which work well, but scenes with strongly contrasting elements, overcast or very sunny days, night exposures, and artificial lighting can fool them into poorly exposing a picture. If you make regular use of your camera's LCD preview screen, this shouldn't be a problem—review the picture, and make another exposure using EV compensation and white balance controls to assist the metering.

Filling the Gray Areas

But let's assume you've made several exposures none of which can be repeated, some of which have turned out to be poorly exposed: what can be done? A lot, in fact. Image-editing software can readily rescue pictures which might otherwise be discarded using built-in automatic tools, and those which can be customized to a particular image. Later on in this chapter we'll look at correcting color pictures, but first let's turn our attention to the grayscale image...

Dodge and Burn

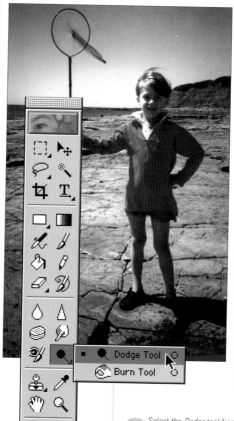

1 Photoshop Elements' *Dodge* and *Burn* tools make for excellent selective adjustments to small areas of an image. Both tools work equally well with grayscale and color pictures, but they're especially useful when applied to black and white photographs, which can be tricky to enhance and balance when you're working with the overall image.

2 Select the *Dodge* tool from Photoshop Elements' *Tool* palette. If the *Burn* tool is showing, right-click it and choose the *Dodge* tool from the pop-up pick-list.

3 From the *Options* bar, choose a suitable brush from the pop-up palette—65 works well for small areas, and 300 is excellent for balancing tone over larger areas. Select *Midtones* from the pop-up *Range* palette, and use the slider to enter a value of around 50% into the *Exposure* field.

4 Position the *Dodge* tool over the area you want to lighten, click and hold, then move the tool a little this way and that, until you begin to see the area brighten. Do this a little at a time (i.e., release the mouse button then click and hold again during the process) so that you can use *Control > Z* to go back a step if the dodging appears overly zealous.

STUCK IN THE MIDDLE?

Paint Shop Pro also offers shadows, midtones, and highlights tools to target and correct light and dark areas within an image. Open your picture, and from the *Colors* menu select *High/Midtones/Shadow* from the *Adjust* submenu. To address high, mids, and lows individually, ensure the *Dynamic Adjustment Method* button is selected. *Linear Adjustment* shifts all tones up and down the tonal histogram (see pp. 92–93 for more information about histogram measurements).

5 Experiment with the *Shadows* and *Highlights* settings too from the pop-up *Range* palette until the image is just right. Save As using the *File* menu or by pressing *Shift > Control > S*.

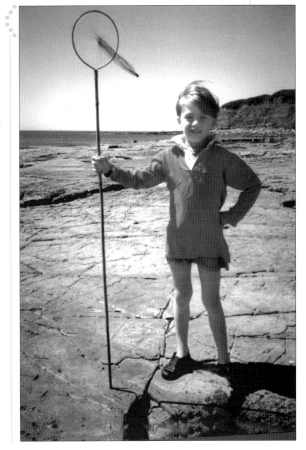

CROPPING

Great pictures rely on strong compositions and creative cropping to emphasize the interesting elements within them. Cropping digital images is easy and fun, and forms the basis of all kinds of interesting special and novelty effects.

A major factor that sets professional pictures apart from those taken by novices is skillful cropping—trimming the unnecessary parts from a picture to draw attention to the area of interest. Indeed there are few if any professional pictures—whether in galleries, newspapers, or magazines—which haven't been cropped. Even an already good picture can be made extra-special by a radical or adventurous crop.

Previously of course, cropping was done at the darkroom stage. As the negative was projected onto photographic paper, the photographer zoomed in on the strongest element letting the rest spill over onto the enlarger's baseboard and be cropped out of the picture.

The Digital Way

Many digital cameras offer cropping facilities built in, and those which don't, of course, can transfer pictures to a computer for editing. But the good photographer should consider the composition first, and you'll learn over time to seek out the main areas of interest and compose the image in the frame.

Elemental Cropping

1 Some pictures demand to be cropped. Here, the interesting part of the picture is all too obvious—you just have to remove the useless material around it!

2 If you're using PSP, open the picture and select the *Crop* tool by clicking on it. The tool is identical in Elements.

3 Move to the picture, click, and drag a rectangle around the part of the picture that you want to keep. When the rectangle encloses the desired part of the picture, release the mouse button.

Cropping in Photoshop Elements

4 If you release the mouse button and find that the rectangle doesn't quite enclose the area you want, click and hold within the rectangle and relocate it. Alternatively, enlarge or reduce it by moving the mouse pointer over a side or corner. Click and drag to enlarge or reduce the image.

5 Double-click within the area of the rectangle. The material outside is discarded and the picture cropped. Press *Control > Z* to undo the crop and have another go.

1 Photoshop Elements offers a similar cropping solution in the form of the its own *Crop* tool...

2 Drag a rectangle (Adobe calls this "bounding box") around the picture selection you want to crop, and Photoshop Elements displays the material which will be removed as an opaque "shield." This is useful in helping you to visualize how the cropped image will appear.

3 What's more, by clicking in the shielded area you can rotate the crop selection bounding box. A right click provides a pop-up "crop or cancel" menu, or you can double-click within the bounding box to crop, much like you can in PSP.

4 You can switch off the crop shield by clicking the appropriate check box in the *Options* bar. If you'd prefer to view the shield as a color, click the *Color* box in the *Options* bar. Select a hue from the *Color Picker* dialog. To change the degree of opacity, use the *Opacity* slider or enter a value in the *Opacity* field on the *Options* bar.

Just for Effect...

1 Save your pictures from inducing sea-sickness in those who see them! Hand in hand with cropping, straightening an image which isn't quite on the level is easy using an image editor such as Photoshop Elements (shown here) or Paint Shop Pro.

2 Pull down the *Image* menu and, from the *Rotate* submenu, select either *Straighten and Crop Image* or *Straighten Image*. If the former would result in the image rotating outside of the window area (and thereby creating an irregular crop), enlarge the canvas (the imaginary area upon which the picture data sits).

3 Open the *Canvas Size* dialog (*Image > Resize > Canvas Size*) and type new values into the *Width* and *Height* fields. Use the *Anchor* locator boxes to determine where the new canvas area will fall.

Super Vignettes

1 By combining cropped images (or crops of the same image in a new canvas) you can create interesting new effects such as this vignette-style image (*opposite*) with ease.

2 Open the picture, choose the *Elliptical Selection* tool (right-click the *Selection* tool and choose *Tool Options* from the resulting pick-list). Draw an ellipse around the picture and press *Control > C* to copy it to the clipboard.

3 Press *Control > N* and create a new canvas with an area large enough for experimenting (and based upon say, three times the area of the original image). Press *Control > E* to paste the clipboard onto the canvas as a new selection.

4 Back at the original, choose the *Freehand* tool to draw a new shape for cropping as shown here. Once again, press *Control > C* to copy the crop to the clipboard.

5 Click on the new canvas to select it and press *Control > E* again to paste in the new clipboard image as a selection. Move the image around to marry up the two to create the desired "keyhole" effect...

6 Select the *Crop* tool to draw around the "keyhole," while leaving in enough of the black background to give the illusion of peeking through a keyhole!

If you're cropping to a particular size, for printing perhaps, or commercial processing, use a cropping mask—essentially, a blank picture of the required size into which you paste the picture, moving here and there until the material you don't want lies outside the mask. A step-by-step guide to making and using a digital mask appears on pp. 114–115.

Masterclass Tips

Image-editing software is to a darkroom what a 747 is to a Cessna: both will get you where you want to go, but there's a world of difference in range, speed, and comfort! Combine your digital camera with even entry-level editing software, and you'll have at your fingertips the kind of creative potential that photographers could only dream of previously. In the last chapter we covered a number of editing possibilities that demonstrated the type of tools and filters available to you, and we indulged in some fancy image manipulation. In this chapter—not for nothing entitled "Masterclass Tips"—we'll continue that theme, exploring the more complex options and learning how to make what's in your mind's eye appear on your printer.

COMBINING IMAGES

Adjustments to your pictures—increasing contrast, tweaking color saturation, and so on—are analogous to similar improvements within conventional photography but the ability to manipulate pixel-based pictures beyond the conventional makes for a world of possibilities.

All image-editing packages offer a range of what can only be described as "special effects"—features for distorting, texturing, combining, and coloring images—and it's these that make digital photography such fun. Improving contrast or enhancing color will make a good photograph of an otherwise ordinary one. Special-effects features—such as combining several pictures into one, mirroring, distorting, adding grain, feathering for highlighting and shadows, or the really wild special effects such as transforming your pin-sharp digital image into something resembling a watercolor or an impressionist painting—can really stretch your imagination to the the limit!

Don't Overdo It

It's fair to say that many of the more outrageous special effects can become tiring, and it's often difficult to see where you might use some of them (but kids love playing with special effects!). However, it's when manipulating pictures that might otherwise be discarded that digital photography and image-editing software come into their own. And even as a beginner, you'll find that creating amazing effects is easy with a bit of practice...

Make Do and Mend

1 Here's an example of the kind of manipulation that makes image-editing software such a powerful tool—even for beginners. This picture of rolling fields of hay is spoiled by a nondescript gray sky. A fix is just a click, cut, and paste away...

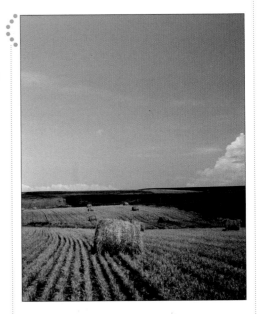

2 Launch your image editor and open the picture you want to correct. Select another picture that features an attractive sky. Using the *Marquee* tool, draw around a selection of sky and press *Control > C* to copy it to the clipboard.

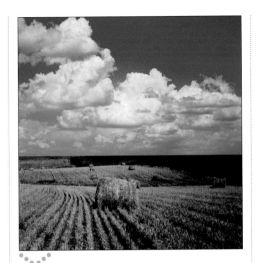

3 Open the original image and paste the recently copied sky onto it. Here we've used Photoshop Elements and have called this Layer 1.

4 Now make just the original image layer visible and active. Using *Magic wand* tool, with appropriate tolerance (95 is used here) select just the sky area.

5 Next make the new sky layer visible and active. Invert the selected area and delete. The new sky now follows the horizon line of the fields and your new composite image is complete.

6 The finished picture. There's much more that can be done, but with even just a simple cut and paste from another picture we've improved this one enormously. As you work through the more advanced examples, you'll begin to see the possibilities for manipulating your own pictures and developing your skills along the way.

DISTORTING IMAGES

Distortion techniques have long been used by professional photographers to heighten the impact of a picture. The ability to distort digital images easily opens an incredible palette of creative effects that will enable you to-go far beyond the simple family snapshot...

Anyone familiar with the music of the Beatles will be aware of the photograph of the band used on the cover of the "Rubber Soul" album. The photographer produced a distorted, rubbery image by projecting a transparency of the image at an angle and reshooting it. The effect was and is startling: eye-catching certainly, but with an underlying tension that is at once unsettling and compelling.

If you've experimented with wide-angle lenses or a wide-angle setting on your digital camera's zoom lens, you'll have noticed that features become exaggerated or diminished depending on where the camera is in relation to the subject, and shooting tall buildings causes them to "lean" in relation to each other (the effect is known as "converging verticals").

Don't Look Now

Whether caused by the lens or manipulation of the picture once it's transferred to the computer, distortion can have a dramatic effect—even slight distortion is in some way unsettling because it makes us look at the world in a way that is different from reality. However, as with all visual effects, remember this works better on some photographs than on others.

In a Spin

1 Photoshop Elements is particularly well endowed with distortion filters (more are available as third-party plug-ins), and some of them are truly spectacular!

2 Try this: open a picture in Photoshop Elements—one that features a tall subject will work especially well.

3 Pull down the *Filters* menu and select *Polar Coordinates* from the Distort submenu. When the *Polar Coordinates* dialog is displayed click the *Rectangular to Polar* button then click OK.

4 Now soften the edges of the join. Select the *Blur* tool from the tool palette. Pop up the *Brush* menu on the Options bar, and select Brush 46 (or a similarly loosely defined brush). Set the *Brush Pressure* value at 60%. Click and rub the *Blur* tool over the sharply defined edges of the image.

5 All that remains is to crop the background that no longer contains picture data, and then save the results.

Hall of Mirrors

1 Create your own version of the "Rubber Soul" record cover. Open an image (a group portrait works well) in Photoshop Elements. Summon the Shear dialog (*Filters > Distort > Shear*). Click and move the line in the distort grid at the top left of the dialog. The image is distorted along the curves you specify.

2 Using the Pinch distortion filter (*Filters> Distort > Pinch*) you can distort an image so that its centre is "pushed" or "pulled" toward the viewer.

3 Get the fish-eye lens effect with the Spherize filter (Elements: *Filters > Distort > Shear*). Use the slider to determine whether distortion will be concave or convex, vertical, horizontal, or spherical. Crop the image to further emphasize the effect.

DISTORTION DOCTOR

Distortion is an eye-catching effect, but there may be an occasion when you'd prefer to go the other way: to straighten an image that has unintentional distortion generated by the camera's lens. Andromeda Software offers a Photoshop plug-in to do just that. LensDoc is an easy-to-use utility for image-editing software that can make use of Photoshop plug-ins. A demo is available for download at *www.andromeda.com*.

ADDING TEXTURE

Not content with the visual impact of your pictures? Spice them up by-adding a sprinkling of texture. Known as "noise," it is the equivalent of creating a grainy conventional picture. Very atmospheric, particularly with black and white images.

Previously we examined the issue of digital noise—speckles of color that invade, and can blight, an otherwise attractive picture by appearing randomly throughout. These speckles can be removed quite easily using the ready-made tools provided by most image- editing packages. We tried one or two of them, such as the *Edge Preserving Smooth* and *Despeckle* tools in Paint Shop Pro earlier in this chapter, and there are others which we'll look at elsewhere on these pages. Those packages that don't sport noise-reduction filters can be used manually to remove noise (but the task can be onerous).

Not All Noise Annoys

Paradoxically, you might actually want to add noise! Contrary to normal intuition, inserting speckles where none existed previously isn't necessarily a quick route to a spoiled picture. A noisy image can simply be a grainy one which, given the right subject matter and tonal value—a gritty black and white street scene perhaps—is enhanced by the "realism" that noise brings. First though, let's look at one or two further options for removing noise...

Gritbusters #1

1 Although more usually associated with color images, noise can affect black and white pictures too. Paint Shop Pro provides several tools that work with both color and black and white pictures, but especially well with the latter. Launch PSP and open your image.

2 Pull down the *Effects* menu and, from the *Noise* submenu, select the *Median* filter. Although it is intended for use on small selections that are markedly different from the overall picture, the *Median* filter also works well when applied to an entire image if you use it sparingly.

3 The default for the filter aperture is about 30 pixels depending on the image (the number of pixels that are averaged and then deintensified). Over an entire image, this will produce an attractive effect —but conversely a great deal of detail is lost.

4 Instead, type in a value of about 5 pixels and click OK. Much of the grain is removed and a little of the fine detail. Now apply the *Unsharp Mask* and the noise has all but gone.

Gritbusters #2

1 PSP's *Salt and Pepper* filter (*Effects menu> Noise> Salt and Pepper*) works especially well with grayscale images. By determining when a light or dark speckle in a picture differs substantially from its neighbors, the speckle can be removed.

2 Fine detail is easily lost using *Salt and Pepper* so select smaller areas of the picture—those without fine detail—and apply the filter. Experiment with speckle size and sensitivity until you balance the loss of detail with the removal of speckles.

3 Afterward, use the *Sharpen More* and *Clarify* filters to add contrast and sharpness to the overall image. But don't overuse the *Sharpen More* filter.

4 Unlike the *Salt and Pepper* and *Median* filters, *Texture Preserving Smooth* (*Effects menu> Noise*) attempts to retain detail while ridding an image of speckles. It does this by gauging and comparing "textured" areas and working selectively.

5 Once again, experiment by entering different values into the *Amount of correction* field and gauging the trade-off between retaining detail and losing noise.

True Grit

1 Adding noise to an image—particularly a black and white picture—can give it a "period" feel. A street scene perhaps, or a railroadstation will respond well to a grayscale and grain treatment.

2 Of course, there's no need to start out with a black and white picture. If the image you want to manipulate is in color, begin by discarding the color data. Here, PSP's *Grayscale* filter can be applied (*Color menu> Grayscale*).

3 From the *Effects* menu, select *Add* from the *Noise* submenu. You can experiment with the percentage of noise to add—about 10% is a good starting point. Click the *Uniform* button to select it.

4 What was at first a pretty, but dull picture of a main street is transformed into a period piece that harks back to a bygone era.

MOTION EFFECTS

You don't always want your pictures to appear razor sharp. Add a bit of dynamism by using creative blurring techniques (and especially adapted filters) to give the illusion of motion to your pictures.

Earlier, we looked at correcting out-of-focus, fuzzy images—the result of camera movement, low light, or a moving subject—by applying various software filters, but there are times, strangely, when you might actually want to blur an image rather than sharpen it. Creative use of blurring can be used to give an impression of speed and a degree of "movement" to your pictures—a shot of a moving car or motorcycle, for example. Photographers using conventional equipment pan the camera—that is, move it in time with the moving subject—while using a slowish shutter speed.

Panning

Panning has the effect of keeping the subject in focus while blurring the background, thereby recreating the sense of speedy movement. Digital photographers can pan by moving their cameras too, but it isn't an easy technique to master. However, there's another way to get more or less the same effect which is fun and requires little effort!

Panning Motion

1 Conventional panning is-easy to try, but difficult to master, so let's cheat to get the same effect using image-editing software. First open your preferred software—here we've used Photoshop Elements—then load a suitable picture, in this case, a-BMX cyclist.

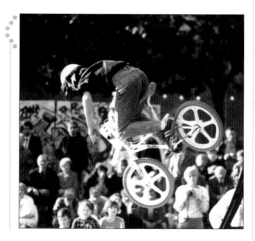

2 Carefully draw around the cyclist with the *Freehand* tool, then copy it to the clipboard by pulling down the *Edit* menu and selecting *Copy* (or simply pressing *Control > C*).

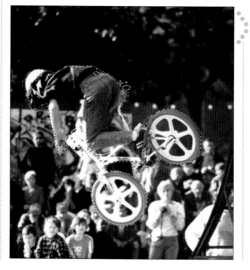

3 Right-click on the image to deselect the selection. Pull down the *Effects* menu and, from the *Blur* submenu, select *Motion Blur*. The *Motion Blur* dialog is-displayed.

4 Click and hold the *Direction* pointer and rotate it to the opposite direction to that of the bicycle (so that if it is traveling to the left, rotate the pointer to the right). Now move the *Intensity* slider so that a figure of about 10 pixels is shown. Don't apply too much blur—it's easy to lose all definition! Click OK.

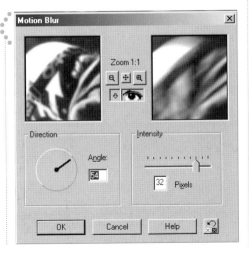

5 Back at the now blurred picture, press *Control > E* to paste the copied image of the cyclist back into the picture as a selection. Take care to position it exactly over the existing, but blurred cyclist—instant panning!

6 It may be necessary to soften—"feather"—the edges of the cyclist slightly to get him to sit comfortably within the picture again. Using the *Freehand* tool, draw a lasso a few pixels in from the edge of the cyclist, and select *Feathering* from the *Selections* dialog (or press *Control > H*). A figure of about 20 pixels should be enough to aid blending.

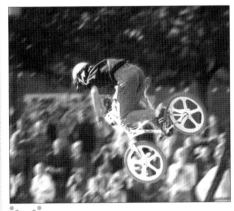

7 The finished picture replicates remarkably accurately the effect achieved when panning in a more conventional way. The cyclist is frozen in action, while the spectators in the background are blurred, giving the impression of camera movement.

VIGNETTES

Have fun transforming your nearest and dearest into living antiques using sepia tones, and some creative cropping and feathering techniques. These make up an instant aging process that is fun to try and attractive to display to others.

Many cameras provide a range of effects that can be applied before the images even leave the camera for the relative safety of your computer. A perennial favorite is sepia toning, which makes an instant antique of virtually any photograph. The technique is best applied to portraits and is especially good when combined with other effects such as "feathering"—cropping and softening the edges of a picture—from within an image editor.

If your camera provides sepia toning "at source" then by all means apply it and save yourself the trouble when the picture is imported into the image software (though it might be that toning from the software provides a better result—experiment!).

If the camera doesn't offer the effect, follow the steps outlined here to create living antiques of your friends and relatives—they'll be delighted!

Ten Steps to Tone

1 Select a suitable image. While almost any picture can be artfully cropped and sepia-toned, a portrait works best—head and shoulders or full length with one or more subjects.

2 Launch your favorite image-editing software (here Photoshop Elements) and open the picture.

6 Press *Shift > Control > I* to select the background (that is, to switch from the selected portion to the previously unselected portion of the picture—all will become clear in a moment). Pull down the *Select* menu and choose *Feather* (or press *Alt > Control > D*).

3 Begin by discarding existing color information. Pull down the *Enhance* menu and, from the *Color* submenu, select *Remove Color* (or press *Shift > Control > U*). The picture is rendered in black and white.

4 Artful cropping enhances the ultimate "aged" effect. Select the *Elliptical Marquee* tool by clicking on it. The tool defaults to the *Rectangular Marquee* tool. If yours is rectangular, click on it and hold until the pop-up selector appears, and then choose the *Elliptical* tool.

5 Draw an ellipse over the image by clicking, holding, and dragging. If it isn't positioned quite right once you've drawn the ellipse, click on it and move it until it's just right.

7 Back at the picture, press delete. As if by magic, the background material is removed leaving the subject matter with a feathered edge.

8 Apply the sepia tone by selecting the appropriate filter from the drop-down *Filter* tab.

9 The finished result, looking for all the world like it came direct from Kodak No.1, circa 1900!

ADDING EFFECTS

Many image-editing programs provide a number of interesting and fun texture effects to apply to your pictures. Some of the texture filters are extremely effective while others are... well, clichéd at best. But all are fun to play with and, used sparingly, can enhance an otherwise dull picture.

Texture effects really come into their own when used to create greetings cards, T-shirts, and the like—a novelty finish is just the thing to grab the attention! How best to use the texture and similar special effects? Experiment! Control-Z will undo any effect, or you can simply abandon the picture without saving or "Save As" to make a copy. Only by playing with the effects provided by your image-editing software will you envisage what can be done and where best each can be applied. Only a few pictures lend themselves to this kind of treatment, but the results when they do can be startling!

(*Below*) The same image again, but this time after having PSP's *Colored Chalk* effect applied (*Detail* 50, *Opacity* 96). A similar effect, but with even more texture.

Paint Shop Pro's Black Pencil effect (*Effects menu> Artistic Effects> **Black Pencil**) adds a kind of stippling effect to this grayscale vignette of a steam engine and carriages. The picture is transformed into a lineside, sketchpad drawing.

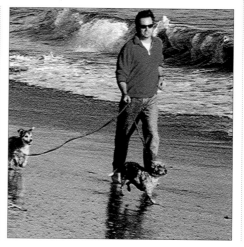

(*Left*) Instant artist! PSP's *Brush Strokes* effect transforms a digital picture into a work of—traditional—art. Experiment with the length and density of the strokes, the width, opacity, and number of bristles in the "paint brush."

(*Left*) Photoshop Elements' *Liquify* filter can be used to create all kinds of interesting effects. Set the *Brush* size to a low value say, 10, and you can tinker gently with straight edges in a picture to soften them. A large brush of say, 130, combined with a pressure of about 15 or 20, will completely transform an image!

(*Above*) Much the same texture using Photoshop Elements' *Brush Strokes* effects. Elements offers a wide selection of painted effects including the watercolor shown here.

(*Left*) Ocean Ripple (*Filter>Distort> Ocean Ripple*) makes an image appear as if it's being viewed through a piece of frosted glass. Color pictures respond exceptionally well to this effect. The distinction between colors is blurred, but their intensity is enhanced. Elements also provides a distortion filter called *Glass* (*Filter> Distort> Glass*) which has a similar, but more intense result.

(*Above*) Extrude is a very popular effect that can be seen in advertisements, magazines, flyers, and the like. Photoshop Elements makes recreating the effect easy. Open your picture, pull down the *Filter* menu, and select *Extrude* from the *Stylize* submenu.

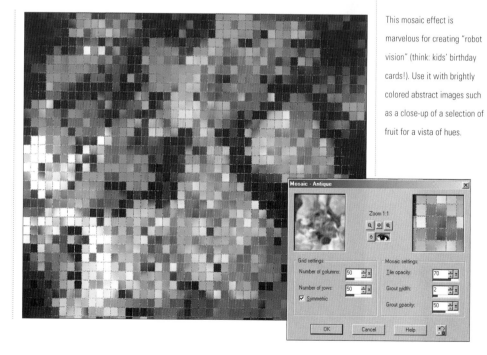

This mosaic effect is marvelous for creating "robot vision" (think: kids' birthday cards!). Use it with brightly colored abstract images such as a close-up of a selection of fruit for a vista of hues.

And here's yet another way to recreate the illusion of motion within a static image. The *Wind* filter (*Filter> Stylize> **Wind***) slides pixels left or right to give the effect of a strong gust of wind! You choose between *Wind*, *Blast*, or *Stagger*!

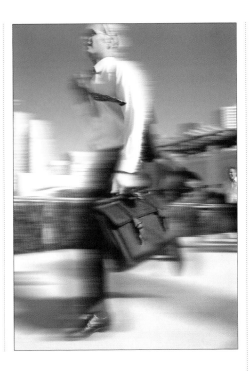

IN EFFECT...

Photoshop Elements' Texturizer function offers a range of effects, but you can expand on these by acquiring third-party "plug-in" effects packages.

1 Use your favorite Web search engine to locate plug-in Photoshop Texture effects. Try searching on "PhotoShop" and "texture" (in this way: +photoshop+texture or "photoshop texture").

2 Select from those on offer and download them to your computer.

3 From the *Texturizer* dialog, access the pop-up *Texture* menu and select the *Load Texture* option. Navigate to the downloaded textures using the file browser.

4 Apply the new textures by choosing them from the pop-up *Texture* menu in the usual way.

Or for the ultimate in textured canvas effects, summon Elements' *Texturizer* dialog (*Filter> Texture> **Texturizer***) and select from brick, burlap, sandstone, and so on. Use the *Scaling* and *Relief* sliders to determine the size and depth of texture.

CREATING PANORAMAS

See the world in 360 degrees using photomontage techniques—this impressive effect combines lots of individual pictures into a single uninterrupted image that spans an entire horizon.

In the 1950s and 60s a number of imported cameras became available which would take a panoramic photograph spanning more or less everything from left to everything right in front of the photographer. These were used quite seriously to capture images of large groups of subjects such as parades of soldiers, engines, and carriages—even wedding pictures! The panoramic camera featured a swivelling slitted lens housing which turned through 180 degrees. The slit admitted light a slice at a time to reach and expose the film within.

By Hand

Many photographers copied the technique using ordinary cameras. By standing in one spot, taking a picture, turning to the left or right slightly, taking another picture and so on, the resulting prints can be cut up and stitched together to make one long photograph.

As a digital photographer you have the means to produce truly incredible panoramas and photomontages. Some cameras actually enable you to create a composite image at source using software within the camera itself. But even if yours doesn't stitch together images using editing software is easy. Some image editors (notably Photoshop Elements) provide specialist tools for panoramic shots.

Stitch Up

1 Let's assume your camera doesn't provide for panoramic shots, and your image-editing software is of the plain-vanilla type. The first step is to take the pictures that will become the panorama. This is best done with the aid of a tripod or other steady rest to ensure that all the images are taken at the same height (though even then corrections can be made digitally). Allow plenty of-overlap between each image and try to keep the same distance from the subject to preserve the perspective over what will become the composite panorama. Launch your software and browse the images.

2 Select what will be the first in the sequence and open it (here with PSP). Ensure the picture is selected and press Shift-I to summon the image information dialog. Make a note of the picture's dimensions. Repeat for each image that will be featured in the montage.

3 Press *Control > N* and create a new picture box based on the collective dimensions of the pictures for the montage. Give yourself plenty of elbow room—you can crop neatly when the images are in place.

4 Select the first in the sequence. If you want to use the entire picture, press *Control > C* to copy it to the clipboard, otherwise make a selection using the *Selection* tool and copy the selection to the clipboard.

6 Often what gives the stitch-up game away is the different tonal qualities of one "frame" to the next, caused by the time delay (and therefore potentially the light quality) between each shot. Adjust and match the brightness of the individual images by opening and adjusting their histograms.

5 Select the empty picture box and press *Control > E* to paste in the contents of the clipboard as a new selection. Repeat for each image, carefully aligning as you go.

7 Although the new image is complete, the joins are hardly seamless! Select the *Clone* tool, right-click a "clone source" near enough to the first join, but not so close that the cloning effect becomes obvious. Crop to suit and save.

Painless Panoramas

1 If your image-editing software provides the necessary tools to stitch together separate images, the task will be easier still! Here is Photoshop Elements...

2 As before, ensure your sequence is taken on a tripod in light that is not subject to wild changes (i.e. nice, blue sky and no clouds to create unwanted shadows). Maintain perspective where possible by staying at a uniform distance from the chosen subject.

3 Open the *Photomerge* dialog from the *File* menu and click the *Add* button. A file browser will be displayed. Navigate to the folder that contains your images. Shift-click over the range of pictures and click *Open*.

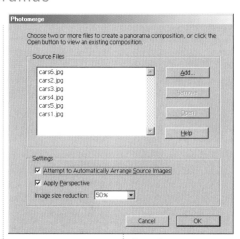

4 Elements' *Photomerge* will make an excellent attempt at automatically merging the images into one panoramic picture, or you can choose to position them manually before the program smoothes away the obvious edges. Click the *Attempt to Automatically Arrange Source Images* check box. Check the *Apply Perspective* box and type a figure of, say, 50%, into the *Image Size Reduction* field (otherwise the resulting composite will become unwieldy). Click OK.

5 Elements now takes over, opening, positioning and adapting the sequence of pictures to make a single image. Sit back and watch the-fireworks!

6 When the composite is created, the *Photomerge* screen is displayed. The *Preview* window shows the image as it will look before cropping. Use the *Navigator* window to move around the preview image by clicking and moving the red rectangle within the *Navigator* window (the slider beneath this zooms in and out of the preview).

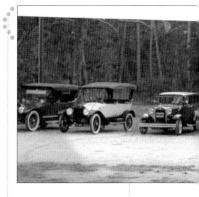

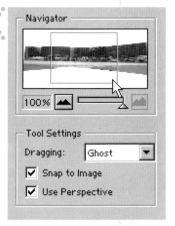

7 Click *Cylindrical Mapping* and *Advanced Blending* in *Composition Settings* to flatten and blend the image. To see a preview of these effects, click *Composition Settings Preview*. Click *Exit Preview* when you've viewed it. Now click OK.

8 Back in the Elements editing window proper, use the *Rectangular Marquee* tool to crop unwanted areas from the image (such as the overlaps above and below). Click the *Hand* tool, then click the *Fit in Window* button.

9 The finished image. All that remains is to save it from the *File* menu.

CREATING SOFT FOCUS

A blurred image isn't necessarily a bad one if the blurring is used selectively to create a "softer" atmosphere. The technique is used by photographers all the time and it's one that lends itself perfectly to being replicated in the digital darkroom!

The camera never lies is an old saying that rings only partly true. Certainly what the camera's lens sees is what the camera captures on film or digital storage card, but there are many tricks and techniques which can ensure that what the end-viewer sees is something markedly different to what was snapped. Of course, these techniques are not intended in any way to fool those who see the picture, they're used to enhance it.

Premeditated or Not

To achieve a soft-focus effect, conventional photographers use various filters fitted to their lenses which help to diffuse the light and create a softer, slightly misty atmosphere without throwing the subject out of focus. Of course to achieve this effect the conventional photographer must decide in advance whether to use a soft focus filter or not. Not so the digital photographer, with basic image-editing software the same effect can be achieved in a matter of moments, and applied to any image that is suitable.

Sharp and Sweet

1 Only after taking this picture did it become clear that the subject's light coloring would lend itself well to a soft focus effect. It really is easy to achieve.

MOVING TARGET

Soft focus and blurring can also be used effectively to create the illusion of movement. One way to achieve this is known as panning—a technique which can also be synthesized in the digital darkroom. Turn to pp. 112–113 for details of how to do it.

2 Open the image with your image-editing software (here Photoshop Elements was used). Duplicate the image either via the *Layers* menu, or by dragging the existing image onto the *New Layer* icon as shown here.

FIELD STUDIES

D epth of field (aka "depth of focus") is the portion of a picture between the foreground and farthermost point at which the image is in focus. Lenses of different focal lengths offer different depths of field. Combined with aperture, it's easy to isolate a focal point. That's why a moderately long lens of, say, 85mm to 135mm is ideal for portraiture. The depth of field is compressed, flattening features and enabling a strong focal point to enhance the subject.

3 Select the duplicated layer (called *Background Copy*) and apply an appropriate amount of *Gaussian Blur*.

4 The next step is to *Lighten* the background copy, accessed via the *Layers* menu. This will allow the original background layer to show through.

5 Finally position the background copy layer over the original layer, and the blurred but slightly opaque copy of the original layer will create the diffuse effect of the conventional soft-focus filter.

ALTERING BACKDROPS

Build incredible pictures by combining separate images—one on top of the other—in a kind of layered sandwich, editing each until they appear exactly how you want them, and then merging for a final effect that can't be equalled using a single image.

Working with layers is the great secret of master image manipulators and the frosting on the cake of the best image-editing software such as Adobe Photoshop, Photoshop Elements, and JASC's Paint Shop Pro.

That power lies in the ability layers give you to construct a composite image by combining pictures, one on top the other, each of which can be edited individually without in any way affecting the other layers. In this way it's possible to enhance everyday pictures beyond measure, and create fantastic special effects and convincing montages and panoramas.

Mix and Match

You can rotate layers, color, and render them transparent, link one or more together to apply an effect across several layers, and import and delete them. Image editors that support layers generally provide a palette of some sort so that you can see at a glance the layers that make up an image along with their attributes. When you're satisfied that the picture is how you want it, you can compress all the layers into one to reduce the size of the file, but without compromising quality. So now let's explore a fun example of using layers...

Spirit of Fun

1 There are many famous—but faked—photographs of people in incongruous settings. But whereas in the "good old days" of conventional photography, photographers had to go to painstaking lengths to achieve barely believable results, in the wonderful world of digital imaging, it is now possible to travel just about anywhere in the world. You, your family, and your friends could be sunning themselves in the Caribbean in next to no time. It's easy to source some vacation destinations—spend just two minutes on the Web and you'll find you have countless, albeit low-res, exotic paradises to choose from.

2 Select a suitable image of the people that you want to send on a dream holiday of a lifetime.

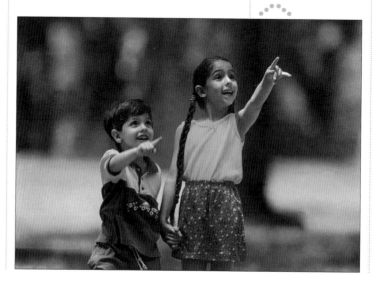

3 Using the *Freehand* tool, carefully draw around the figures. It is worth spending time doing this, as the more accurately you draw around them the more realistic the effect. Select *Copy* from the *Edit* menu (or press *Command > C*)

4 Select the Background image and paste in the image from the clipboard as a new layer. Pull down the *Edit* menu and, from the *Paste* submenu, select *As New Layer* (or press *Control > L*). The second layer appears over the top of the first layer.

5 Click the *Toggle Layer Palette* button on the *Standard* toolbar to display the *Layer Palette*. Now you can use the various image-editing tools to ensure the tones and colors are balanced.

6 At any time you can select and reposition the top layer by clicking on it. When the picture appears as you want it, flatten the layers in the image by selecting *Merge All* from the *Merge* submenu on the Layers menu and *Save As* from the *File* menu.

ADDING WORDS

A picture, so the old saying goes, is worth a thousand words, and while it's certainly true, there are times, believe it or not, when a line or two of text can make all the difference to your pictures.

By now you're probably tiring of us extolling the virtues of the digital over the conventional. It's true that photographs from film are often higher quality (in terms of resolution and color rendition) than their digitized counterparts and that digital photography is still relatively expensive, even considering the lack of processing. But digital photography is so supremely flexible and the pictures accessible—no darkroom, no chemicals, and complete mastery over the images, as you know so well by now. And one more truly useful advantage in the digital world is the ability to add text to your pictures, and not just plain text either!

Say it in Words

Combining text and images presents some marvelous opportunities to create greetings cards, flyers and handbills for club events, church fairs and the like, documents in support of your business or simply to enhance the image and give it a new twist!

There are many ways to add words, as a simple line of text that is a caption to the picture, as a separate and fancy greeting or slogan, or as part of the picture itself, the letters embossed or stencil-cut from the subject matter of the image.

Words and Pictures

1 At its simplest level, adding a line of text to a picture is easy using image-editing software, though it's rarely possible simply to type text on top of the picture as you do when you enter text into a word-processor document. Instead, position a cursor on the picture, summon a text dialog, and enter the text into that cursor position afterward. Photoshop Elements is one of the few packages that enables you to type text into pictures as effortlessly as if you were typing in a word processor. First, launch Photoshop Elements and open the selected picture.

5 Move the cursor around the edges of the text until it changes to this text-moving pointer. Click and hold and you can relocate the text and position it exactly where you want it.

2 Select the *Horizontal Type* tool in the *Tool* palette by clicking on it. Move the cursor to the picture and start typing text.

3 You can select the font, size, and color using, the menus and fields in the *Options* bar.

4 The *Warp Text* dialog from the *Options* bar provides a range of ready-made text shaping algorithms that you can apply simply by selecting one from the pop-up *Style* menu and using the slider bars in the dialog to determine the level of the selected effect.

6 The end result. Obviously you can apply the same technique to any picture you like. Ideal for party invitations, house-warming parties and so on.

FRAMING

Surround your shots with an attractive border and you'll strengthen the contents within. Some cameras provide built-in border functions, and you can create and apply them in image-editing software too...

The popularity of borders—the edges which frame a picture—waxes and wanes according to changes in taste. Once, all photographs sported a white border a few millimeters wide. The border is actually an unexposed area of the photographic paper on which the print is created. In the 1970s, the vogue for borderless prints was all-pervading. Today, both are available but borderless prints are probably slightly more popular than the bordered variety.

What's often missed in the bid for greater image area is that far from taking something away from a picture, a border can strengthen the composition and provide a reference point against which the picture is balanced.

Many digital cameras offer a number of frames that you can apply to a picture before it's downloaded to your computer, and of course, adding all kinds of plain and fancy frames is easy once your picture has been opened within image-editing software.

If the borders provided with your image-editing software, don't fit the bill, Extensis PhotoFrame, a third-party plug-in, has plenty on offer.

Bordering Beauty

1 Paint Shop Pro and many other image editors offer picture framing functions. Start by launching your software (here PSP) and open a picture.

2 Pull down the Image menu and select Picture Frame. The Picture Frame dialog is displayed.

ON-BOARD BORDER

If your camera offers a selection of built-in frames, you usually apply them by selecting one before taking the picture. Flick through the frames on offer, choose one, and size and position it using the LCD preview screen, then take your picture. Often it's possible to download more frames to your camera from third-party suppliers or even design and download your own. Refer to your camera's directions for details. The disadvantage of using built-in frames is that they become part of your picture—you can only remove it by cropping using image-editing software.

3 Select available frames using the pop-up pick list at the left of the dialog. To apply frames your image must be grayscale or 24-bit color. Increase to the required color depth using the Increase Color Depth option from the Colors menu.

4 Elect to apply the frame within the existing picture area or-outside it. The program automatically increases the canvas size.

5 Click OK and the border is applied. As ever, press Control > Z if you decide the border isn't right for the picture.

COLORING

Color photography has long been available and all digital cameras take saturated images that are nothing short of lavish in their rendition of colors, yet hand-coloring a black and white image can make for a striking picture, and the process is easy using image-editing software.

There are two kinds of hand coloring. The first involves your taking a black and white photograph and adding artificial color. The other type of colorizing might better be described as hand "uncoloring" and we'll show you that technique over the page.

A hand-colored photograph has an esthetic—and perhaps even artistic—value beyond that of the picture alone.

The mechanics of colorizing are made exponentially easier using a computer and a digital image, but getting good results continues to be a fine art (in every

sense) though much of the fun lies in the execution. You can color old black and white photographs you've copied with your digital camera or grabbed with a scanner, grayscale digital pictures you've taken yourself, or even a color picture from which you've discarded the color information!

Decolorizing—taking the color out of an image leaving only a small colored portion—is easier, but can add a great deal of impact to a picture. The effect is often used on advertising billboards and the like precisely because it is so eye-catching.

Adding

1 Select a picture you want to hand color and open it with your chosen image-editing software, (or open a color image and remove the color information rendering the picture as a grayscale image).

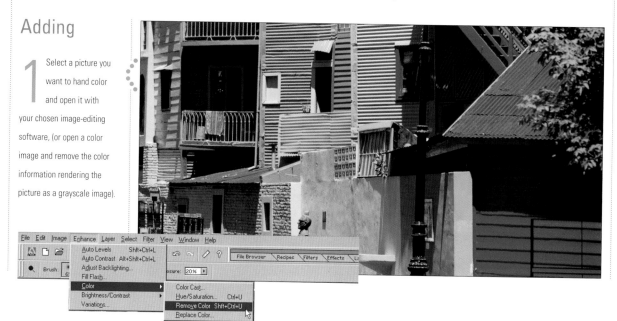

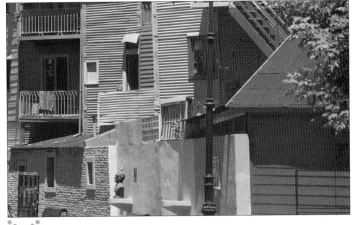

2 You can choose colors from the selection provided in the image-editor palette. A neat trick is to open a color picture that features the tones you want to use in the colorized picture. Use the Eye drop tool to suck a hue from the colour picture.

3 Switch to the grayscale image, select Paint brush, and paint in the new color. Larger areas can be filled with the Flood fill tool.

4 Don't worry too much about the accuracy of the colors. Exaggerating colors is what gives a colorized image a whimsical appeal. Save As from the File menu to retain a copy of the original image.

Subtracting

1 Decolorizing an image (i.e., discarding all color information except one part of the picture) can be done in several ways. Those who've read through Chapter 5 and now know how to manipulate layers can work with two copies of the same image, one grayscale, one color, throwing away all but the small color element in one, and flattening the two layers so that they merge into a decolorized image. However, there are far easier ways to get more or less the same effect. Try this...

2 Launch your image-editor (here Adobe Elements) and open the picture you want to decolorize.

3 Select the Lasso tool, and carefully draw around what will be the color subject in the image. Press Shift-Control-I to select the background.

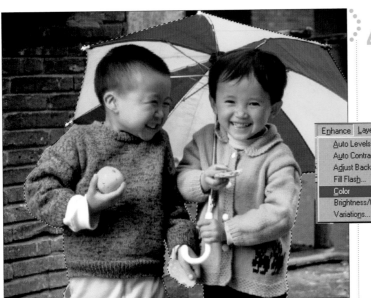

4 Pull down the Enhance menu and select Remove Color from the Color submenu (or press Shift-Control-U). The color information is discarded from the picture.

5 Use the Clone Stamp tool to decolorize small areas missed when you have selected the subject with the Lasso tool. Next select Save As from the File menu.

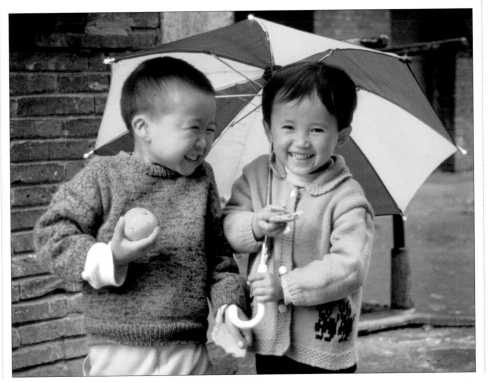

AIRBRUSHING

It's time to bring it all together and put yourself in the picture using the techniques discussed in this and earlier chapters. If you've ever wanted to stand shoulder to shoulder with Laurel and Hardy or be the fifth Beatle, now's your chance...

Woody Allen and Steve Martin have both starred in movies that featured shots of them spliced with clips of long-dead politicians, gangsters, celebrities, and film stars; even some beer commercials got in on the act. *Zelig* and *Dead Men Don't Wear Plaid* explore the amazing possibilities of using clever camera and editing trickery to fit Allen and Martin into clips filmed years earlier, some from Hollywood, others sourced from newsreels of real-life events. If you have seen either film (but particularly *Zelig*) you'll know how amazing the results can be.

Join the Stars

Now it's your turn. With your digital camera, image-editing software, and the techniques we've worked through elsewhere in the book, cutting in on the action is relatively easy and great fun! Amaze your family and friends and rub shoulders with stars of the past and present. Here's how...

Rewrite History

1 First catch your celebrity! You can use a picture of a politician, actor, sports star, notorious criminal—even a character from history. A picture that features the celebrity alongside another person is best—you can simply substitute yourself for the companion! A word of warning, however, be careful not to infringe any copyright laws if you intend to put your picture up for public consumption.

2 Using the print copying methods discussed earlier, digitize the celebrity picture. A scanner is best for this task but if you don't have one, you can use your digital camera and get reasonable results.

3 Ask a friend to take your picture against a neutral background and posed as closely as you can manage to the companion you're going to replace in the original picture. Don't worry too much about relative sizes at this point. Reducing the new shot to match the original won't lose a great deal in quality.

4 Download the picture and open it in your image editor. Next, open and activate the picture of the celebrity. Press Shift-I to summon the Current Image Information dialog and make a note of the dimensions. Repeat for your own image and adjust by resizing (Image> *Resize*, or Shift > S) to match the two photographs.

HEADS UP

If you're having difficulty matching a full-length picture of yourself against that of the celebrity, try replacing just the face of the companion. With a bit of ingenuity, resizing, cloning work, and some feathering, it's quite easy to blend your face into someone else's.

5 Select your picture and draw around yourself with the Freehand tool (try to do this accurately so you pick as little background as possible). Pull down the Selections menu and choose Feather from the Modify submenu (or press Control > H). When the Feather dialog appears, enter a value of about five pixels. You might need to experiment—the idea is to soften the edges just enough to blend them into the new picture. Press Shift > Control > I to select the background and delete it. Right-click to deselect. Press Control > C to make a copy of this image in the clipboard.

6 Activate the celebrity image by clicking it. Use the Clone tool to remove the greater part of the companion—you can do this quite roughly because your image will overlay the one you're removing. Pull down the Edit menu and select Paste As New Layer (or press Control > L) to paste the clipboard selection into the celebrity picture layer.

7 Position the layer of you as closely as you can to the original. You can use the Clone tool to aid blending.

BLACK AND WHITE BLEND

If you're having trouble blending two color images convincingly, try rendering both as grayscale. The eye can be more easily fooled by the subtle shades of gray.

8 To create an illusion of depth in the picture, you can create more layers by selecting bits of the original picture using the Freehand tool, copying them to the clipboard, and pasting them back into the picture as a new layer (Control > L again). In this way you can build multilayered pictures that truly blend your image with the original.

9 When the picture appears just as you want it, flatten the layers by selecting Merge All from the Merge submenu on the Layers menu. Finally, Save As by pressing Shift-Control-S.

DELETING RED-EYE

Let's continue the masterclass with a relatively simple yet nevertheless highly useful technique for ridding blighted pictures of the dreaded red-eye phenomenon! This infuriatingly common occurrence is the ruin of thousands of pictures.

Red-eye is caused by light from the camera's flash illuminating, and being reflected by, the subject's retina. It happens because in dim light the pupils open wide to allow more light to enter the eye. The intense flash of light from the flashgun occurs far quicker than the eye can respond, and so it is caught by the camera while wide open, reflecting the light as a red disk.

Red-eye looks particularly unpleasant when it occurs in the eyes of pets such as dogs and cats, and though we've come to live with the phenomenon, it spoils many otherwise excellent photographs. Over the years photographers have developed techniques to try to avoid red-eye. With conventional film you only know red-eye has blighted your pictures when you get them back from the laboratory. Digital photographers can review pictures as they're taken and reshoot as necessary but the potential for red-eye is just as strong a possibility.

Flash Compensation

Many cameras offer a red-eye-beating flash option which fires a pre-exposure flash burst, pauses momentarily while the eye adjusts itself to the new light level, and then fires the flash again. If your camera features red-eye compensation then use it. If you forget, don't have time to set it up, or didn't realize there was a potential for red-eye until you saw the spoiled pictures downloaded to your computer, here's what to do to restore them to good health...

Red Shift

1 Photoshop Elements, Paint Shop Pro and many other image-editing programs provide dedicated tools and filters to enable you to remove red-eye quickly and easily. Shown on these pages is the red-eye removal brush from Elements.

2 Open the picture and click on the red-eye brush to select it. Choose a suitable brush size from the pop-up brush palette in the Options bar. Move the tool over the offending red-eye and you'll notice that the color in the Current field on the Options bar changes to match. By selecting First Click from the Sampling pop-up menu on the Options bar, a simple click on the eye will cause the brush to seek and replace the color you clicked on.

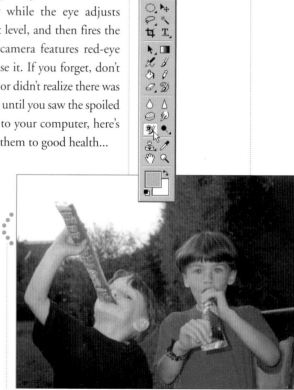

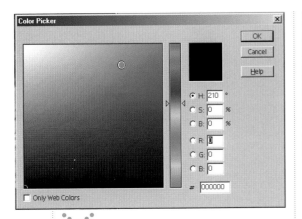

If you click on the Replacement field, the Color Picker is displayed. You can select a color from this dialog that matches the subject's eyes or elect to use the red-eye defaults (click Defaults on the Options bar).

To remove red-eye enlarge the picture and simply click in the red part of the eye to select it. Elements substitutes the default or custom color previously selected for the offending red. Repeat until all the red has been removed from both eyes and use Save As to make a copy of the picture.

PRO OPTIONS

Paint Shop Pro provides a comprehensively equipped dedicated red-eye dialog box which can make intelligent automatic adjustments to human and animal eyes. There's also a red-eye "quill" to enable you to selectively remove the effect manually and you can select from a range of eye color types (which change in color depending on what you select from the pop-up *Hue* menu).

The dedicated Red-eye Removal dialog box in Paint Shop Pro has a number of preset options that cater for just about every incidence of red-eye, humans and animals!

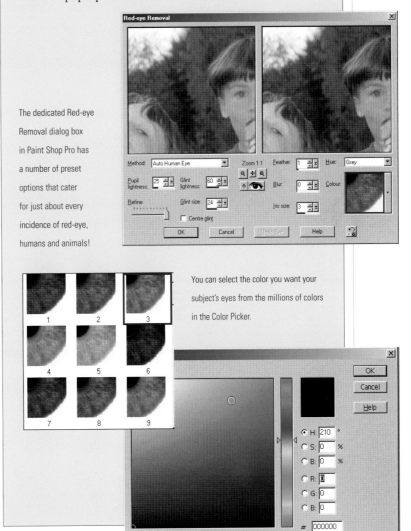

You can select the color you want your subject's eyes from the millions of colors in the Color Picker.

The Projects

OK, we've seen the science. Now all you need is to get your imagination fired up, boot up your computer, make yourself comfortable, and try out these easy-to-follow, fun projects that will give your memories a whole new lease of life. Let's turn your scissors and paste scrapbook into an interactive experience for you, your family, and friends to enjoy, wherever in the world they might be...

BEFORE YOU START...

Not all of the equipment below is absolutely essential, but to get the most out of the projects in this book, you will need:

- A Windows PC (Windows 98 up to Windows XP), or any Apple Macintosh computer running Mac OS 9 or preferably OS X. A good word-processing program, such as Microsoft Word, would be an advantage. If you have the full Microsoft Office suite, then so much the better—and a CD or DVD writer would really put you ahead of the game.
- A digital camera, or a good quality conventional camera and an image scanner. If you've got a video camera, especially a digital one, then you'll get the most out of the later projects.
- A basic image-editing program, such as Adobe Photoshop Elements, Paint Shop Pro, or-similar (we'll tell you the options).
- A basic website-building program, such as iWeb, WebEditor, or-similar (we'll tell you what to do if you don't have this).
- Loads of imagination, some ideas, and all the old photos, memorabilia, souvenirs, and mementoes you can find!
- Oh... and that Internet connection! Got it all? Here we go...

A Holiday Album

Let's dive straight into a rich photo resource. What's the best holiday you've ever had? Where are the pictures? Let's hope you didn't forget your camera—and that you know where your old-style album is! Your collection, whether it's carefully organized with every picture captioned and dated, or stacked in an old grocery box, is a priceless treasury of memories. In this project we'll give you the key to unlock it—to transform these ready-made images into a new experience, an album that will delight its viewers all over again. This first project is about giving you an insight into the qualities of a good picture. Why is it that some images tell a story while others stare dumbly back at you? How come some pictures work well in combination, while others need to be on their own?

Many billions of photographs have been taken since the invention of photography. That's generally credited to the Frenchman Nicéphore Niepcé, but the most significant pioneer of photography as we know it today was William Henry Fox Talbot, who was spurred into action by a holiday experience. His companions were all accomplished artists, recording everything in sketchbooks, while he could only look through the lens of a "camera obscura" and attempt to trace around what he saw. Some 150 years later, his and Niepcé's technology allows all of us to capture the moment without effort.

Beached!
This one has it all. Surprise, humour, good composition, varied texture, harmonious color, creative viewpoint. If you have even a few pictures like this, your project will be a snap.

THE IMPORTANCE OF VIEWPOINT

Most conventional cameras sit naturally in the hands with the shutter button under the right forefinger, the right eye looking through the viewfinder and the left hand adjusting focus. That's why the great majority of photographs end up in landscape format, shot from eye level. This can be great—but it can also be boring. It's natural to want to include as much as possible in every shot, but the result can be a picture with no point of emphasis. A show without a star.

The plain vanilla shot: there's plenty of detail but nothing leaps out to grab you. Put this one in the "back in the basement" pile.

The chocolate-chip shot: getting in close, or zooming if you're nervous, produces a far more exciting image.

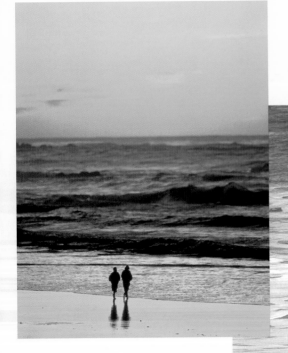

Warm Horizons

A good example of when to let nature take-its course: the faraway shot that works. Bold stripes of color and a strong sense of scale, all wrapped in spectacular evening light.

Back to the Future

Forget the old instruction books: there are moments when the back view is best. You can almost feel the waves around your toes, inviting you to join the rush to the sea. But have these guys got cold feet?

Close Up and Personal

Is this the yard of beach next to your foot, or an aerial shot of strange mountain ranges? This miniature landscape has much of-the fascination of the full-size version. You can use details like this creatively, as we'll explore later...

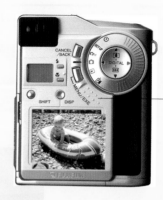

If you don't yet own a digital camera, consider investing in one: prices are falling, and you'll find it easy to gather and store thousands of images for posterity. If you own one already, you may have a collection of holiday pictures that cry out to be displayed to their best advantage. But if you are still in the foothills of making that decision, your raw materials for now will be your existing prints, slides—perhaps even video footage (see page 26 for ways to connect video cameras).

As well as conventional images like these, you can use all the other bits and pieces that you've probably saved to remind you of that special time. Look for postcards, theatre programmes, travel tickets, and tags. See-over the page for an example of how you can add these items to your digital photo scrapbook, and turn your ephemera into something more permanent. This project aims to reassemble a number of existing album pictures and print them out as complete sheets. There are several practical considerations that may influence the choice of images from-an existing album. Very old pictures stored in unfavourable conditions can-suffer from blemishes of various kinds. Some of the problems your old pictures might have are: mould; discoloration due to glue staining through the back of the print; damage on the front through being stuck to other prints or to the album leaves themselves; fading of the image due to sun exposure or insufficient chemical fixing when first made; brown staining from iron oxide in the album or the print substrate; all the way through to scribbling marks made by disrespectful relatives. All these faults can be cured, or at least improved,-using the digital techniques outlined in this book.

Transferring from a digital camera

If your camera contains a removable memory device like a CompactFlash, SmartMedia, or MemoryStick storage card, you can insert the card into a reader, which then plugs into a port (usually the USB slot) on your computer, and download the pictures to your hard disk. There is often a cable alternative linking the camera and computer directly. If the camera only has a fixed internal memory, you'll need to use the-cable method.

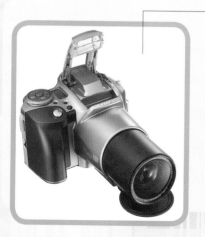

Scanning existing pictures

Very good results can be obtained using an-ordinary desktop scanner. In fact, you will-often be able to improve the appearance of-old-pictures with just a few adjustments, either-in the scanner's own software, or afterwards in an image-editing program.

Just place the print on the scanner, then rev up your software engines...

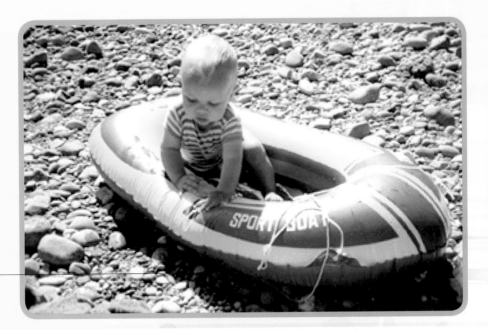

You can store dozens of images on any of the memory cards or sticks that come with some digital still and video cameras. Then just slot into the reader and… you're off.

Ah, springtime in Paris. With help from your scanner software, it's brighter and more colorful than ever.

147

Those of you who have never stolen hotel soap should skip over these pages. In this project, you can use your holiday "ephemera" such as travel tickets, souvenir bookmarks, sunglasses, keyfobs, and guidebooks to complement your photographs. Your scanner can deal with shallow three-dimensional objects, although you shouldn't chance its glass surface with large chunks of Uluru or the Grand Canyon. On the other hand, items like that can make handy targets for close-up photography with your digital (or conventional) camera to give your scrapbook a real sense of place. The more you travel the world, the more you'll see that local graphic designs and typography reflect the countries and cities you visit: the chic lettering on the shopping bags from your trip down the Champs Élysées, for example; the bright, sunny colors from your West Country beach holiday...

To further blur the edges between your photos and the local culture of your holiday destination, why not try inserting one into the other? Scan the front page of the local newspaper you picked up and use an image-editing program to add your family members, and revise the headlines to announce your arrival in town. The techniques to do this are basically the same as the retouching tricks you need to work on faulty pictures (which we'll deal with throughout the book).

Look at the size of the items at your disposal and enlarge or reduce them dramatically. For example, you can use the airline tag from your suitcase as an all-over background for a whole album page. Make a pattern out of those left-over banknotes, coins, and unspent traveller's cheques. The door is open wide for the enthusiastic scanner operator!

Above: **Clean Up!**
If there are specks of dust on your scan or on your original, or if the original picture has been damaged in some way, you can use some of the repair tools and filters in Photoshop Elements to fix them. *Dust & Scratches*; *Restore Damaged Photo*; *Red Eye* and *Quick Fix* (for contrast and so on) are just some of the options.

Uluru on a Shoestring
Small objects can be scanned and turned into a digital image you can use like any other, or a background texture for a page.

Coloring Monochrome Graphics
Maybe your album page is a little light on colorful items. It's easy to change dull bits of newsprint, for example, into brilliantly colored gems. All that's needed is some contrast between the tones in the original. Select one shade of grey in an image-editing program, and fill it with vermilion; select another grey and fill with turquoise. With digital techniques, the options are limitless.

Right: There are two routes to producing a complex collage like this. Route One has you arranging your items in perfect order on the scanner, taking care to overlap each one and, much more difficult than it might seem, getting them absolutely at right angles relative to the edges of the scanner glass. Assuming you can keep things organized (and remember, your images need to be face down, not face up!), it's just one scan and you're done. Route Two, though longer, is recommended. Put two or three items together on the glass, close but not touching, and scan them as a group or, if your scanner/software combination will allow, as separate items. Separate scans will allow you to change the size of each item, giving you much more flexibility when assembling the collage. Following this method, you can assemble the scans layer by layer in your image-editing program, retouch them individually as required, and add shadows for that final, lifelike look.

Now for the easy bit. The pictures have been downloaded or scanned, sized, cropped, retouched, and stand ready for your final layout. With your computer, you have more than enough flexibility to change their relative sizes; but remember that scanned photos can always be quickly rescanned if they run out of definition under extreme enlargement. This is the moment to try any combination of pictures that appeals to your eye. You can try formal and informal layouts; you can overlap or not overlap; use vignettes and shadows. Liberated from the usual album constraints of glue pot, sticky corners, and rectangular picture shapes of fixed size and format, you are free to decide, change your mind, then decide again. You have all the possibilities of the newsstand magazine designer, with none of the deadlines. Take your time to swap the layers around. Keep back the picture that doesn't quite work, and store it for use in another layout. You'll begin to make judgments about what works well, and what doesn't. Developing this kind of selection process is vital groundwork for moving onto webpages and even more complex presentations. And we'll get on to those soon enough!

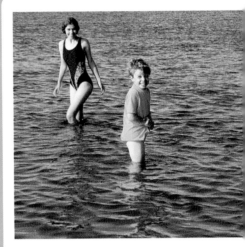

CHOOSING PAPER

As we've mentioned before, glossy "photo" papers offer the most saturated colors with inkjet printers, but tend to be expensive. Quite a bit of trial and error may be necessary before you find a brand that suits your eye and your pocket. Some cheaper papers skimp on the coating process; the worst offenders will show ugly bands of-varying density. Your printer software will usually offer different settings for various kinds of paper, and adjust the ink flow automatically to get the best result. At the top end of the price range, you'll find inkjet-suitable "watercolor" papers, which come from the same mills where the regular artists' version is produced. Other unusual surfaces include imitation silk on a plastic sheet.

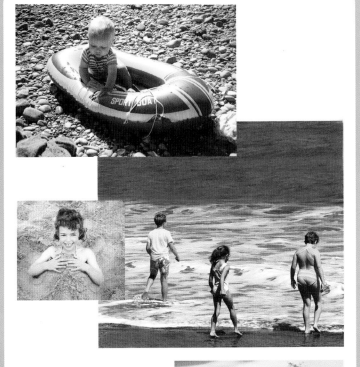

Resolution

Above: Your printer probably offers "draft" quality for speed and economy. The number of dots of ink is reduced and the print-head moves rapidly across the paper surface. The trade-off may sometimes be acceptable, but most times you'll want to stick to high resolution for printed work.

Playing it Straight

The traditional rectangular layout (*above left*) needs strong images like this to keep the eye interested. A small vignette provides good contrast.

The Layered Effect

Angled pictures must be handled with care. Borders and backgrounds help make both these sets of images work together, giving a real sense of place to bring back those precious memories.

Now that you have your pictures selected, enhanced where necessary, and composited into single sheets with vignettes, drop shadows, applied textures, and scanned memorabilia, it's a good time to consider the final format and style of your newly revamped, conventional scrapbook. If you buy a commercial product, these decisions are mostly made for you. Depending on your budget you can choose padded covers, gold blocking, elaborate interleaving, even an integral musical box (if that's to your taste). In theory you could use any kind of blank book.

If you're a practical person, it's not hard to construct an album of your own. Imagine you have some stunning panorama shots. It's a crime to stick them across two pages with a gap in the middle. Why not mount your panoramas back-to-back on thin cardboard? Then make matching front and back covers on heavier cardboard, and get the local print or copy shop to bind the whole production together. They can generally offer plastic comb binding (not very beautiful, but effective and strong), Wire-O (more elegant, and more expensive), or, if you only have a few prints, a simple slide-on plastic spine. If you prefer to do the whole job yourself, be careful with that Scotch tape: your efforts will look a whole lot better after 20 years without a garland of semi-liquid gloop.

TELLING THE TALE OF YOUR HOLIDAY

The secret of this first, easy project—and of digital scrapbooking techniques in general—is to choose, edit, and compile images that really tell the story of your holiday. So, page one could be leaving home, the trip to the airport, the luggage—and the inevitable wait. Move on to page two and you've arrived exhausted at your destination, probably hours late and yearning for the comfort of your hotel room. Keep the tickets if you can, the menu at the hotel, a napkin or two, maybe even that vital "Do Not Disturb" sign in six languages. All will take on a life of their own once you've scanned them, edited and composited them in your image-editing program. Then it's straight on to the main event: those days on the beach; the local bars and restaurants; the guide books and souvenirs; those few secretly taken snapshots of family members as they complained about the service. It's your story!

Preserving your Work

Once you've composed a few pages of pictures, put your drop shadows in place, and maybe scanned some textures or found objects, it's time to start compiling your new, improved, yet still traditional album. Why not try canvas-textured paper for an economical "fine-art" look. Or make two moves in your image-editing program: use the *Watercolor* function to give a painterly effect over the whole layout, then choose *Canvas Texture* as an overall filter.

Lickety-stick

Who remembers lick-and-stick photo corners? The modern way is to protect the prints under a thin transparent sheet. As a bonus, static electricity holds them firmly in position. Avoid albums with actively adhesive sheets of any kind—every bit of lint you ever saw will be preserved forever.

The Family Event @ Home Page

Take your place on the worldwide stage with this fun-to-do family Web project. Whether you delve into your store of existing images or set up a whole new event just to be sure of getting the shots you want, creating this kind of record is an ideal way of honing your picture-making skills. You select the shots, you direct the layout, you mastermind the order of events—and with our help you can overcome the technical challenges of assembling your first scrapbook and uploading it to the Internet. It's easy!

Digital technology can help you bring your family pictures to life on the Internet, and that's what we're going to do with this project. But first, there's some more technical stuff to get through before we move deeper into the projects...

We've looked at the basic technical issues surrounding websites in our introduction. But what about the software? If you wanted to, you could learn HTML, but these days there is no need to do this: a whole host of programs will write the code for you "behind the scenes," and you need never know what it looks like, or what it does. But if you're keen to find out, the big screen of code *opposite* is what HTML is really like.

If you have Microsoft Office installed, many of the programs in the suite have a *Save as Web Page* function. Take Word, for example. You can turn just about any document prepared in Word, which might include photos and graphics, into an HTML document (your own web page) and publish it on the Internet, burn it onto a CD, or email it to your friends. It's easy! There are dozens of other options, but let's talk Word first.

The Secret Code

Lurking behind every web page is a secret code, called HTML, which describes how each element of a page appears (and tells your browser where to find other elements, like graphics or sound files). Here it is... ugh!

```
index.html - Notepad
File  Edit  Format  View  Help
<html>
<head>
<title>%namo-title%</title>
<meta name="generator" content="Na
<meta name="author" content="John Smi
<style>
<!--
body { color:rgb(0,0,0); font-family:A
h1 { color:rgb(128,64,0); font-size:14
h2 { color:rgb(128,0,0); font-size:12p
-->
</style>
<meta http-equiv="content-type" conter
<script language="JavaScript">
<!--
function na_preload_img()
{
  var img_list = na_preload_img.argum
  if (document.preloadlist == null)
    document.preloadlist = new Array()
  var top = document.preloadlist.lengt
  for (var i=0; i < img_list.length-1;
    document.preloadlist[top+i] = new
    document.preloadlist[top+i].src =
  }
}

// --></script>
</head>

<body bgcolor="#FF8000" text="black"
<div align="left">
    <table border="0" width="750">
        <tr>
            <td width="744"><font size
<div align="center">
<img src="nav/nav_1_index_bhb.gif" nar
border="0" class="namo-banner" alt="Ho
<!--NAMO_NAVBAR_END--></font></td>
        </tr>
        <tr>
            <td width="744">
                <p><font size="2">&nb
            </td>
        </tr>
        <tr>
            <td width="744"><!--NAMO_
<div align="center">
<a href="index.html"
onmouseover="na_change_img_src('nav_i
onmouseout="na_restore_img_src('nav_i
border="0" class="namo-button2" alt="
onmouseover="na_change_img_src('nav_i
onmouseout="na_restore_img_src('nav_i
border="0" class="namo-button2" alt="
onmouseover="na_change_img_src('nav_i
onmouseout="na_restore_img_src('nav_i
```

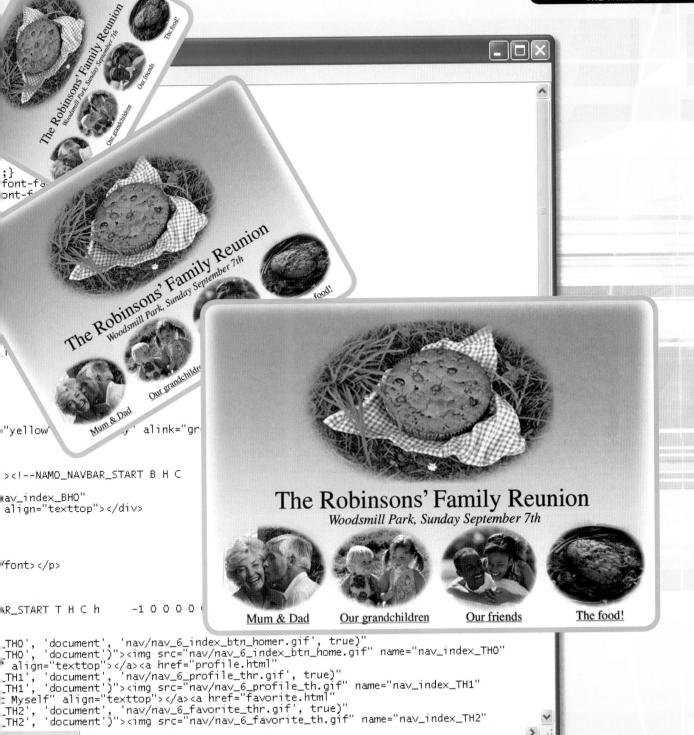

```
;}
font-f
ont-f
```

```
"yellow"                     alink="gr
```

```
><!--NAMO_NAVBAR_START B H C

av_index_BHO"
align="texttop"></div>
```

```
/font></p>
```

```
R_START T H C h        -1 0 0 0 0
```

```
_THO', 'document', 'nav/nav_6_index_btn_homer.gif', true)"
_THO', 'document')"><img src="nav/nav_6_index_btn_home.gif" name="nav_index_THO"
" align="texttop"></a><a href="profile.html"
_TH1', 'document', 'nav/nav_6_profile_thr.gif', true)"
_TH1', 'document')"><img src="nav/nav_6_profile_th.gif" name="nav_index_TH1"
" Myself" align="texttop"></a><a href="favorite.html"
_TH2', 'document', 'nav/nav_6_favorite_thr.gif', true)"
_TH2', 'document')"><img src="nav/nav_6_favorite_th.gif" name="nav_index_TH2"
```

Once you've produced a page in Word, simply select *Save as Web Page* or *Save as HTML* from the *File* menu. You can then open this document in your Web browser (FireFox, Explorer, Safari, or one of the various good alternatives, such as Opera, at *www.opera.com*). Of course, the document still sits on your computer—it's not yet on the Internet. We'll show you how to post it online in a few pages' time.

If you want to see what the HTML version of your document looks like for yourself, simply select *View Source* while the page is displayed in your browser and you'll see a screen full of HTML that the program has written for you behind the scenes.

Using this technique (in Word, you'll also need to select *Online Layout* from the *View* menu) you can quickly transform simple documents into effective web pages—but bear in mind that some of the familiar Word features can't be used. Multi-column newspaper-style layouts, for example, won't transfer to HTML. There are plus points as well, though: you can select a range of background colors and patterns that aren't available as standard for word processor documents.

Exporting from Word is a quick way to put something online, but to lay out a site properly you'll need a dedicated web design program. Namo WebEditor (*www.namo.com*) and iWeb (*www.apple.com*) are relatively cheap and easy to use; Microsoft FrontPage (*www.microsoft.com*) and NetObjects Fusion (*www.netobjects.com*) are more ambitious; and for the professionals there's Macromedia Dreamweaver and Adobe GoLive. Even the more basic packages are fun to use and will probably take you as far as you ever need to go. Many of these programs can be downloaded as free trial versions, and you can also pick up free or trial packages on computer magazines' cover-mounted CDs.

There are lots of other ways to build a site. The Netscape browser has an optional program called Composer, with which you can build simple web pages. At Moonfruit (*www.moonfruit.com*) you can make a site within your own browser in an hour or two, without any extra software. There's a small monthly fee to "host" your site on the Internet, but you can try out the service for free. Mac users with a subscription to Apple's Mac service (*www.mac.com*) can build a site using the HomePage feature.

OK, now let's turn your family event into a fun, interactive scrapbook that will give your photos a new lease of-life!

You've Seen How the Experts Do It...
You've watched Google search for web pages, pictures... even direct you to websites that let you track down long-lost friends. But why not make your own home page, or website, that brings those friends to you?

Untitled

G http://images.google.co.uk/images?q=%22mr%20and%20mrs'

Q▾ Google

Apple .Mac Amazon eBay Yahoo! News ▾ Google UK

Web **Images** Groups News **more »**

"mr and mrs smith"

Search Advanced Image Search
Preferences

Moderate SafeSearch is on

Results **1** - **18** of about 23 for **"mr and mrs smith"**. (0.15 seconds)

Show: **All sizes** - Large - Medium - Small

page3-4x.jpg
344 x 412 pixels - 23k
www.mckennas.demon.co.uk/
images/page3-4x.jpg
[More results from
www.mckennas.demon.co.uk]

12650-large.jpg
300 x 429 pixels - 10k
images.screenselect.co.uk/.
../0/12650-large.jpg

14279-small.jpg
80 x 114 pixels - 4k
www.screenselect.co.uk/
visitor/browse.html?no...
[More results from
images.screenselect.co.uk]

salsa_band.jpg
200 x 150 pixels - 6k
w.cubancyclechallenge.co.uk/
cuba_party.html

26.gif
37 x 66 pixels - 2k
www.blackstar.co.uk/
video/year/1941/j:L

Don't say a word! If your intended subjects—family, friends or colleagues—suspect that they are about to become raw material for your web project, you may well get an icy reaction. Although there are few people who still believe the camera can steal the soul, many get irritable when being stage-managed. What you need is that most difficult combination: organized spontaneity. Dilute your presence as camera-person by inviting a crowd, setting up games and distractions, even getting a friend to act as a decoy photographer while you skulk around the edges catching people off guard. Clearly, none of this subterfuge is necessary if your subjects are natural actors, craving the adoring gaze of the camera.

To establish the sequence, try to get a really wide shot of the scene, ideally before the fun starts (the calm before the storm?), making a handy contrast to the shot of everyone departing at the end. Shoot the invitation if there is one—or if you made it on the computer, save a copy from your graphics program as a JPEG image, or bring it up on-screen and take a "screen grab." In Windows, press the PrtScrn key, then open your photo editor and make a new image from the Clipboard. On a Mac, press Command-Shift-4 and draw around an area of the screen to store it on your Desktop with the name "Picture 1."

When things get started, you'll have to rely on your natural cunning to get the best shots. Try to shoot everyone, since, in spite of their denials, no-one likes to be left out. Get someone to shoot you, for the same reason. Shoot people doing something, even if it's only gesturing impatiently at you. Shoot from above; lie down and get a shot from the ground; shoot through trees, windows and doors; shoot against the light; shoot the food and drink, and the kids at play; capture the adults in deep conversation, and don't forget the pets (they'll be far less self-conscious).

If you're shooting digitally and are sure that these pictures will only be used on the web project, set the camera to its lowest quality. This will normally give enough resolution for a web page at 72 dots per inch, and you'll get many more shots into your camera's memory.

Getting Down to It
You'll be lucky to get a shot like this. Corn cobs and skewers rarely line up so neatly, and it's hard to get the people to do the same. Try, but don't get sunburned or sizzled by the barbecue.

Where's the Sun?
Try to break the old rule about having the sun immediately behind you. Faces look better when not in full sun. Eyes don't pucker up. And sometimes you get a bonus of a backlit halo of hair or a hat. Ah... a star is born.

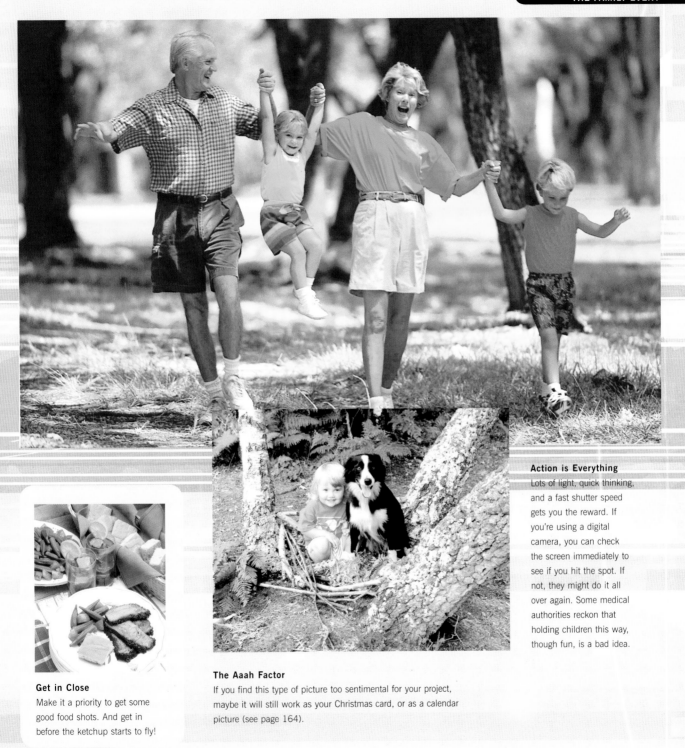

Action is Everything
Lots of light, quick thinking, and a fast shutter speed gets you the reward. If you're using a digital camera, you can check the screen immediately to see if you hit the spot. If not, they might do it all over again. Some medical authorities reckon that holding children this way, though fun, is a bad idea.

Get in Close
Make it a priority to get some good food shots. And get in before the ketchup starts to fly!

The Aaah Factor
If you find this type of picture too sentimental for your project, maybe it will still work as your Christmas card, or as a calendar picture (see page 164).

Back at home in the calm glow of your monitor, it's time to review your harvest of pictures. If you've shot on conventional film, this selection procedure is especially important. There's no point in scanning stacks of prints that you know in your bones are never going to make it. If you've been shooting digitally, there's still a selection to be made. If you can't face the idea of trashing anything, then burn a CD, or make some other form of backup. That way you can have the luxury of changing your mind right through the process.

In either case, you may find it useful to sort the pictures into groups on-screen. You could make folders called simply "Start," "Middle," and "End," for example. Soon you'll have another folder called "Odd," and another one called "Email" containing pictures so hilarious that they won't wait to be turned into a web page, but have to be emailed *right now*.

LOSE THAT WEIGHT/WAIT

Welcome to the hard realities of image compression. The same law that makes your digital camera run more quickly on its low-quality setting means that web pictures have to be slimmed down to load quickly. There are several ways this can be done. Your digital camera probably compresses its pictures automatically into JPEG format ("Joint Photographic Experts Group," pronounced "jay-peg"). Your scanner probably produces TIFFs (Tagged Image File Format, acronym fans). Your image-editing software can deal with both of these and others such as GIF (Graphics Interchange Format). The quest is to make the picture file as small as possible without losing too much quality. The main tool is trial and error. The process is known as "optimization," though it often feels like "leastworstification." That's the classic trade-off between quality and file size that the Internet creates. Deal with it!

Another file format is GIF (Graphics Interchange Format), which deals mostly with images containing significant areas of flat color. So JPEG is likely to be your main weapon. First, establish the required size of the image (it's always measured in pixels, since you're dealing now with screen display). Then choose the amount of compression, moving the slider from low to high, hit *OK* when you're happy, and it's ready to take its place on-screen. When you see it again, it will have a ".jpg" tag (extension).

The Quality/File Size Trade-off

Whenever you save an image for the web, you'll need to get the file size down, so it doesn't take an age to load. This means losing some quality by "compressing" the data. One option is to let Photoshop Elements make settings to achieve a desired size—or close to it.

160

Saving Face

The original portrait *left* has a lot of subtle colors and a wide contrast range. The lit areas of the hat are completely white, and the pupils utterly black.

Trying too Hard

In the program window *above,* the original can be examined closely alongside a preview of the optimized version. Choosing "JPEG Low," though it makes a small and speedy file, is obviously wrong—the image begins to fill with ugly blocks that invade the light areas. You'll need to up the quality a bit—but watch that file size!

On the Edge

This solution (*JPEG Medium*, or 30 in the *Quality* dialog) is a good compromise between small file size and clarity. You don't have to know about file sizes and what they mean: a useful measure is to keep an eye on the timing note at the bottom of the optimization screen. This shows how long the picture would take to download via the (very) average modem. How long would *you* wait?

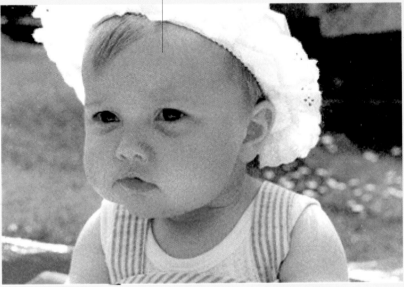

Now you have it all: a plan (remember those pencil sketches?); the picture selection all resized and optimized; some spare pictures in case the first selection needs amending; an idea about the words and maybe a background color scheme. Make sure all the pictures are in the same location on the computer to save needless navigation, and plunge in.

You can try all this out without having any web space of your own. Just set your browser to work "offline" and you can develop a miniature website like this completely independently of the Internet. You could equally well send the project to a friend by "attaching" the files to an email, or burn them onto CD. To actually "publish" your pages, however, you need web space and a small piece of software which sends or "posts" them to the Internet. So, another set of initials: FTP (for File Transfer Protocol). This software takes your files directly to your web space, and allows you to pull them down again whenever necessary for updating. There's normally a password system to prevent others interfering with your space. Some web design programs and browsers have the FTP routine built in, but if not, there are freeware versions like Fetch and Transmit (for the Mac) or CuteFTP which do the job just as well.

In any web page program, there'll be a sample site. Look at the way it's put together, then try substituting your own pictures in their place.

A Web Address of Your Own
www.internic.org is the place to track down web authorities from which you can buy a domain (Internet address) of your own. Try it out, and follow the simple instructions you'll find there.

Greetings from the Country
Here's what you're aiming for: a simple, colorful home page that can take your friends and family (the ones you didn't invite) right there to your day in the park or the country. Simple links to each section will allow you to display your pictures topic by topic, and your visitors to navigate quickly.

The Robinsons' Family Reunion
Woodsmill Park, Sunday September 7th

Mum & Dad Our grandchildren Our friends The food!

The Moonfruit has Landed
If website-building software is too
much of a giant leap, then take
one small step by going to *www.
moonfruit.com*. This is a simple
online service where you can
build a website in an hour or
two. It's easy, and you don't need
programming skills or software.
There's a small monthly fee to
show your site to the world.

How do I make a vignette?
See page 114

PAGES, PAGES, PAGES GALORE

For your first Web project, keep it simple: just half a dozen pages or so.
These will be enough to get a flavour of the event online—or onto a CD
or an email attachment—and you can add or subtract as many pages as
you like later. But for any of these projects, it's a good idea to test your
web page in more than one browser. Don't assume everyone has the
same browser as you, because web pages have a nasty habit of appearing
differently in different browsers, as we mentioned in the introduction:
FireFox, Internet Explorer (often known as "IE"), Safari, and other
browsers work in slightly different ways. Follow the simple instructions in
your web design software about naming files and putting them in the right
places, and you'll soon be creating simple web pages like these, *left* and
right. Don't forget to link to the other pages from your home page.

A Pet Calendar

How old's your dog in dog years? When's her birthday? And when do your cat's nine lives begin all over again? (Don't forget that visit to the vet's tomorrow!) Paper-based calendars aren't just useful for keeping track of important dates and events, they make an ideal foil for your favourite prints. But when those calendars are digital and interactive, a whole world of possibilities opens up—you can edit them, reuse them next year with new dates, even print them onto posters, bed linen, or crockery (we'll show you how to do this later!)

Many image-editing applications provide templates for creating calendars, and simply by working through a step-by-step process you can use these to produce customized calendars featuring your favourite shots. Photoshop Elements 3 is one good example. From its "Creations," choose Wall Calendar. You'll find a variety of formats on offer, each with the option of a title page and/or captions for each image. If you start your Creation while in Organizer mode, the images currently displayed are automatically imported into the calendar; otherwise, you can add selected shots from your Catalogue. Either way, you're then shown which image will appear with each month, and swapping them around is just a matter of clicking and dragging. Elements also warns you if any of your pics lack the resolution to come out well when your calendar is printed. Type a title, add your captions, and all that remains is to save your calendar as a PDF file, which you can print out or email to any friend or relation with a PC or Mac. And all in two shakes of a dog's tail.

Create a Wall Calendar

Step 2: Arrange Your Photo

Add Photos... Use Photo Again

Title

May

Jun

GETTING RID OF UNWANTED DETAILS

If your pet photos are ready to use just as they come, count yourself very lucky! Getting our furry friends to behave for the camera, let alone to pose, can be well-nigh impossible. So many of your photos will need a little retouching prior to inclusion. Removing details—such as a steadying hand or foot (as here), or a distracting background—will make your pictures more imposing. On the next page you can see how this shot was given more focus—by blurring it.

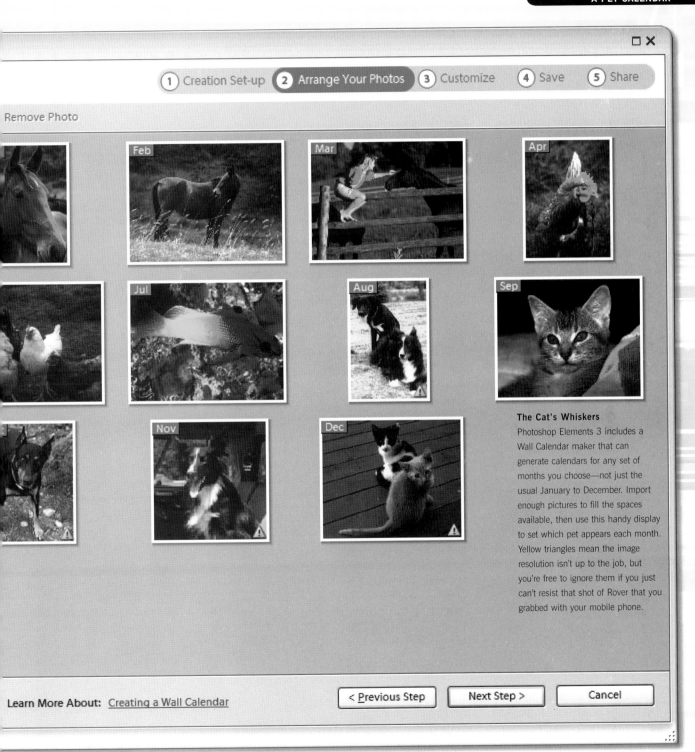

① Creation Set-up ② Arrange Your Photos ③ Customize ④ Save ⑤ Share

Remove Photo

Feb

Mar

Apr

Jul

Aug

Sep

Nov

Dec

The Cat's Whiskers

Photoshop Elements 3 includes a Wall Calendar maker that can generate calendars for any set of months you choose—not just the usual January to December. Import enough pictures to fill the spaces available, then use this handy display to set which pet appears each month. Yellow triangles mean the image resolution isn't up to the job, but you're free to ignore them if you just can't resist that shot of Rover that you grabbed with your mobile phone.

Learn More About: Creating a Wall Calendar

< Previous Step Next Step > Cancel

Before you paste your pet pictures into a calendar, there's plenty you can do to make them look even better. Remember that you—or anyone you give the calendar to—will be looking at the photo for a whole month, so there'll be plenty of opportunities for criticism!

One of the best ways to emphasize the subject of your photo is to remove the surrounding background, especially if your pet's not known for its tidiness. Image-editing applications provide several ways of achieving this effect. Two of the cleverest are Adobe Photoshop's *Extract* command, which sadly isn't included in Photoshop Elements, and *Background Eraser*, which is (*right*).

A more basic alternative, found in almost all image applications, is the *Lasso* tool. You can use this to draw around the edge of the subject. Since few of us have hands steady enough to draw an accurate outline with a pencil, let alone a mouse, some programs—including Elements—provide a variation called the *Magnetic Lasso*. Rather than relying on your freehand technique, this attaches itself to the edge of your subject automatically as you draw— roughly—around it. It's far from foolproof
(it can be confused when there's more than one edge to follow), but with a little practice you can achieve very effective results indeed. And we'll bet there've been times when you wanted to lasso your pet...

If you have a pet with a *very* fluffy coat, you may find neither of these methods is able to select every hair. Professional photo retouchers use add-ons such as Corel KnockOut in these cases, but it's unlikely to be worth your while investing in such a specialist tool. Instead, try a method—such as those below—that doesn't rely on a perfect outline.

IMAGE EXTRACTION

You can get rid of a distracting background using Photoshop Elements' *Background Eraser*. Here it is in action. You'll find the tool in the main toolbox along with the ordinary *Eraser* (click and hold the icon to pop out the alternatives). Select it and you get a cursor consisting of a circle with a cross in the middle. The basic idea is that when you click with the mouse, it deletes everything within the circle that isn't the same color as the cross. So as long as the cross doesn't touch your subject (here, the dog), it won't get erased, while the background will. Continue around the edge to get a complete outline, and you can then use other tools such as *Lasso* to remove the background beyond this.

OTHER EFFECTS

Image extraction isn't the only way to emphasize the subject of your photo. Soft edges, blurring effects and even color changes can all help create a more effective image. In the case of the cat (*right*) we've applied a *Grain* filter to give a textured finish to the photo. For the picture of the dog (*far right*) we've used the *Lasso* tool again, but then blurred the background. For a final flourish we've also applied a vignette (see page 114) to soften the edges.

Paws for thought? This combination of grainy and soft edge effects adds character to our canny cat.

Blurring the background (and the foot!) has focused attention on the subject, not your footwear.

The *Background Eraser* **and its Options**

After you activate the *Background Eraser*, you can set the Brush Size, Limits and Tolerance in the *Options* toolbar. Set Limits to *Discontiguous*; switch to Contiguous if you get holes in your pet! Reduce the Tolerance depending on how similar the background color is to the subject.

The Extracted Image

Once you've worked all the way around the subject, use the *Freehand Selection* tool (Lasso) to draw roughly around inside the area you just erased. Then use *Inverse* (*Select* menu) so that the remaining background is selected. Press Delete (Windows) or Backspace (Mac) to remove it. Use the normal *Eraser* to tidy up any bits left around the edges.

EXPOSURES WITH CLOSE-UP

When taking photos of your pets close up, there can be exposure problems when using some cameras. Flash exposure tends to be too great, resulting in a photo that's over-exposed. You can instantly correct much of this by-using the "quick fix" or "auto" enhancements in most image editors, or simply alter the brightness and contrast sliders.

The *Elliptical Marquee*
Open your image in Elements
and choose the *Elliptical Marquee*
tool. The *Feather* option sets
the softness of the edge of the
selection you're going to make.

CREATING A VIGNETTE
We'll use this photo of a tabby cat as the basis of a
vignette portrait—an image of the cat's head with a
soft edge. When you place this in your calendar, it
will blend seamlessly into the white page. This is also
another way of removing a distracting background.

OTHER SPREADSHEETS
On this page we explain how you might use
Microsoft Excel—available as a stand-alone
product and as part of Microsoft Office—to
make a customized calendar. You could
achieve similar results with other spreadsheet
applications, such as Lotus 1-2-3 (part of
IBM's Lotus SmartSuite), Quattro Pro (found in
Corel WordPerfect Office), or the spreadsheet
modules in low-cost "productivity suites" like
AppleWorks (on the Mac), StarOffice and
Ability Office (for Windows). With most of
these packages you can not only lay out your
calendar and format the dates as you please,
but also enhance your creation with colors,
textures, graphics and text effects.

It may surprise you to hear that Excel—the spreadsheet included with
Microsoft Office—is a great alternative for calendar production. There
are three good reasons why. First, its grid of resizeable "cells" is perfect for
a calendar layout. You could have standard week and month tables, or go
for something more avant-garde, such as a frame of days and dates around
a central image. Second, it offers lots of date formats and options, and of
course extensive calculation abilities—how about a calendar calibrated
in dog years? Third, you can use some of the simpler spreadsheet tools
to bring your calendar to life—even online on a website (you can save a
spreadsheet as HTML). With a bit of imagination, and a basic knowledge
of maths, you could set up a few simple calculations. If you divide the
average cat's lifespan by nine, how many of its nine lives has yours used
up? How long has it been since her last visit to the vet?

Importing images into Excel is as easy as clicking a button on the
Picture toolbar. Use this to import your images, trim them (using the

Fur and Feather

Set your *Feather* first—try about 5% of the image's width in pixels—then use *Select>Inverse* to invert the selection: now it's the area outside the head that's active. Press the Delete key (or Backspace on the Mac) to clear this, leaving white space.

Crop command), and make fine adjustments. Once an image has been imported you can use its "handles" to resize it to fit your calendar layout. Repositioning is equally easy: just click and drag.

It's true that Excel is a professional business tool, and many of its features and concepts are designed for the advanced financial or scientific user. But don't let that put you off—the nature of Excel is such that if you don't need those high-powered tools, you needn't see them! Stick with simple tables and you'll have all the power you need. Then explore the Formatting palette and examine how you can alter the look of your calendar with a change of font or a little color. Use the Cell Shading feature for those important jab dates!

For colorful or dramatic text (to use as captions or to name the months), give Excel's WordArt a try (*Insert>Picture>WordArt*). Select a WordArt style, type in your text and press *OK* to emblazon your page with text worthy of the local signwriter.

Using your Vignette

When you're happy with the result, save it under a different filename. Import this file into your calendar and see how it looks!

There's another group of applications that's ideal for constructing calendars: page layout software, also known as desktop publishing (DTP) programs. These are the same applications that you'd use to produce your community, club, or society newsletters, and even national magazines and newspapers—as well as books like the one you're reading now. The Big Daddy of DTP is QuarkXPress, which is used to create many of the publications you'll see on the average newsstand. There's little that Quark—as it's generally referred to—can't do, but it's too expensive for most people even to think about. Adobe InDesign is quickly catching up with Quark in popularity and is quite a bit cheaper (especially if you invest in other serious graphics programs, such as Photoshop, at the same time). It also provides more help for beginners. But if you don't need all the professional capabilities, budget packages to consider include Serif PagePlus (*www.serif.com*) (Windows only) and Ready,Set,Go! (*www.diwan.com*), which is available for both Mac and Windows and in editions that support Arabic and other non-Roman written languages.

With page layout applications, especially InDesign, you're far less limited in the way you can mix photos and text. You could have your calendar flowing around the vignette image we created on the previous spread. Or you could fade the image across the page and lay the calendar dates over the top. The only limit is your imagination.

Once you've created your calendar, don't be afraid to share it. It will look great on your wall, but give one to friends at the pet club and await the plaudits! Or link to it from your home page, email them your web address (URL) and wait for the visitors.

TRANSFERRING DATA

Just as Microsoft Word's native data format has become the standard for document exchanges between computers and over the Web, so the Excel format (indicated by the file extension ".xls") has become the standard in spreadsheet exchanges. Even if you don't use Excel, there's a high probability that the application you do use will be able to understand a page from an Excel spreadsheet. Page layout applications tend to be more parochial. If you've used one of these, the best way to save your document for others to see is as a PDF (Adobe Portable Document Format). Note the options to "optimize" your file either for print, which will make a large file with high-resolution images, or for web/on-screen use, which will make a smaller file.

Seen it All Before?

The toolboxes provided by page layout programs such as Adobe InDesign and Serif PagePlus (*above*) feature many similar tools to those used in image-editing applications. Although getting to grips with every feature could take months, with only a little practice you'll be able to exploit the key features required to create a calendar. All these programs—from QuarkXPress, available for Mac and Windows at huge cost, down to older versions of PagePlus for Windows, which you can get free from *www.freeserifsoftware.com*—have extensive on-screen help and tutorials, and usually some special features to help with tabular layouts.

April *2006*

Sun	*Mon*	*Tue*	*Wed*	*Thu*	*Fri*	*Sat*
						1
2	*3*	*4*	*5*	*6*	*7*	*8*
9	*10*	*11*	*12*	*13*	*14*	*15*
16	*17*	*18*	*19*	*20*	*21*	*22*
23	*24*	*25*	*26*	*27*	*28*	*29*
30						

Well, the weather's getting warmer -- but who turned the radiators off?

A Day to Remember

Whatever your pictures show, a few special effects (here we used Photoshop Elements' Diffuse Glow) will make them look special. Your finished calendar will not only be a work of art but a useful tool – or a great gift.

Pass it On

You can print your calendar out or save it as a PDF document, which other users can view and print using Adobe Acrobat Reader software (already installed on most computers). There's even an option to email it straight off.

Let's Move House!
And Home Page...

How do your friends get to your new house? And how do you tell the story of your day? Moving house scores highly on the stress scale, so photography will probably be the last thing on your mind in the flurry of activity on moving day. But, like all life-changing events, it's full of images that will make most families feel a lot happier about the event once the move is done. The necessary healing interval might be days, weeks, or even years, depending on the success of your particular migration, but you can be sure that a little planning in the pre-move period will bring great rewards. On these pages you'll find many tips that suggest alternatives and enhancements to the regular shots of comings and goings. And one more thing: make double sure that the box-labelled "family photos" gets top priority safe handling. Otherwise you could be reconstructing your family history from other people's albums. And the key to this project, the key to your "moving home" page, is making something useful that you can email your friends and family members, or publish online. Just email them the web address!

THE HOME PAGE OF YOUR DREAMS
Keep the estate agent's brochure that first attracted you to your new home (the one with the captivating, sunlit picture and the carefully crafted words). If you bought your home through the Internet, download or screen-grab the page. If you're not feeling too happy about your buy, you could always compare the picture that attracted you with one you took of the real thing...

The Right Direction
Whether your new location has pressed steel or top-of-the-range carved stone, make sure you shoot the street sign.

Two Places, One Time

It's unlikely you'll get all the required pictures on the day of the move. Do as they do in Hollywood and shoot the missing frames another day. Although the removal truck will be long gone, there's still plenty of useful material to shoot out on the street and around the neighborhood. And if yours was just a local move, why not take an early trip back to the old home to see how the new owners are settling in? Or aren't they talking to you any more?

If your move took you to another county—or country—you'll be able to create a real travelogue. Remember that your audience may not be familiar with your new location, or even the old one. So you'll need to look for maps. You may find free local street maps at your new town hall or Tourist Information office. Printed maps, of the kind you buy in stationers' and petrol stations, generally have an excess of detail—there are just too many contour lines and bridle paths. You could trace over them to simplify them, but that would involve the hassle of scanning them, and the area you want is bound to cross over two pages!

Instead, turn to the new breed of Internet mapmakers. Try any of the route-planning websites and you'll see examples of their work. These maps are kept deliberately simple, since they're designed to be viewed, and printed out, at a wide range of sizes. When you zoom right in to an area, the map will change its character completely to show a denser mass of information, with streets and even buildings starting to appear.

It's easy to copy a map by dragging the image from your web browser or doing a screen grab. But remember this isn't strictly legal (see below right), so keep it for personal use only.

A QUICK GUIDE TO ONLINE MAP SERVICES

The mind of the mapmaker works in a different way from that of the map user. Where we want to know how many centimetres to the kilometre or miles to the inch, the mapmaker prefers to deal in scale ratios. 500,000:1—five hundred thousand to one—gives you five kilometres to a centimetre, or around eight miles to the inch (see why we went decimal?). The map *above right* is shown at this scale. Let's say your move was 50 kilometres, and you're looking to fill most of an average-sized web page with a map that covers your start and end locations. So, 50km at 5 kilometres per centimetre gives you 10 centimetres—easily accommodated on-screen, with room to spare at each end. The largest scale normally available in online maps is 5,000:1, which would be ideal for showing your route if you'd just moved around the block!

BEWARE OF COPYRIGHT!

A legal notice on the map site shown here (*www.multimap.com*) points out that you're not allowed to do anything with the maps except look at them within the site in your web browser. For a fee, businesses can licence maps showing their location for use on their own websites. Copyright in maps is heavily protected, so don't be tempted to copy one onto your own home page!

of United Kingdom | Multimap.com

n/map/browse.cgi?client=public&X=3 ○ ^ Q▼ Google

Google UK

my multi map ❂ Register ❂ Log in ❂ Log out ❂ Help

APS | DIRECTIONS | AERIAL PHOTOS | BUSINESS SERVICES | ABOUT US | SITEMAP | HELP

estern
nd the UK

Best Western

dom

Print | Link | Aerial | Traffic | Book hotels | Buy map | Bigger | Help

LOCAL INFORMATION
Pick or type a category:

--

fault_kw=

OFFERS

Generators
Buy Electricity
Generators Here Low
Prices And Delivery.
www.Top-UK.co.uk

MY MULTIMAP
You are not logged in to
MyMultimap

❂ Log in here
❂ Register here

CUMBRIAN MOUNTAIN

Ullswater

Thirlmere

Haweswater
Reservoir

Ambleside

Homing In?

When you finally get your route
in your sights, there'll be a lot
of-other items competing. Make
a screen grab of the map alone.

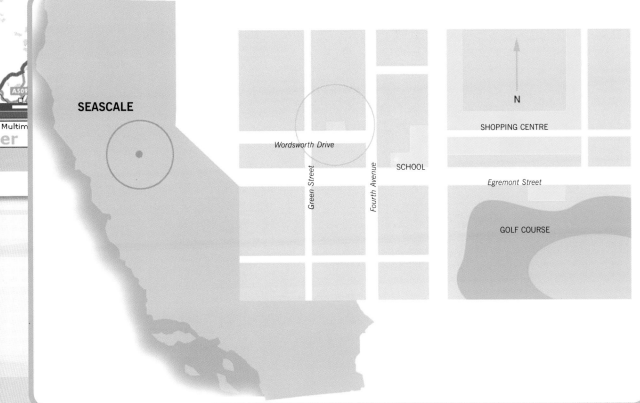

SEASCALE

Wordsworth Drive

Green Street

Fourth Avenue

SCHOOL

N

SHOPPING CENTRE

Egremont Street

GOLF COURSE

It's time to put some meat on these bare bones. If you have some experience with an image-editing program, you are probably already thinking, "I can make a better map than the one I've just downloaded," and you probably can. One way to start is to print out the online version (just in black-and-white) and begin drawing over it with colored marker pens. Emphasize the areas that mean most to you in your old locality, and those that look attractive in the new one. Pretty soon you'll begin to see what's important to the story, and what can be left out. Take the opportunity to write all over this trial map as well—it's likely you'll trigger ideas for a whole new view of the move. Whether you redraw or simply reuse the maps you acquire, start thinking about the sequence of pages from the audience's point of view. You can zoom in or out, and shoot off down some interesting side streets and design alleys to vary the pace. If the move didn't go exactly to plan, include the disastrous diversions as well. Show, as here, a close-up view of your new area superimposed on a small-scale general map of the whole region.

Now let's start making the online neighbourhood your own! In your image-editing program (if it provides web-linking functions) or web design program, you could add "hot spots" to your final map, with links to more detailed maps or photos on a new web page, or to interior shots of the rooms in your house. Alternatively, place a link under a map reference—such as Seascale in the map, *opposite*—which takes you to a zoomed-in view, or to some local history text.

SEASCALE

DESIRABLE RESIDENCES

Look for landmarks. You may not pass Big Ben or the Angel of the North on your trip, but there must be a notable sight somewhere in the region! As well as the vital shots of the homes at either end of the moving route, why not include some others along the way? You might, if you're very cunning, even use these impressive pictures to keep your audience guessing exactly which of these palatial dwellings is the final destination. You may be lucky and find your view unobstructed by vehicles and ugly utility poles; if not, you can extend your retouching skills by copying a bush or tree from another shot, and pasting it over the offending item.

Butler Required
Can this be the one? A lofty lobby with chandelier would be delightful. Or maybe you're more of a Modernist.

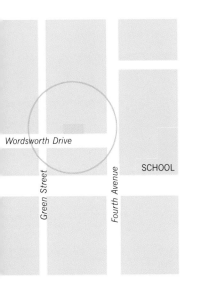

Wordsworth Drive

Green Street

Fourth Avenue

SCHOOL

N

MALL

Egremont Street

GOLF COURSE

A LITTLE LOCAL COLOR

The old conventions: water is blue; grass is green; built-up areas are vaguely brown; these serve well enough for regular maps. Why not make yours different? Why not make your house stand out in bright red? Your street in flaming yellow? Whatever you choose, keep it light and bright so that superimposed text can be easily read.

Using Layers

You can achieve the illusion of depth even with a simple image-editing program. Using a shadow under the coastline kicks it into relief. Try various treatments for the street map—this version has them cut out as white channels, but you could simply edge them with a darker color for greater contrast.

Decorator Required

Is this Xanadu? Maybe all that white paintwork will prove a problem. Didn't Madonna live here once?

Gardener Required

How to keep all those cars off the lawn? Disagreements might follow...

Lighthouse Keeper Required

Round rugs in the baronial tower? This could be journey's end. I see no ships!

Here are some more images that you can add to your map, whether it's destined for print, email, CD, or the web. Welcome to the extraordinary world of clip-art. Again, you can use these to embellish a printed page or a simple emailed document (perhaps saved as a PDF or as a web page), or you could use them to hide links to other, related web pages in an interactive project. Clip-art has a long history going back to the colorful fragments that children used to paste into scrapbooks a century ago. Then the clippings came free with soap or chocolate bars, now they come in their millions on CDs and on the Internet. The best CD collections prove to be very useful resources for those of us who can't draw; the worst make excellent coasters. There's no reason in any case for you to rely on the commercial product. You have the tools to make your own, far more interesting and personal collection. Flick through your old print albums looking for standout figures, pictures with signboards and posts, perhaps. All these, and many like them, can, with a little scanning, invention and trickery, be made into a useful treasury of instant humour to jazz up your project.

In this particular project, what's needed is direction, in every sense of the word. Pointers, arrows, and signposts for a start. Follow on with street signs (and don't neglect your friendly local speed cameras!) Once you've planted pictures on your map, they need to be tied to their locations with arrows or lines. Here we've drawn circles around the key spots, but the choice is yours. In an image-editing program it's easy to select a circular area, maybe soften the edges of the selection, and change the color to contrast with the background. You could even leave the small circular selections in color, and everything else in black and white.

SEASCALE

USING CLIP-ART
Once you have one bit of art, you can easily multiply it. One clip-art door key (or why not scan your own?) can soon become a whole drawer of "hardware." Use them as decorative borders or backgrounds, along with squadrons of arrows. And don't forget the old favourites—the endlessly cheerful salesman and the impossibly elegant pointing hand.

Wordsworth Drive

Green Street

Fourth Avenue

SCHOOL

N

MALL

Egremont Street

GOLF COURSE

PICTURE RESOLUTION

When you start adding pictures, don't forget about resolution (see page 14). For a web page, what you see is what the audience will get, so if you've resized your pics to the area you want and they look fine, they *are* fine. But if you're planning to print your work—as an invitation to that long-promised housewarming party, for example— your images will need to be at about 300dpi. The same applies to the map itself: you must set up your blank canvas at 300dpi at the size you plan to print it, and if it's A4, that means a pretty big file. Alternatively, create it using a drawing or desktop publishing program—their "vector" graphics can be scaled to any size.

It's easy to develop your opening page into a linked series. Using Word, you can follow the *Web Page Wizard* (accessed via *File>New>General Templates>Web Pages*) or strike out on your own with *View* set to *Web Layout*. To get started, put a page together with some sample text, a couple of pictures (just hit *Insert>Picture>From File* to use some of your own) and maybe a colored background. Save this page as "Index," and be sure to save it in *Web Page* format, giving it the ".htm" suffix. Save it again as "Page 1." You can now change the elements on this second page while preserving the style of the first, and begin to create links between them.

For example, type "Next page" at the foot of your "Index" page, highlight those words, and choose *Hyperlink* from the *Insert* menu. You'll see a dialog box that prompts you to locate "Index" in your folder. Select the correct file, then view the results with *Web Page Preview* on the *File* menu. Repeat the operation for "Page 1," inserting something like "Back to first page" as the text. Now you can rock back and forth between the two. If you have a dedicated web design program, the procedure is similar—see the software's instruction booklet for specific details. You can turn graphics into hyperlinks as well, or draw "buttons" in an image-editing program and add links and rollovers to those. You can use the *Table* function to organize your words, pictures, and graphics into manageable groups.

Now we're on the finishing straight. Experiment in your image editor to get an idea of what might work as a background. You might choose to stick with one dominant color, or to assemble a set of contrasting or matching colors. Select a typeface (font) that looks elegant and legible. If you're stuck for choice, try *www.1001freefonts.com* for free ones, *www.myfonts.com* for cheap ones, or *www.fonts.com* for professional ones.

The Grigson fa

SEASCALE, HERE WE COME!

So much more arresting than the usual moving card—more personal, colorful, versatile, informative, and in every way more fun. Why doesn't everyone do this? Vivid graphics, maps that seem to pop out of the screen, zooming changes of scale, buttons to push, all topped off with an enticing invitation to your new home. Great stuff, and easy to do.

BE KIND TO MODEMS

Way back in this book we spoke about download speeds and file sizes. Now is when all those figures start to mean something! Your image-editing or web-design program will help you get it right. Let's review the basics. More colors or large images means bigger files. Bigger files take longer to download and display. Longer download and display times make for grouchy audiences. The two weapons at your disposal are GIF and JPEG: the first is good at squashing down images with reasonably large areas of flat color, the second works best on photographs (or similar images). PNG is another format for web graphics, but isn't so universally recognized. TIFF is the best format for print, since images can be compressed—though not as much as with JPEG—without losing quality.

How do I burn a CD?
See page 206

y are moving...

Arrows of Outrageous Fortune?
All the madness of moving house, symbolized by a swarm of arrows. Try setting up a link on the solitary one to take your visitor to the next page.

Home has Moved Away
The key is in the door, the drinks are on ice, and all's well in Wordsworth Drive.

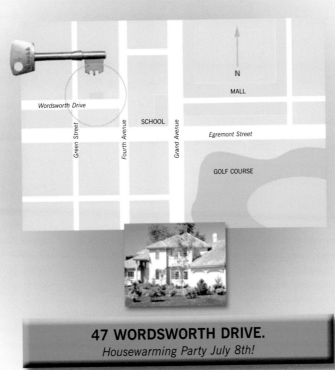

Wordsworth Drive
Green Street
Fourth Avenue
Grand Avenue
SCHOOL
Egremont Street
MALL
N
GOLF COURSE

47 WORDSWORTH DRIVE.
Housewarming Party July 8th!

Small Office, Home Office...

MBP Accountants Online

Now let's explore the possibilities of using your newly acquired skills in the context of a small or home-based business. Most big businesses use sophisticated presentation software and equipment. But if you're thinking of setting up your own business at home, or already have one and want to use your computer to reach out to a wider client base, your digital scrapbooking skills could be used to enhance presentations and win yourself new business. We've used the example of an independent accountant: the type of business that can be run from home, but still have customers that demand professionalism. Of course, the principles can be applied to whatever plans you have in mind!

You may already be aware of the PowerPoint presentation software that comes with Microsoft Office, or Apple's Keynote. These programs start from the premise of creating slideshows, although the results are now more usually displayed as a sequence of images on a computer monitor. PowerPoint offers beginners a helping hand with its crew of *Assistants*, or *Wizards*. For example, there's the *AutoContent Wizard*, a template slideshow that you can amend with your own words and images. It's easy, and with a bit of perseverance it's also fun.

ESTABLISHING A STYLE

Here we've imagined an accountancy company with an existing "corporate identity" (the brand and the logo that people come to associate with a company). If you don't already have a logo like your corporate peers, why not design one using your graphics program? A "vector" drawing or desktop publishing program is ideal, as your logo will scale to any size, but an image editor will give you more scope for cool effects, as long as you work at a high resolution. The color and type should set the style for all your publicity material, websites and presentations. It needn't be too serious—try something bright and cheerful.

Which Style is Right for You?

Assemble a few ideas and play around with them to see what works.
If you're stuck for illustrative material, you'll find there are numerous
searchable archives of images you can buy, or sometimes use for free.

If you don't have PowerPoint, you can create slideshows using many of the latest image-editing and organizing programs, including Photoshop Elements and Apple iPhoto—and they can look equally professional. Just watch out for the amount of control you'll have over playback. For example, your slideshow may be saved as a movie file. That's fine if you want your audience to watch passively as it plays through, but when you're presenting "live" you'll want to be able to move between slides as and when you choose. It's best to make a self-playing presentation file that runs under its own steam and lets you click to move it along.

You can approach this type of project in the same way as-you-plan your family album. Ask yourself: who is the intended audience? Is this a-presentation to establish your credentials, or has it got a specific message? Sketch out the main points on paper and push them around until you see a structure emerging. Does the presentation need to be simple and colorful, or sophisticated and modern? We've done both.

Following the basic slideshow format, you can build in the capability to move forward or back, or skip, but the presentation will essentially be linear. If your software supports interactivity, different possibilities arise. You could offer two pathways through the show: one giving a flavour of the business, the other detailing your proposals or business plan. This will give viewers a richer experience, but it's up to-you to make sure they don't get lost! *Forward/Back/ Home* commands are standard, and even better is a navigation system that

MBP Accoun

Your business—
safe in our hand

- ◯ Flexible
- ◯ Responsive
- ◯ Experienced
- ◯ Trustworthy

Images and Words

Balance words and images for maximum effect. Less than 20 words suffice for this opener, combined with a striking and inviting graphic. Strong colors and uniform type treatment hold the whole screen together.

Leave Nothing Out

Setting up the office shot is vital. The message is: we have the technology and a relaxed working environment. Ergo, we can do good work for you—and will be pleased to hear from you. But couldn't we do something more imaginative with images like this? See page 190!

WHERE'S THE ARTWORK?

Why not scan your existing business documents and use the image as a background for each slide, or turn any flat, scannable object you can find around your desk into a-graphic you can reuse on every slide? Alternatively, why not do what we've done here and take some photos of your home office? For those all-important facts and figures, you can easily make graphs and charts in PowerPoint, or you can import them-from Excel or another spreadsheet program. If you've got Microsoft's Office suite (or an alternative) installed, all the software you need is right there on your machine already! If you want to put something together really quickly, PowerPoint comes with its own clip-art library containing thousands of items, which you can even search: just tap in "success," for example, and your reward is images of trophies, rosettes, and leaping figures. And it's not just images—there are movie clips and sound files as well. You can find plenty more clip-art online, but the best quality at reasonable prices comes with CD- or DVD-based collections such as Hemera BizArt (*www.hemera.com*).

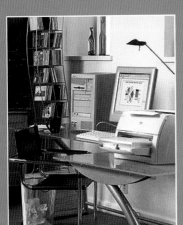

ants Online

Show the Detail

It's not all technology. There are still people here with conventional diaries and a serious attitude. Our studious man at work here is actually "teleworking" from his local restaurant. Does he *never* stop work? Find out what more you can do with images like this on page 190!

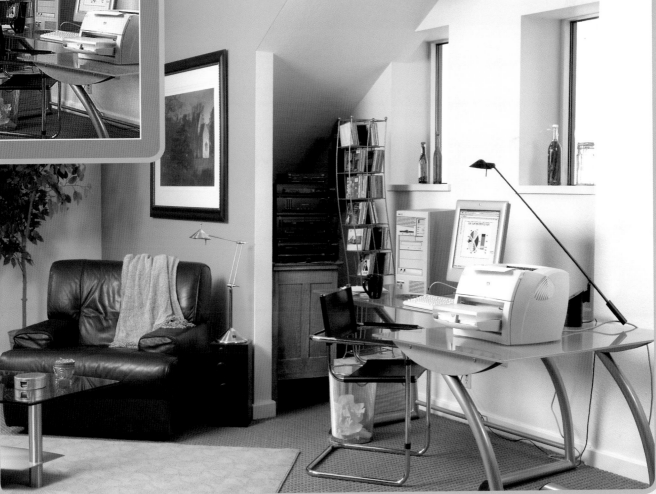

Image courtesy of Hewlett-Packard

appears on each screen—rather like a website. In fact, an increasingly popular way to create presentations is to make a website and store it on the computer you're presenting with, or deliver it on a CD-R. With a few extra clicks you can put it online too.

Now it's time to start our introductory sequence. Our first, bold and colorful version uses an "open door" clip-art graphic. In PowerPoint, draw a picture box, then go to *Insert>Picture>Clip* and find this image in the collection supplied. Of course, you'll also want to use your own images, and you can import these using *Insert>Picture>From File*.

Our graphic gives way to the draft company logo in the second slide. The animated "transition" between the slides is programmed in the *SlideShow* menu, which offers dozens of different transition styles, as well as a *Random* setting to cycle through them all. The simplest choices are a straight "cut" or a dissolve, but, whichever you choose, resist the temptation to use more than two or three styles in one presentation.

The screen shown *right* is genuinely a "work in progress." We're trying out several versions of the company name and logo to see which works best

OUR WORK IN PROGRESS: CREATING THE LOGO
Effects like bevelling, embossing and soft shadows, now standard in graphics programs, can help turn an ordinary piece of type into a logo. Don't forget the importance of hierarchy: make the most important element the biggest, so it catches the eye first, then fit the rest in smaller type to underline it. You may not need to use an image or pictogram if you can make the type strong enough.

ccountants Online
ccountants Online

- Flexible
- Responsive
- Experienced
- Trustworthy

nds

e door

security

MBP
ACCOUNTANTS

(remember a logo often works better as a label than as a title). You can design everything within your presentation software or create graphics in your image-editing program, then import it. The flexibility of programs like this is there to be exploited, especially when it comes to the color and style of text and backgrounds. Embossing and shadows are easily produced in PowerPoint's *Font* menu, while other graphics software can be used for more complex effects. Always have the viewer's eyesight—and the limited resolution of the screen—in mind: avoid typefaces with fine strokes, and fancy script styles, and take care with color combinations. Colors on the monitor can be as vibrant as you like, but the effect over several screens could frazzle sensitive eyeballs.

Next, for our first presentation, we've added some pictures of our (unusually tidy) office. Got the digital camera ready? Take your shots and import them into PowerPoint as before. Designing your slides gets all the trickier with photos to fit in, so try a fairly regular layout with one picture per screen and perhaps your logo staying in the same place. Charts and graphs, which you can create in any spreadsheet, will help to present complex information and add to the gravitas of the presentation, as long as you keep them simple and legible. Once all your elements are decided on, you can play around and get the slides looking right.

This is a good time to consider that you needn't build your presentation from the ground up using PowerPoint or Keynote. Have a look at our second presentation on pages 190 and 191. You could use any word processing or image-editing program to produce these images. Import them into your presentation or slideshow program, and just use it as a "slide projector" to string together your ready-made screens.

Let's try this process in Photoshop Elements. The sequence of operations could go as follows: make a new document 512 pixels wide by 342 pixels high

MBP Accountant

Your business— safe in our hands

- Flexible
- Responsive
- Experienced
- Trustworthy

GETTING DOWN TO BUSINESS

Having imported some more images and thought out the structure of your presentation, you can start to create a progression of slides. Elements such as the "bullet points" above can be made to appear successively, fading in or flipping on like a light. To make sure your audience follows what's going on, you could highlight them successively in the opening slide of each section of your show. By copying each slide from the last, or using a master slide, you can keep everything consistent, so that items transition naturally from one slide to the next rather than jumping around confusingly.

How do I add music and video to a slideshow?
See page 210

LIES, DAMNED LIES. . . AND STATISTICS

Check out a few companies' graphs and charts. It's surprising how many of them don't show a full scale rising from zero on the upward axis. Although the cause might be space-saving, focusing on a narrow band of figures usually has the effect of accentuating small, upward fluctuations (in other words, it makes a small amount of growth look huge). If the statistics are not so good, a lot of companies create graphs that show them as small blips in a longer timeframe.

The Bottom Line

You can generate charts in the graphing module of PowerPoint, or create them using a separate program such as Excel and import them as images. Keep the color palette consistent with your presentation.

CROPS, DETAILS, EFFECTS: OUR SECOND PRESENTATION

We think you'll agree this is much more like it: it's much simpler, much snappier, a touch more sophisticated—and far easier to do! Simply take a few pictures from interesting angles, or use your eagle eye to select the most interesting details to home in on and crop. We've used our man at work shot, then applied a *Posterize* effect to it. While you can do this in Photoshop Elements (*Image>Adjust>Posterize*), for example, we achieved this effect in a page layout program by changing the contrast (including the contrast between the colors). This creates an image we can use as a background. We've then added some other cropped pictures, and added some text on top. Simplicity itself!

(an ideal slide format, as it'll display on any system); produce your artwork and type as required; save the results as a series of TIFF files; and import these into PowerPoint, Elements' own Create Slide Show feature, or your preferred alternative. Photoshop Elements' "layers" let you move and scale graphical elements independently, and you can use the *File, Duplicate* command to make a copy of your first slide, complete with layers, as a separate file to start your second. The same approach can be used with any software capable of producing image files—Paint Shop Pro, CorelDRAW, DrawPlus, or even a desktop publishing program.

Whichever style you decide on, the results can be incorporated into a website, sent out by email, burned onto CD, or printed out on paper, overhead projector transparencies—or even slides! Alternatively, turn the whole idea on its head, give your presentation software a day off from the office, and use it to make a slideshow of your latest family snaps.

Opening the door
to financial security

RESIZING POWERPOINT
FOR REGULAR PRINT

Choose *Web Content* **in the PowerPoint** *Preferences*
dialog, and select *Picture*. **Choose one of the
two large monitor options, 1800 x 1440 pixels,
for example. This is also a good setting for video
projection. When you save the show, also save
a copy as JPEG files. You'll get a folder full of
individual files which your conventional printer can
reinterpret as smaller, but higher-resolution images.**

Wedding Bells:
Online or Video

Official Photographs
Official wedding photographs can be clichéd but, used with less formal shots, make an ideal basis for your production. This one was over-zealous with that filter!

If any event is guaranteed to get the photographer snapping and the video camera out of hibernation, it's a wedding. The unique combination of setting, color, and emotion make for powerful images. But isn't it unfortunate that all too often such a momentous event is left to languish in a rarely viewed album, or on an anonymous videotape? So why not make your wedding photography—whether still, video, or both—something to remember? Over the next few pages we'll look at raising your photography above the rest, and how you can share the fruits of your efforts on videotape, CD, and the Web. The starting point of the project is, of course, the event itself. If you've been asked to photograph a wedding, make sure you go well equipped. A digital camera and/or video camera are the basics, along with a good solid tripod and microphone. Never rely on the on-camera microphone for your important jobs.

A digital video camera is strongly recommended. Not only does it offer superb picture quality, it's the easiest to transfer to the computer. But don't worry if you've an analogue model—we'll see later that there are ways of importing video from this too. Make sure you take plenty of spares: batteries, tapes, and memory cards. And, although it doesn't deserve to be called a spare, a conventional SLR camera too.

Informal Photos
Capture the formalities, of course, but also try and catch the bride and groom looking at their most relaxed, or crop to charming details like this.

WEDDING—OR WARNING—BELLS?
One of the great things about digital video is that it's easy to review. You can perform simple edits on your PC almost immediately. And if you have a well-specified laptop or notebook computer, you could even provide a preview screening during the reception. Take your notebook computer and you could even set up a webcam for those relatives unable to attend! But don't forget the smaller details: remember those spare-batteries! Digital cameras and camcorders have a voracious appetite for power, rather like the best man. It's also a good idea to ensure that all batteries are fully charged, and to pack the relevant AC adaptors too—especially handy when filming at the reception.

Group Photographs

Producing a set of group photographs is more or less obligatory for the official photographer. Photos of large groups, such as the one shown here, are an ideal way of ensuring that as many guests as possible are included in your production, including those who might not make their way to the reception. But getting everyone to keep their eyes open is another matter, lady in the white hat!

Spontaneous Shots

More so than official photos, spontaneous shots often capture the true atmosphere of the day. Don't worry if such photos are not perfect (they rarely are), you can always improve them digitally, as we'll explore in this project.

The Dance Floor

Like spontaneous photos, video of people dancing (or socializing generally) often provides some of the best memories of the reception. Video footage of family members dancing self-consciously is particularly prized, of course.

When photographing a wedding, take a leaf from the book of the professional photographer and work to a checklist. This is easy enough to compile and should include all the principal stages of the event. This way you'll always ensure that you're at the right place at the right time, and that you haven't missed anything crucial. And, like the professional, you shouldn't skimp on the number of photos (or the amount of video footage) that you take. It's both easy and desirable to cut down the amount of material later, but it's impossible to recreate any parts that you missed. More digital data costs little or no extra, so there's no excuse.

If you're not allowed to video the service itself, use your video camera to record the sound. Few venues will have any objections to this. When you come to compile the movie, you can insert still images (which may have been taken before, during, or after the service) to provide the visuals. The audio track alone will be sufficient to trigger memories, while the stills will make up for the lack of "live" video. Prepare yourself for this by taking some "cutaway" shots—general views of the venue, floral displays, or even waiting guests—either as still or video footage that can be inserted into the "audio only" passages.

Cutaways are an excellent general-purpose resource. Not only can they be used to fill in sound-only passages, you can use them to link scenes, provide transitions, and even—when converted to still images—as titles on a web page. You could also do the reverse, and create material—such as backgrounds and title shots—from still images. Often only a little manipulation is required (such as recropping or removing backgrounds, as *opposite*, where we've picked out the bouquet).

WHAT TO DO ON A RECONNAISSANCE MISSION

If you have been commissioned to take photographs or video at a wedding (whether as the official photographer or not) it makes very good sense to visit the venue (or venues) in advance to determine the best places to take shots from. You should also take the opportunity to discuss your intentions with representatives of the venues. In some churches, for example, you may find that still photography is permitted during the service but video photography is not. In others, no photography whatsoever is allowed during the more solemn parts. Respect whatever rules are in force. If they seem to preclude recording important parts of the ceremony, don't worry; with a little skill and digital sleight of hand during the editing we can make good any omissions.

CATCHING THE BOUQUET

It's very useful to collect shots that can be used as titles on a website or video or to separate sections of your project into "chapters." When these have not been recorded during the event, it's easy to produce them from some of the other photographs you've collected. Here's a good case in point. The bride's bouquet, shown clearly in this group photo, makes an ideal detail to catch! The final image has a variety of uses: a "thank you" card, perhaps; a page in your scrapbook; or a web page background.

Transparent vs White

If you have Photoshop Elements version 3 or higher, you'll find that when you first click with the *Background Eraser* your "Background" layer changes to "Layer 0," and areas you erase become transparent (shown as a checkerboard). With older versions, it will erase to white. Before adding a new background, use the *Magic Wand* to select the white area, then press the Delete key to clear it, leaving it transparent.

Removing the Background

Begin by importing the image into your image-editing application and zoom in on the bouquet. As you only require this part of the photo, crop the image reasonably tightly around it. Removing the background is a task for the kinds of tools discussed on page 51, and once again the *Background Eraser* in Photoshop Elements is a particularly good option. The *Lasso* or *Magic Wand* tools could be used in other programs.

Adding a New Background

Once the original background is-transparent, you can add a new one, either by pasting in a different image or by creating a new layer and filling it. Drag the new layer to the bottom in the *Layers* palette. Here we've used the *Gradient* tool to blend between two colors. Notice how our chosen colors complement those of the bouquet.

When we look back at important events such as a wedding, we usually have a romanticized view. The weather was perfect (even if there was actually a howling gale), everyone was happy, and the setting was like a dream. But reviewing the photographs we are quickly reminded of the reality. Things were not entirely as we remembered! But with a little post-production work we can improve on that reality and put right many of the problems that are all too obvious in the photos.

The image-enhancement techniques we use in such circumstances fall into two broad camps. In one there are the corrective measures. These amount to manipulating those photographs that have minor faults, such as being a little dull (underexposed), bright (overexposed), or otherwise suffering faults affecting the whole image. In most cases, these can easily be corrected, often using quick-fix commands such as *Auto Enhance* or *Auto Correct*.

In the other are those photos that are substantially perfect, but are in some minor way compromised. The photo, *right*, is a good example. The photographer has successfully "caught the moment" and recorded the intimate and memorable moment of the couple's kiss. Sadly, at this precise moment another guest has strolled by. Although the photo is still great, it would be much better if this person was removed from the scene so that the couple were truly the centre of attention.

Fortunately we have the *Clone* (*Rubber Stamp* in Photoshop and Photoshop Elements) and *Healing Brush* tools, which enable the removal of the errant guest. Rather than removing superfluous detail by using tools like the background eraser, the *Clone* tool lets us cover up distractions by cloning—copying—other parts of the scene. It's a very powerful and versatile tool. You could also use it to clone material into the scene. For example, were one of the guests in a group photo to have blinked during the shot (and how often has this happened to you?) we could clone their open eyes from another shot into this image.

Some people find making overt changes such as these a little alarming. Wedding photographs are meant to be a record of the day's events and those events should be authentic. Most of us, though, want our wedding photographs to be as near perfect as possible. With your combined collections of official photographs, and those of guests, you have a wealth of material to choose from. And you could include a mix of "perfect" images (using image-editing techniques) and those that show a more authentic picture of the day's events.

Clone, Rubber Stamp, and Healing Tools
Clone tools are best described as painting tools. But, unlike other painting tools that use a solid color, they copy parts of the image, such as foliage here, and paint them to another.

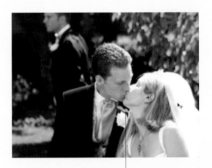

Random Cloning
It is important that you select different "clone from" points when covering a large subject such as this. This creates a natural and random result, and avoids making the fix look too obvious. Pay particular attention to the boundary between cloned and original material.

REMOVING A DISTRACTION!

Removing an unwanted element from a scene is an ideal use for the *Clone* tool. Here we'll use it to remove the guest who has innocently walked by at the precise moment that the photographer, concentrating on the bride and groom, took the photo. The photo itself is otherwise perfect and, even with the guest in shot, would make an excellent print. But notice how our corrected photo (bottom) is compositionally much more powerful.

The Finished Portrait

How did we make the unwanted interloper (*top left*) quit the scene (*above*)? It's all thanks to our image-editing software (*top right*). The professionals use these tricks too, you know.

Those ad hoc photos taken at the reception, whether by you or other guests, often need a little more remedial action to make them look good. This is not necessarily because guests have poor photographic skills (mixtures of alcohol and emotion can compromise those skills!), but rather because the situations in which these photographs have been taken are not conducive to good results. Guests will, in general, be using compact cameras (whether digital or conventional), and will be aiming to make their own, informal record of the day.

Fortunately, most cameras today are capable of very good results, even when used in fully automatic mode. Hence many of the exposure problems that plagued earlier generations are gone. With small, but surprisingly powerful, flash units, photography in the dimly lit conditions of the reception are a cinch. But wait: flash brings its own problems. If you watch professional photographers in such situations you'll see that they tend to use a reflector, or flash units that are either mounted away from the camera, or angled upward to the ceiling. These lighting techniques give softer, less shadowed lighting that is more flattering to the subject. They also avoid two problems common to on-camera flash units: redeye and hotspots.

Redeye is a result of using a flash unit that is very close to the camera lens, hence the glowing eyes. Hotspots have a similar root cause. This time the light from the flash unit reflects strongly from the centre of the scene (such as from a shiny wall in the background), producing lighting that is very uneven across the scene. Fortunately, both hotspots and redeye are easy to fix digitally.

The simplest way to remove this hotspot is to select the back wall and then replace it with a uniform color, based on the original. Use the *Lasso* to draw around the perimeter of the wall, with the selection boundary close to the subjects.

REDEYE

This photo shows where the power and direction of the flash has illuminated the blood vessels at the back of the subject's eyes. Many image-editing applications (such as Photoshop Elements, here) are equipped with redeye removal tools.

Select the *Redeye Removal* tool and use a brush size similar to that of the pupil.

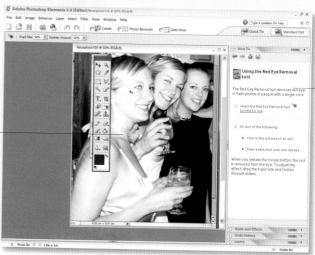

With only the wall selected, use the *Eyedropper* tool to sample the color of the wall away from the hotspot (over the bride's shoulder, for example). Use this color to paint over the selection. In the finished print there is no sign of the hotspot, yet the color remains authentic. A quick fix that won't be obvious.

COOLING DOWN THE-HOTSPOTS

The direct flash light has here reflected off the wall behind the-couple, resulting in a bright and-unsightly patch—a hotspot. Removing it will emphasize the subjects of the photo.

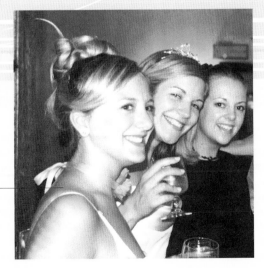

By brushing over the pupil with the *Redeye Removal* tool the red glow is replaced with a more authentic dark grey. Notice that only the red has been replaced; the small white highlight —the twinkle—in the eye remains.

wedding.htm

See the wedding photos here

Create Hyperlink

URL: http://www.johnandsarah.com/wedding/photos.htm

Bookmark:

Target: _self

Tooltip:

Access key:

☑ Open in new window Options...

Clear Link OK Cancel

Edit Edit & HTML HTML Preview

Once you've collected and, where appropriate, manipulated your images of the wedding, you can set about building a web page. As we've already explored, there are many proprietary applications designed for webpage—and website—building, but many image-editing applications also contain the tools for building simple gallery sites. Pages are usually based on a limited range of templates, but you may be able to customize them using basic tools similar to those found in desktop publishing applications. This way you can lay your pages out exactly as you wish them to appear on-screen. Once again, remember that any photographic images destined for web use need to be saved in JPEG format, compressed to make them as small as possible without losing too much quality. Have a look back at page 160 to remind yourself about the pros and cons of JPEG compression and the importance of previewing how your image will turn out.

Video-editing applications, including popular products such as Apple's iMovie, Windows Movie Maker and Roxio's VideoWave, provide the option of exporting very heavily compressed video footage to files small enough to be made available for download from a website. While the quality of such material is not great, a short clip can be ideal for enlivening your site. Ten or 15 seconds—perhaps of confetti being thrown at the church door—is perfect.

THE WEDDING WEB PAGE
Web-design software provides the tools to create web pages that are as simple or as complex as you wish. It's a good idea, particularly if there are a lot of photographs, to provide a front page that offers fast and direct access to a particular section. And don't place too many photos on a single page. Images, even when optimized for the web, will download slowly, and you don't want modem users to give up in despair while waiting!

Hints and Tips

Web Galleries

Photoshop Elements and other image-editing applications let you create web photo galleries with just a few clicks. Although these are basic (and provide little opportunity for customization), they're ideal for distributing pictures quickly. Such a site can be created in minutes and can give all those unable to attend an event the chance to enjoy the day with minimal delay. All you have to do is tell them the web address (URL) to go to. The more entrepreneurial can also use a web gallery to encourage guests to order reprints of their favourite photos!

Online movies

By applying heavy compression to selected footage, it's quite feasible to post short video clips to the web. Apple's QuickTime format, for example, supports every quality level from "quick and dirty" to Hollywood. The complete ceremony will be too demanding for most people's Internet connections, but highlights are easily downloaded and enjoyed—particularly if they include the funniest bits.

Instant website

You can share your photos without any software at all using an online photo printing service such as *www.ofoto.com* or *www.fotango.com*. Upload your photos and add them to your personal online gallery, then email the URL to everyone.

Links are the Thing

As we've mentioned before, it's links that make the web go around. In Namo WebEditor *opposite*, the link creation process is as simple as a click or two. Using the supplied templates *above*, you can set up all your pages' properties, including background and link colors and graphical styles, in one go.

Hold the Front Page!

Here's an ideal front page for a website. A simple, uncluttered design makes it obvious what links have been provided. By clicking on the appropriate icon, visitors to the website can open separate photo galleries—including the bride and groom, bridesmaids, and friends and family. On this site an additional button starts the (appropriately compressed) video.

Editing the movie footage is probably simpler than editing the still images—so don't panic! Assuming you've used a digital video camera, you need only hook up the camera to the computer using a FireWire cable (called iLink by Sony) and start the software.

Applications such as the Mac-based iMovie (*shown here*) have made video editing simple. The software takes control of your camera and will download your chosen footage from tape. Windows has the more basic but useful Movie Maker, and you can buy other low-cost editors such as Adobe Premiere Elements, Roxio VideoWave (*www.roxio.com*) and Ulead Video Studio (*www. ulead.com*). For the heavy hitters there's Adobe Premiere Pro for Windows and Apple's Final Cut on the Mac.

Once the clips have been captured, you can begin creating your own blockbuster. First, drag clips to the "timeline" in the order you'd like them to appear. At this stage you can delete unwanted footage and trim clips of superfluous material (don't worry—you're only deleting the copy on your computer, the original tape remains unaffected).

When you've got the sequence right you can begin adding transitions. Transitions define the way one scene blends into the next. Normally, one scene cuts straight to the next, but you can fade one into another, fade to black, or choose something more avant-garde!

You can also add titles—and even captions. For the titles you might want to overlay text onto a selected video clip (perhaps a scene-setting shot), or you can import the still images you made earlier as a background. Still images can also be imported and used alongside movie footage, either individually or as a slideshow (see page 182-191).

If you used an analogue video camera, you won't be able to import footage directly into the computer. You'll need an analogue-to-digital converter (such as Dazzle's Hollywood Bridge or Formac's Studio) to convert the video signal into a digital form. The digitized signal can then be imported—and split into clips—as above.

Step Aside, Mr Spielberg!

Simple "drag and drop" technology means digital video editing is now remarkably simple. Drag clips to the timeline in the preferred sequence, then add any effects or transitions required. Click on the *Play* button to watch your masterpiece unfold. iMovie, here, also permits two additional soundtracks to be mixed with the original video to provide background music, or perhaps narration. Once you've assembled your production you can copy the movie back to videotape, to CD, or to a file for the web.

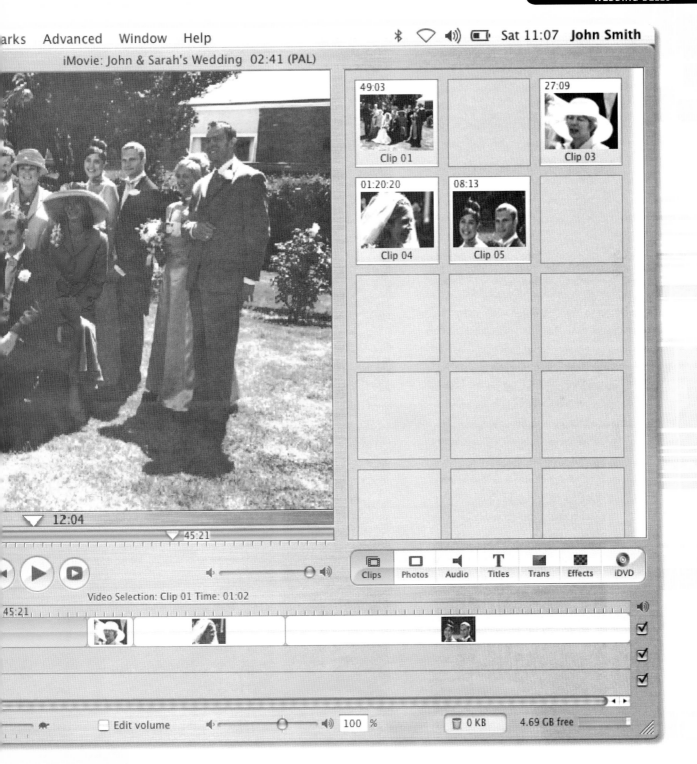

The beauty of using digital video is the quality. You can expect 500-line resolution, substantially more than offered by conventional VHS (around 240), and noticeably more than the so-called "hi-band" formats (S-VHS and Hi-8), which could only manage 400. And, unlike these formats, whose quality will drop further when edited, digital video loses virtually nothing in terms of quality even when intensively edited.

But there is a cost to this quality. When you download your video footage you'll notice your hard disk space is being consumed at a phenomenal rate. At full quality, one minute's video will require 230 megabytes of disk space. If you've an hour's worth of raw footage from your wedding, you'll need no less than 12 gigabytes of free space to accommodate it. That's not a problem with the 100-plus gigabyte hard drives that are now common, but you do need to watch the space.

Of course, you're unlikely to use all the footage you download. There will be duplicated material, inappropriate footage (taken, for example, when you forgot to press the *Pause* button), and superfluous shots. These can—indeed *must*—be discarded. Your aim in producing your movie is to tell the story of the day's events. If you can do that in 15 minutes rather than 45, so much the better.

There's nothing wrong with using a fairly basic video-editing program—people have made productions using iMovie that have been shown at major film festivals! If you feel the need for something more advanced, Mac users can choose the mid-priced Final Cut Express, while Pinnacle's Liquid Edition for Windows (*www.pinnaclesys.com*) is a little more affordable than the Pro versions of Final Cut or Premiere. Serious professionals will want one of these products plus a special effects package such as Adobe AfterEffects or Pinnacle Commotion.

However you choose to produce your movie, the next question is how to show it. By connecting from your computer to your DVD camera, then on to your VHS machine, you can simply record it onto tape—but it seems a shame to convert crisp digital to fuzzy analogue.

Apple Final Cut Pro

High-end video-editing programs such as Apple's Final Cut Pro allow multiple audio and video tracks to be mixed at will. The degree of control and the number of effects is substantially greater than with entry-level applications, and these packages are used every day by professional editors right up to feature film level.

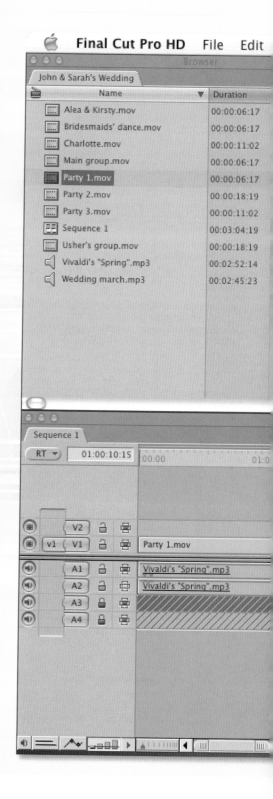

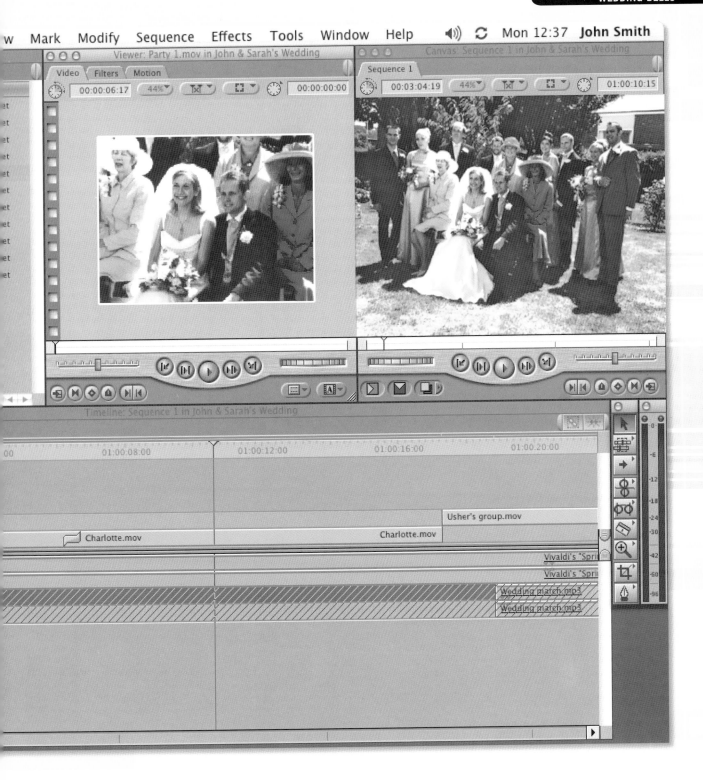

Using CDs as a distribution medium for your production is both viable and economic. A standard CD-R, "burnt" in your computer's CD recorder drive, can hold a large collection of images and compressed movie footage, which can then be viewed on any computer—although you won't be able to maintain the same quality as the original MiniDV. Using any CD burner program for Windows, you need only drag and drop your folders of images and video onto a window to include them on the CD. Mac users have CD-burning built into their operating system.

You can also use widely available software to record VideoCDs—a common option in slideshow programs. This is a CD-based format, which you can write using a CD recorder drive, but can be played in many DVD players as well as in computer CD-ROM drives. You can store up to one hour's worth of video on a single CD, and although the quality isn't great, it's about as good as VHS.

More and more PCs now come with DVD recorder drives, and if yours didn't, you can add one on for less money that you might think. This enables you to create true DVDs compatible with any DVD player. With appropriate authoring software, such as iDVD on the Mac or one of the various DVD creators for Windows, you can produce a DVD complete with chapters, animated menus, and a dynamic mix of audio, video, and still images! Your wedding DVD, for example, might contain the complete video in its original edited form (and quality) along with high-resolution photo albums and a host of additional material, such as guest lists and other ephemera, for users to view as they wish.

Creating your DVD
Applications like iDVD make DVD production easy. By using simple menu selections and dragging and dropping screen elements, you can make a DVD video that's every bit as impressive as a commercially mastered product.

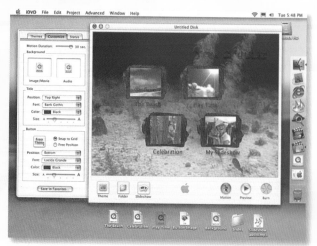

xio Toast Titanium

6.0.7

Audio Video Copy

2923 items – 327.9 MB

327.9 MB
22 K
15.7 MB
25.5 MB
66 K
93.9 MB
13.3 MB
140 K
118.7 MB
22.8 MB
26.4 MB

THE WEDDING CD

Transferring your wedding video and photo collection to CD is simple and makes a very economic way of distributing the production. Talk to the bride and groom—they may commission you to produce one for each member of the family and selected guests as a "thank you" to them. Use a still for the cover, too!

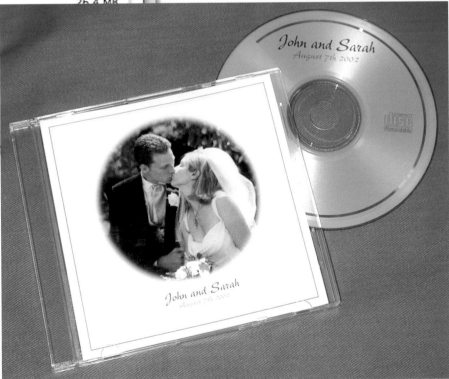

Burning the CD

Writing files—whether photos, movies, web pages, or text—to a CD is simple using applications such as Roxio's Toast (Mac). Drag selected files to the appropriate window, and press the button. After a few minutes your CD will have been recorded and verified (checked for errors).

Kidz @ Play
Multimedia

After the rather formal and rigid structure of a wedding,
a child's birthday party can come as something of a relief. There are no formal
photos to take and no shooting script to follow to the letter. But that's not
to say that you don't need to do a little forward planning. It's always a good
idea to know the what, where and when of events to make sure you don't
miss out on the fun. This is particularly important if you've been delegated as
photographer, and are not the master of ceremonies!

You'll also be in the fortunate position that most children enjoy being
photographed, and will be happy to pose for you—even if that means pulling
faces. But you'll also need your skills to cajole those who are more camera shy:
they (or at least their parents) will thank you for it afterwards.

It is the blowing out of the birthday candles that represents the high spot
of the day, and this is where you could have problems, should you be covering
the event with both still and video cameras. This could be the ideal time to
appoint an assistant, as trying to operate two cameras simultaneously (and
successfully) is impossible. Know your limitations!

Catch the Moment
Painted faces, a touching kiss. Photos that make
children's birthday parties so special.

CAUGHT IN THE ACT
A children's entertainer makes for great photography, both still and video. Totally
captivated by this balloon modeller, these children are at their most natural. Keeping
your distance helps preserve the natural expressions and avoids the audience
becoming self-conscious. Remember to vary your position when recording a video:
no matter how compelling the performance the video will become tedious if it is all
recorded as one continuous shot from one angle.

It's a Date

Add a simple title to the combined image and—most important—give the production a date! *Layer Effects* in Elements have been used here too, firstly to give the original image a glow (called an *Outer Glow* effect), and to give the text a *Bevel* appearance.

July 16th 2001

The Original Photo

The photo of the birthday boy blowing out the candle on the cake will make an-ideal centrepiece for our cover, or for your scrapbook. We'll use the *Elliptical Marquee* in Photoshop Elements to-select an oval vignette that we can paste onto a background of jelly beans!

MAKING A CD COVER

Memorable events call for memorable photos. You can use the photos you take on the day not only to create an album that can be stored on a CD, but to illustrate the CD box. Many image-editing applications include templates for CD covers that make getting the size right simple. You can also print labels for the CD itself—or some inkjets can even print directly onto the CD. Why not get the birthday boy or girl to draw the picture?

Whether you're using still or video cameras, don't forget that there's more to a birthday than just a party. You can photograph the child waking in the morning (usually very early!) and exploring for presents. And, at the end of the day, heading off to bed proud to be a year older, if not wiser. For moviemaking especially, these additional scenes help better tell the story of the day and really are appreciated in later years.

The idea of putting images onto CD is a good one. Despite the tendency to get scratched if mishandled or stored poorly, they have proved to be a very robust storage medium, and one that (despite the high price of pre-recorded CDs!) is very economical. They also have the advantage of being compatible with just about every contemporary computer, no matter what the flavour of operating system.

It is also a very simple matter to copy a large number of image files to a CD. This gives anyone who has a copy of the disk a chance to view, and even print the images. But a directory full of images is not the best of presentation styles. No, wouldn't it be better if we presented the album of images as a slideshow, and even set that slideshow to music?

As we mentioned in Project Five, you'll find that many image-editing and organizing applications will generate slideshows for you, while presentation programs like PowerPoint and Keynote provide even more possibilities for formatting and interactivity. Once you've created a slideshow, you can usually export a "standalone" copy that can be written to CD and will replay itself on someone else's computer without needing any other software. In some cases you may need to create separate versions for Mac and Windows users.

When you create the slideshow, you can determine how long each shot appears on screen (five seconds is typical), and introduce transitions, again as in Project Five, to make the change from one image to the next more interesting and less abrupt. You can choose from a wide variety of transitions, ranging from a gentle fade through to the wacky (and occasionally disturbing) mosaics and explosions. Like most way-out effects, extreme transitions are rarely appropriate, but once in a while they can be a fun way to grab attention.

Before burning your production onto CDs or posting it on a website, you can add some music. A good soundtrack can really "make" your show, and there's no doubt it will make it more enjoyable to watch. You can arrange the sound clips to line up with the on-screen action, and fade smoothly in and out between one piece of audio and the next.

Don't worry if your image editor doesn't offer slideshows. If Microsoft Office is on your PC, you have a copy of PowerPoint, which is more than capable of producing good-looking slideshows with music and even video clips. Alternatively, treat yourself to one of the many cheap slideshow programs for Windows. On the Mac, iPhoto has a slideshow builder.

Let's Put on the Show Right Here
Creating a slideshow involves selecting a sequence of photos, placing transitions between the individual images, and adding some background music. The creation process often involves dragging and dropping images into a chosen sequence, then dropping a transitional effect between. After you've added your choice of music, your show is ready for burning to CD, or posting on the web.

Gallery...
File...

Gallery...
File...

io Track...
nd

MUSIC TO YOUR EARS

The choice of musical soundtrack for your slideshow can be a big problem. Your first choice will probably be to use something appropriate, such as your child's favourites, or even a collection of party songs. The problem with most commercially produced music is that it is protected by copyright, and you shouldn't include it in your own productions without permission, although it'll rarely cause problems if the video is purely for family consumption. Similar restrictions apply to your own recordings of live performers, including the organist, choir or other musicians at a wedding—an extra video fee may be payable to cover this.

Fortunately, there are plenty of alternatives. You'll find that there are extensive collections of music available on CD that are variously described as "copyright free" or "royalty free," meaning that once you've bought the CD you're allowed to use the tracks in whatever way you like (definitely not true of ordinary music CDs!) There may still be some restrictions, so check the reproduction licence details before you buy. Otherwise, why not create your own background music—or better still, get your children to do it!

Bear Necessities: Record a Collection

Whether our passion is model trains, cars, antiquarian books, or, as here, rare or antique toys, we all seem to have an insatiable desire to collect things. And, if we're successful, our collections run the risk of growing out of control! Digital technology gives you a whole new way of displaying your collection— and, if it is valuable in monetary terms, also of tracking your assets and maintaining effective records. So, don't get lost in the woods!

The first step is an accurate photographic record. Isn't your collection photogenic? So wouldn't a photographic archive make an attractive addition to your collection? As we explored in the introduction to this book, the Internet gives you a unique and unparalleled opportunity to talk to other collectors, sharing your passions with like-minded individuals. With digital scrapbooking techniques, you can build a website, advertise your interest in acquiring new items, email pictures, or put together a CD—not to mention a traditional paper scrapbook.

This project will show you how to record the unique features of your pride and joy. An overall view makes a good opening page, but you'll need to record each item too, including its "pedigree," such as a maker's marque, hallmark, or—as in this collection—label, such as Steiff.

Bearing your All!

The simplest of photo records of a collection would involve nothing more than arranging them on the floor and taking a quick snap. But this hardly does justice to you, your passion, or your collection. Think of all the effort (and probably money) that has gone into building it and, by spending only a little more time, you can display your collection to better advantage. Show off the unique details of each item that makes it appealing, unique, or valuable. This will provide the source material for an interactive web page. See page 225 for our finished example!

THE IMPORTANCE OF PENCIL AND PAD

We all seem to hate spending time—or wasting time, as we sometimes see it—planning. Whether our project is straightforward or complex, many of us like plunging straight in at the deep end. It's the same when we buy a new camera or computer, but fail to take time out to read the instructions. Only later do we discover that, had we done so, we would have found our new tool to be easier to use and far more powerful than we'd realized. So, spend just a little time noting down what you want to get from the record of your collection, and you'll be amazed at how much more effective your results will be. And as your collection grows, you won't find that you've painted yourself into a corner, by not having given your record any room for expansion.

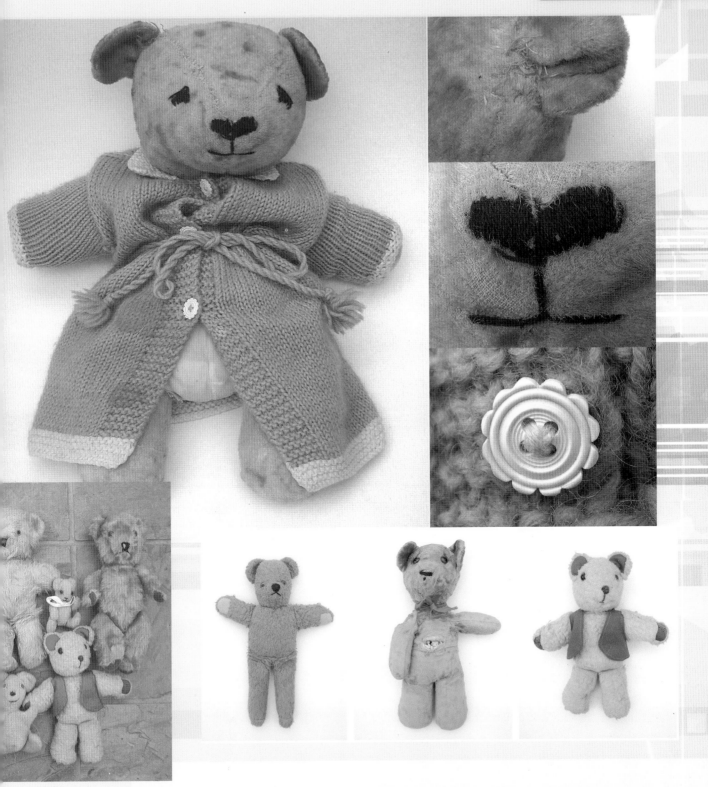

Photographs of your collection need to serve two purposes. The first is an effective pictorial record. These will be photos that can stand alone in an album, or be used to illustrate a website. These make an attractive bonus for you, and could be your "shop window," if you wish, for other collectors or experts. The second is to provide an accompaniment to the written records that describe and define your collection—you've got the passion, so we're sure you have reams of written material on it! There is no reason why you shouldn't take good-quality photos that serve both purposes.

For keeping an effective record of your collection, you need an effective framework. A spreadsheet, such as Microsoft Excel, is ideal. In Project Three we described how you can combine words and numbers in Excel with photos. The process for creating an illustrated catalogue is similar, but this time you need to adopt a consistent method of arranging and entering all your precious, hard-won data.

Arrange columns in the spreadsheet to list data relevant to your collection. For example, you might use basic column headings such as Item Name, Item Number (if you number your collection), Description, and Date Acquired. Other columns can be used to describe details that are appropriate to each item in the collection (such as details of distinguishing marks, notes about damage, color, or size).

For serious cataloguing tasks—and particularly where collections are extensive—there is a more powerful alternative to the spreadsheet: the database. Database software represents the next level up from the spreadsheet in the organizational process. Although not designed for many of the spreadsheets' calculation and numerical tasks, databases allow a much more flexible approach to data handling. You can produce custom layouts in much the same way as you might a handwritten record card, and as with those cards you can decide how much space is devoted to a particular part of the record (known as a field). So, for instance, you need only give a little space to enter a date but can define a large text panel for entering detailed descriptions. Databases really come into their own when you need to start searching. The rudimentary searching abilities of the spreadsheet are replaced with something altogether more powerful and comprehensive.

Not only can we search for specific words, but we can also search for groups of records that meet certain criteria. If, for our teddy bear collection, we wanted to find all those bears that are golden brown, were made between 1901 and 1919 in Germany, and are no more than 25cm tall, we need only issue the appropriate request!

Be a FileMaker Pro!

Not only do database catalogues work more flexibly than spreadsheets, but their screen layout can be adapted to fit the data required. Designing a database using the current crop of dedicated applications, such as FileMaker Pro (*pictured*), is not as quick as customizing a spreadsheet, but it's just as simple once you get the hang of database terms and techniques. It's just a pity the database is often left out of all but the Professional edition of office software suites. If you can get your hands on a database, you'll find its power comes from the comprehensive searching tools. Most databases are general-purpose, but some are specifically aimed at cataloguing image files, and by adding custom fields they can also be used to organize your collection, with images to the fore as the ideal at-a-glance reference. You've the bonus with these of being able to keep track of your collections of photos as well as physical objects.

Spreading the Load?

Image databases such as iView Media (*right*) and Extensis Portfolio are easily adapted to use as a catalogue of your collection, including details of each item. Various low-cost "photo album" programs, such as Paint Shop Pro Album, can also serve this purpose, as can the built-in Organize function of Photoshop Elements 3 and higher. Alternatively, you can use Microsoft Excel, or any other spreadsheet, to set up a basic inventory of your collection, with images and information.

Photographing objects in your collection is really a form of portrait photography. And if you've ever attempted to take proper portraits, you'll be aware what a problem it can be to light the subjects well. But photos of your *objets d'art* do require slightly different treatment. Rather than trying to produce a portrait that captures a person's "essence," your aim here is to accurately record the subject neutrally. And the shadows that can give substance and form to portraits need to be banished, so that every possible detail of your subject is visible.

For a big collection, you'll save a lot of time by investing in a specialist lighting arrangement. Studio kits comprising two (or more) light sources along with stands, reflectors, and diffusers (which can be used in any number of possible configurations) are widely available, reasonably inexpensive, and work equally well for a table-top setup as for a studio. In our case we want to make particular use of the diffusers. These spread the light from our source (generally flashguns) over a wide area so that the subject is not at the mercy of hard shadows. Place one of these either side of the subject, and you'll have virtually "flat" lighting, which is ideal for these purposes.

What about backgrounds? If you've invested in specialist equipment you may also have been provided with one—or more—background screens. With names like "Color Fantasy," "Forest Leaves," or "Desert Skies," you may be tempted to enliven your photos by using them. Please don't! Your bears will be forever lost in the woods. Although these are great for normal portraiture (and are the staple of many professional portrait studios), don't be tempted to apply such artistic flourishes. On a website in particular, they'll look cluttered and confusing. Stick to a plain, white background or, if you prefer, a soft, off-white. A plain background makes it much easier to view the subject, and will give you the flexibility to manipulate the shot digitally later.

The best way to achieve consistent lighting is to use a lighting "cove." A white-sided enclosure (normally made of translucent Perspex), this is designed to provide shadowless, even lighting. Commercial photographers who need to shoot products for advertising or promotion typically use these devices. And although commercial models command the prices that professional users expect, only simple carpentry skills are needed to build one yourself. By fitting a translucent top (or even leaving it open) and painting the whole interior white, you can achieve similar shadowless results for very little expenditure.

CHANGING THE BACKGROUND

You might not always want the same background for your photos. For example, you might want to color-code them on a website (using different colors for different decades or manufacturers). Here we've used the *Extract* tool that we mentioned on page 167. It's only available in the full version of Photoshop, but is excellent for cutting out teddy bears because it's adept at handling furry edges. More basic selection tools will always retain some of the background between the hairs!

LEAVE ROOM FOR EXPANSION

Even if there are, ultimately, a finite number of objects to collect in your chosen field, it pays to keep your options open and allow for more entries in the future. Whether you use a spreadsheet or database application, you'll be able to make additional entries easily (as new rows or columns in the case of a spreadsheet, or new records in a database). With this in mind, it's important that your catalogue can accommodate future expansion—make sure that your planning has made allowance!

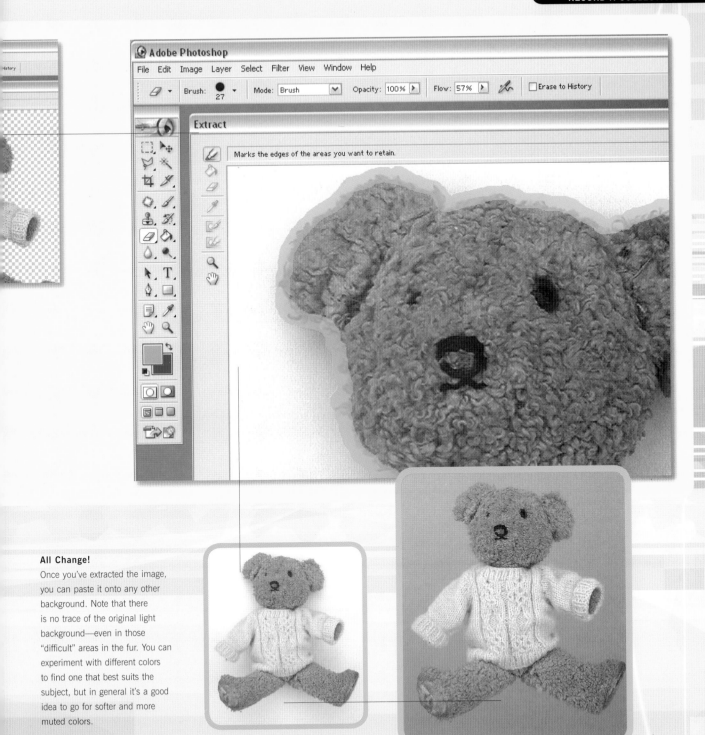

All Change!

Once you've extracted the image, you can paste it onto any other background. Note that there is no trace of the original light background—even in those "difficult" areas in the fur. You can experiment with different colors to find one that best suits the subject, but in general it's a good idea to go for softer and more muted colors.

Spending a little time in preparation shouldn't just apply to planning the project as a whole. Time spent preparing to take the photos themselves can pay real dividends too. An extensive collection is going to take time to photograph, and at times you will feel you're on something of a production line. And with large numbers of photos coming from your conveyor belt, you'll want to keep any postproduction image manipulation to a minimum.

But inevitably there will be a few little jobs that need attending to after you've finished photographing everything. They might include small changes to contrast and brightness levels (our "flat" lighting style is never 100% right for all subjects), and removing unwanted artefacts (like the fingers used for support in the illustrations opposite).

You could annotate your photos once you've pasted them into your spreadsheet or database, but you might also want to include captions on each image to give a unique reference or description. The filename of the photo is usually sufficient to describe the photo uniquely (matched with the corresponding record), but many people prefer the additional level of insurance that an on-screen identifier can provide. Adding text in your image editing application, perhaps in combination with lines and arrows to highlight one or more features of the object, is particularly useful if you intend to share the photos with others. Adding text is easy, but you should ensure that the text size is sufficient to be read, yet not so large that it intrudes on the image. It should also be of a neutral color that makes it easily read. "Sans serif" fonts (those like Arial and Verdana that have "clean" edges) are easier to read on-screen and are preferable to "serif" fonts (like Times and New Century Schoolbook), whose tails and flourishes often make them harder to read on a computer monitor.

SHADOWS ARE YOUR ENEMIES!

It's crucial to avoid deep shadows when taking photos of your collection, and the same applies if you're going to use these shots in a simple animation—even more on this shortly! But for a simple "movie" of one of your collection, flat lighting is no longer sufficient; you'll need to move your diffused light sources further to the sides and introduce another to the front, in-line with the camera. Viewed in isolation, the results you'll get from this form of lighting look a little absurd; it is shadows, after all, that help create the illusion of three-dimensionality in the subject. But don't worry: when compiled into a sequence, the shots will look fine! See page 223.

CHECK BEFORE TAKING THE PICTURES

How many times have you taken a photo, only to find when you examine the results that you've committed some howling gaffe? That tree apparently growing out of someone's head, or that missing limb, are just two examples of defects that could so easily have been recognized when composing or arranging the shot. When you're photographing your collection it pays to be equally vigilant. Don't just check in the viewfinder once; check again. And if you are using a digital camera, review your shots periodically so that you can correct any deficient images quickly. You will be able to fix many problems digitally later, but why bother when you can get things right in the first place?

REMOVING UNWANTED DETAILS

Sometimes you've no alternative. To display your objects to best effect you might need to use an improvised stand, or even, as here, a steadying hand. Removing the evidence is simple—if you've taken our advice and used a plain white background! Here we've used a *Clone* (or *Stamp*) tool in our image editor to copy color from the background over the hand. Getting a good clean edge is easier if you use a selection tool to define the clone area.

There was no alternative to a steadying hand here, but...

...a little work with the *Clone* tool gives teddy all the support he needs!

PHOTOGRAPHIC HINTS AND TIPS

THE LONGER VIEW

What is the best lens—or the best focal length—to use when photographing your collection? Many cameras feature a modest, wide-angle lens as standard, which is ideal for capturing wide, sweeping landscapes or group photos in a confined space. Unfortunately, these are not ideal for photographing objects in your collection. Wide-angle lenses tend to exaggerate perspective. Faces, in particular, look unusually round when taken in close up, and although it might not be immediately obvious, the same problem will affect the photos in your collection. It's better to use a basic telephoto lens. If you are using a 35mm camera, look for focal lengths between 80mm and 125mm. On digital cameras (or compact cameras) with zoom lenses you'll need to set an intermediate focal length around two thirds of the way from the wide-angle setting (the precise focal length is not critical).

GET IN CLOSE

Most digital cameras feature a useful *Macro* setting that lets you get in really close to your subject. Switching to macro lets you fill the frame with a tiny detail, and if your collection already features small items (perhaps jewellery, or even stamps) you could find that the *Macro* setting is more or less essential for filling the frame with each object.

A SENSE OF SCALE

The downside of photographing each object in isolation is that you lose the sense of scale, and it's impossible to tell how large any item is. Consider placing something in the scene that restores the sense of scale. It could be a clearly visible ruler or, for smaller subjects, a coin. If you collect vintage cars, steam engines, or boats, you can assume their scale will be fairly obvious—unless you have a giant ruler handy!

The trouble with the photos we take for record purposes is that they are—to be frank—a little dull. Of course this, as we explained, is born of necessity. But collections are there to be enjoyed, so why not make the best of them? OK, so we've already shown how a photograph of our collected teddies has almost no photographic merit, but you can create some very effective alternatives.

One way is to create "virtual shelves." Once you've taken all your "catalogue" photographs, you can line up all those standard, face-on views and blend them together seamlessly into a wide, panorama-style shot without any editing. And hope no-one sees the join! The consistent lighting and plain background should make this simple to construct. But an even easier way to compile selected images into a panorama is to use panoramic software—which would be particularly effective if you collect cars, for example, and line them up outside. But let's stick with our teddy bears. There are various economically priced packages for merging several images into a seamless panorama, such as Photovista Panorama (*www.iseemedia.com*) (available for Windows and Mac), and many image-editing programs, including Photoshop Elements, have the feature built in.

Panorama software can automatically identify common features in adjacent photos and blend them together. As our bear photos have no common elements (except for the white space), the feature will be unable to interpret these photos automatically, but it may work for your collection. In our case, we adjusted the subjects' relative positions manually. But with little effort, here's the result, *below*!

The Usual Suspects
Below Despite comprising eight individual photos, the resulting "panorama" suggests that all eight were in the same line-up. So which one do you think hit Goldilocks?

STITCHING IN TIME

Panoramic software may be easy to use, but there are some complex calculations going on behind the scenes. For best results, you'll need to identify the focal length of the lens used to take the photos (perspective corrections differ with focal length) and provide a significant (around 30%) overlap between adjacent scenes. This gives the software something to lock onto when linking images. Joining the images—called stitching—is an automatic process, but most programs allow some manual intervention. This can be critical in cases where the software is unable to identify common points, or is confused by repeating patterns or similar features. If your panorama is wide enough, you can even produce a 360-degree view. When viewed on-screen you can circle continuously through your collection—and so can your website visitors if you post it online!

Whether strictly for recording purposes or more artistic interpretations, our object photographs only provide single viewpoints. You could include additional shots that show what lies around the back, but wouldn't it be great if you could display an object from any angle? Well, you can!

You can do this using virtual reality technology. This isn't the virtual reality that involves wearing special gloves and headsets, but thankfully (unless you like dressing up) a practical desktop variation.

This technology, made popular by Apple through its QuickTime VR software, allows the viewing of two types of virtual reality environments ("movies")—panoramas and objects. Both comprise still images. Panoramas are similar to the one we created on the previous page, except that when viewed through an appropriate player, the viewer can choose to move around the scene and even zoom in or out on certain elements. It puts you in the picture, at the centre of the action!

Object virtual reality movies place an object at the centre and, as if it were on a turntable, lets you rotate it to view from all angles. When you view a virtual reality object, the mouse pointer becomes a grab hand. Click with your mouse button and you can use this to drag the object around (nominally round a vertical axis, although triple axis all-direction rotations are possible too).

Creating an object movie involves photographing the object and then moving it around by a few degrees and taking another. You repeat until the full 360 degrees have been covered. The more photographs you take, the smoother the movements will be when the movie is played. At ten-degree increments the movie will be very jerky, while using two degrees will give a very smooth result (albeit with a large file size!).

Producing successful virtual reality is a complex process, but there are easier (and often equally effective) alternatives that you can attempt, such as the movie animation we describe, *right*.

DON'T FORGET THE CD!

Burning the photos and records of your collection to a CD serves two useful purposes. First, it ensures that you have a backup of all your important work, and lets you free up valuable hard disk space. Second, it provides a historical reference of your collection. As your collection grows, you'll be able to look back and check the changes, monitoring all those items you've added and, perhaps, recalling those long-departed ones that you sold or gave away!

Round and Round

For a genuine VR movie, you'll need to photograph each object from every angle. Placing it on a turntable can help here (IKEA sells them cheaply!). Flat, shadowless lighting is essential to prevent strange artefacts, known as "banding transients," spoiling the movie's quality.

MOVIES IN THE ROUND

Creating "real" virtual reality movies is not that simple, and it can also be a laborious process. You can, however, achieve a very similar result by building an animation manually based on a sequence of photos. By using each consecutive photo as a frame of the animation and getting the resulting movie to loop continuously, you'll get an impressive effect. You could use an animation generator for this, such as Animation Shop, supplied with Paint Shop Pro, or Ulead GIF Animator, one of many packages that specializes in the GIF animation format. Alternatively, use a movie-editing application. Import each still image in turn, and set each to display for a short time (0.1 or 0.2 seconds).

When you've finished recording your collection, you might be surprised at how valuable a resource you've created. Even if your collection is of obscure items of minor monetary value, you'll discover there are many other collectors out there. Be a collector of things of more bankable value, and you may find there are many more people interested in sharing your data.

The easiest way to share information is to create a web page. And as you've already created the photos to illustrate it and gathered the technical details, it will just be a matter of putting these together on the page.

It's important that the web page is constructed in a way that makes it easy (and obvious) for any visitor to navigate. Many a potentially useful site has been compromised by poor navigational tools, which make it impossible for visitors to get from one point to another intuitively. Website visitors have expectations based on other sites that they've visited, and they'll have scant patience for anything that isn't as slick!

Don't forget your website could contain not only the images you've created, but any research documentation you've found and links to other relevant websites. And if you've been bold enough to create a virtual reality movie or animation, why not include those too? Or links to your database? You could even consider including some video clips if the items in your collection are in any way "animated." Even items such as "transforming" toys will benefit from the movie treatment, showing how they operate or change. It's easy: just set your video camera on a tripod and record the action!

DAY OF RECKONING

Your records could well have an unexpected use should something unfortunate happen to your collection. If you're unlucky enough to be robbed, suffer a fire, or some other material loss, then proving your loss to insurers and their adjusters could be a huge problem. How do you demonstrate the scope and nature of your collection, when there's no hard evidence of its existence? Your database and the photos in it could come to your assistance. Although they won't prove beyond doubt the details of your collection, they'll go a long way to help you make good. In fact, this is a good reason why you should make an inventory of your whole house. Obviously, it's not feasible to list every possession, but you can record much of the content in comparatively few photos.

1949-1959

Details ◯

1920-29 *1930-39* *1940-48* *1960-66*

Growing a family tree

Whether you're looking into your roots, seeking out an illustrious ancestor, or just plain curious, genealogy has never been more popular. And of all its aspects, the creation of a family tree has never been so easy. The Internet has given us the opportunity to email friends and family—or even see them, via webcam—as often as we wish. And this same technology has made it easy to trace family members, both past and present. So great is the range of information now available to us that you can go well beyond the traditional family tree and construct elaborate histories, complete with photos, videos, and documented details of work and home life. And with your newly honed digital scrapbook skills, you can bring your ancestors back to life! Although the web has provided a great many resources for the family history researcher, by no means all your material will arrive in this way. Most will come from current family members. Just think of the number of photo albums, many dating back decades, that are in the family. These are the ideal basis for your next project!

DON'T FORGET OLD HOME MOVIES!

Old collections of home movies are an ideal resource for discovering more about your—and your ancestors'—past. They will be full of family gatherings, social events, and travel footage that can give you valuable insights into your roots. And think of the resource you can leave your descendants! Why not hold a movie night and invite family members along? You can use the event to help identify your own movie's stars and give further substance to your family tree project. It's also a good idea to transfer old movies to digital video stored on CD, DVD or MiniDV tape. Give posterity a chance!

Check those Shoeboxes!

Those forgotten or archived boxes of old documents—collected in old shoeboxes, perhaps, or gathered from a house clearance—are a great source of information. Birth certificates and letters are an obvious source of important information, but other saved documents can give intriguing insights into the way your forebears lived. Something as humble as a bank statement could be a goldmine (literally, we hope!). You'll see how much your distant relatives were paid and how they used their money—even who they traded with. And wartime documents might give an insight into their lives through their darkest days. Receipts can provide useful provenance on family heirlooms—some of which may be in your possession today.

Picture Collections

Picture collections could be the backbone of your family tree project. Not only do they provide a glimpse of long-departed relatives, they're useful documents that show the way your predecessors lived—and dressed. Get the hair!

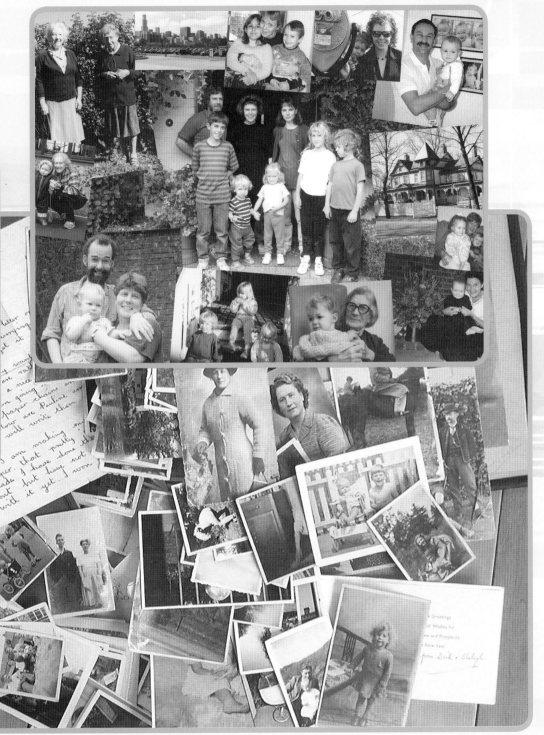

For many researching their family history, the excitement comes from the detective work. It will involve not only a search through family archives (which, in general, tend to extend to only a few generations), but local governmental agencies and church records (which tend to hold much of the historical data in many Christian traditions).

Gathering information from the Internet can be a problem—it isn't yet a cure-all for information ills. If you perform a simple surname search using one of the more comprehensive search engines (such as Google, AltaVista or Lycos), you're likely to get thousands of "hits," even for less common surnames—most of which will be irrelevant.

So, as we covered in the introduction to this book, you'll need to be more focused. If you know your family has some roots in a particular location, search using both your surname and that location as keywords. You can also use one of the excellent genealogy "portal" sites, which link to sometimes hundreds of other resources. These links and access points to further sites enable you to conduct a very precise and detailed investigation. Cyndi's List (*far right*) is a good example.

It also pays to be proactive. Set up your own website and invite others, perhaps distant relations who you may have discovered are investigating their own ancestry, to contribute. By including "metatags" containing relevant words—perhaps surname, ancestors' names and home towns—in the HTML code of your website, you can help attract visitors who are using these same keywords in their own searches. (Find out more about metatags at *searchenginewatch.com*.) The aim is to inform others of your presence and get as much pertinent information as possible. Even a couple of paragraphs of text and some photos will get you started.

IF YOU DON'T ASK, YOU DON'T GET

Not all your information will be presented to you on the proverbial plate. You'll need to do some asking, and—in a few cases—begging! When the begging needs to be done of relatives, assure them that the valued documents or photos you're asking to borrow will be copied and the originals returned to them undamaged. Official records are often freely available—if you know where and who to ask. Depending on where you live, copies from the records kept by local, state, and federal government agencies can be obtained relatively easily. Those from churches and other nonstatutory organizations may involve a little cajoling. Perhaps a contribution to the upkeep of the church might help!

Colls of

Henry Colls of North Elmham
B M. 1628 to Elizabeth
D. 1641

William Colls of North Elmham
B 1632 Husbandman.
M. 1660 to Joanne [née Boyden
D 1673

William Colls of North Elmh.
B 1664 Water-mill owner at
 and later at Aldbo
M - 1691 - Mary née Boyden
D - 1740 at Aldborough

Robert Colls of Itteringham
 Water-mill owner
B 1708 at Burgh Left his
M - Hannah - B 1712 D 1800
D - 1777

John Colls of Horstead marrie
B. 1744 Water-mill owner
M. 1767 at Horstead
D 1806 Grave stone on floor
 of Horstead church
 just inside door, on
 right.

John Colls of Gt Yarmouth Mar
B 1771 Merchant.
M. 1805 to Ann née Weeds
 Daughter of Capt. James

Windows on your World
Genealogical portal sites are a great way of beginning your investigations, and can alert you to new resources.

olk, England.

andman

ary Colls Prudence Elizabeth
B 1630 Colls Colls
M. 1705
To William Banbury

Prudence Colls
B 1669

FROM LITTLE ACORNS... FAMILY TREES WILL GROW

You may be fortunate enough to discover that your whole family tree has already been compiled by-a-zealous relative, but if not there is a good chance that some parts of it have-indeed been documented. Such works could be residing in an official resource—such as local governmental offices or record offices—just waiting for you to uncover them. Others may have already found-their way onto the web. Of course, how easy it is to find the-information will depend on your surname—if yours is relatively common, you'll be facing much more of an uphill struggle to sift your relatives' details from those of thousands of unrelated strangers.-It's very likely that your investigations will ultimately produce a mix of historic documents-and web-delivered material.

Anne Colls B1711 D1733 Eli
teringham B 1
her's mill at D.
rough in 1736

zabeth Anne Colls Hannah
Everard B 1755 Colls
n Sprowston marrie
46—1811 Willia
 Partri
 1762 wi
 remar
 1770 to
 Willian

Colls B1777 Hannah Colls Ma
ried William M. Thomas
Mack Thurtle or
s I Farmer Sculthorpe
at Arminland

Cyndi's List of Genealogy Sites on the Internet

http://www.cyndislist.com/ Google

Apple .Mac Amazon eBay Yahoo! News ▾ Google UK

WHO WERE YOUR ANCESTORS?

Enter your family's last name: [] > Click Here!

Cyndi's List
of Genealogy Sites on the Internet

Updated October 10, 2004

- Main Index (below)
- Topical Index
- Alphabetical Index
- "No Frills" Index
- Text-Only Index

- Search Cyndi's List

More than **240,400** links!

- **236,050** categorized & cross-referenced links
- More than **150** categories
- Another **4,300+** new, uncategorized links in the works

- What is *Cyndi's List*?
- Are You New to Genealogy?
- FAQ (Frequently Asked Questions)

Fellow genealogists have used this main index page 39038582 times since March 4, 1996!

- Browse the New Links
 October, September, August and more
- Submit a New Link
- Join the Mailing List
 Browse or Search Archives

Hosted by RootsWeb

- Make *Cyndi's List* Your Homepage!
- Create a Link to *Cyndi's List*

As your investigations continue, you're likely to come up against some obstacles. Some of these will be difficult to overcome. There might, for example, be an abrupt break in the records, or the records might themselves be missing or have been destroyed. Others will be a simple challenge, such as the discovery that your ancestors or relatives had emigrated to or from other countries. Clearly, it's not feasible to visit each of these countries and continue your enquiries directly, so you'll have an ideal opportunity to test your web-investigative skills!

Some of the larger web portals can give useful pointers to websites to explore in other countries. A useful feature of many portal sites is their database collections. These list databases of official records—ranging from national census surveys through to local parish and probate records—that are available online and can be browsed by the researcher. Ancestry.com, for example, lists (or provides access to lists of) hundreds of millions of names from around the world, and has nearly a million subscribers. You can search through census records, military records, the Land Registry and Probate Office (for those with British ancestry), Civil War records, and more—much, much more.

Gathering information from so many sources is almost guaranteed to produce results. But if you are particularly successful, and discover a great number of relatives and ancestors, how far back should you go and how many strands of your family should you include? In many respects that's a very personal question. People have their own reasons for delving into their pasts, but as a rule of thumb most people tend to construct family trees that are deeper than they are broad. So you'll find more generations—the "depth" of the tree—listed than parallel strands, which are those parts of the tree populated by "removed" cousins and the like, who comprise the "breadth." People, it seems, are keener on seeing where and who they came from than discovering where distant cousins are now. Of course, there are exceptions. If you're convinced you are a distant relative of royalty, or share the genes of those in political power, broad trees will be essential.

Under One Roof

Websites like Ancestry.com act as both portal and search engine. Bookmark these sites and visit often, as new material and extended resources appear all the time—you may find that crucial database you have been awaiting has arrived. You can also opt to be emailed.

ncestry.com – Genealogy and Family History Records

ww.ancestry.com/

Google

Login | **Subscribe** | Help

y history records on the Web

cords | Family Trees | Message Boards | Learning Center | Shop

Welcome to Ancestry.com

tors: (Enter what you know)

Robinson

ne(s) **Last Name**

England ▼ Herefordshire ▼

Year **Country** **County**

Ireland ▼ All Counties ▼

Year **Country** **County**

- The largest collection of family history records on the Web

- Learn details about your ancestors' lives

- Build your family tree

Try Ancestry.com today with a Free Trial!

Click to learn more

ch ▶ Advanced Search

ges

More Genealogy Records

10

)0

- Family & Local Histories - **Take the tour**
- U.S. Immigration Collection - **Take the tour**

)0

- Birth, Marriage & Death Records (SSDI)

)0

- Historical Newspapers (1786-2002)

years

- U.K. Census Collection NEW

What's New?

- Westbrook and Vicini...
- Some original land g...
- Early times in Meade...

» list recent or all databases

Records | Immigration Records | Genealogy Records | U.K. Records | Historical Newspapers

ATEMENT | Contact Us Copyright © 1998-2004, MyFamily.com Inc. – Terms and Conditions

Once you've collected your information and family history documents, it's finally time to start growing your tree. There are many software packages available to help you do this, but do you actually need anything other than a large sheet of paper—or word processor file? It depends on the detail you require. Pen and paper have served the genealogist for centuries, and examples of his or her art may well be in your family history portfolio. If your tree is to be equally simple, you could build it in anything from Photoshop Elements to Microsoft Excel, adding in old and new digitized images or subsidiary information, as you did in our pet calendar project (see page 164).

For a more ambitious project, dedicated family tree software has several advantages. Most significantly, it can make one of the more difficult tasks in any family tree construction—reconciling all the branches of the tree—simple. And you need only enter the names of the relatives to set up your basic framework. You can instantly print out the results. Or enter more information—facts, figures, or personal histories—relating to these. Pretty soon your tree will be blooming.

Virtually all genealogical software applications will also help you extend your search. By carefully analyzing the information you've already provided (such as the names, place and date of birth, and so on), these packages can search the appropriate databases and attempt to uncover further relatives for you to investigate. Bear in mind that British data such as census indexes is not available in such good quantities as its equivalent for the US, so you may face more leg-work.

Don't underestimate the power of assisted searches, though. For example, one of the most popular applications, Family Tree Maker, scours almost every genealogy-specific site currently on the Internet and finds those most likely to contain information pertinent to your searches. It can then help you study those sites for more clues to your ancestry.

Another plus point for family-tree software is its ability to track your data. As your tree expands, the number of resources that you've accessed in its construction can quickly grow, so managing them can become impossible. By keeping tabs on all the material you've searched, wasted effort is limited.

But for most of us the mechanics of creating the tree are only of peripheral interest—we want to see the end result! And you can produce stunning family trees with photos and illustrations. Some applications even produce chronologies and timelines that show the evolution of your ancestry and correlate family events with historic milestones.

Your New Family Friend

Family-tree websites and software packages can deliver more than an easy way of presenting your family history. They can enhance and increase your information trawling, and give you more ways to organize all that compiled data.

y History Software and Historical Records

ex_n.html Q▼ Google

ealogy.com announces the release
amily Tree Maker 2005
ere to learn more

SEARCH | SHOP 🛒 CART | ❓ HELP

ncestors with one click.

son

Name: Go!

old

rs ③ Share with family

logy.com!

you start your family
d share your discoveries
ax and let us help you
ourney.

, just enter a few simple
ily, using maiden
your tree and show
ur family's past.

s
u can, you can use our
ou where to find
ors.

our findings with family
ou how to contact
your family tree.

Choose the
Genealogy.com
Membership that's
right for you:

Gold -
The most extensive online
collection - best value for
your money
Deluxe -
Quickly add branches to
your family tree
Basic -
The ideal collection
to help you get started

Start your free trial

Featured Products
Family Tree Maker 2005 —
Display and share your le
World Family Tree — Ov
million names in 269,000
actual family trees.
Get Started in Genealogy
Super-informative and
educational books!

#1 Award Winning
Genealogy.com has won
more awards and
accolades than any other
provider of family history
products.

Celebrity Trees
Explore these famous fa
trees.

Common Ancestor	Child	Grandchild	G-grandchild
Child	Sister or Brother	Nephew or Niece	Grand-nephew or niece
Grandchild	Nephew or Niece	First cousin	First cousin, once removed
G-grandchild	Grand-nephew or niece	First cousin, once removed	Second cousin
G-g-grandchild	G-grand-nephew or niece	First cousin, twice removed	Second cousin, once removed

Do I Know You?

Genealogy.com offers this handy guide
(*left*) to the relatives you didn't know you
had—or maybe you did, but just weren't
sure what to call them!

○○○ My Genealogy.com

◀ ▶ 🏠 C + 🌐 http://www.genealogy.com/cgi-bin/my_main.cgi Q▼ Google

Genealogy.com®
Trust your family history to us.

Choose the Membership that's Right for You
Start your Free Trial today!
Click here to learn more

LEARNING CENTER | COMMUNITY | MY GENEALOGY.COM | SEARCH | SHOP 🛒 CART | ❓ HELP

Welcome, Visitor! Not a Visitor? Please log in.

My Genealogy.com

My Home Page
 My Family Tree
 My Photos
 My Files
 My Links
My Online Data Library
My Trees and Searches
My Profile

Family Finder

First Name: _____
Middle: _____
Last: _____
☐ Still living
Go!

My Trees and Searches
▸ Create a tree, save it, and search for
entire branches of your family tree with
the click of a mouse.

My Online Data Library
▸ Enjoy instant access to all of your online
data subscriptions from this single
location. This library is always open!
View All

My Home Page
▸ Share personal family trees, photos, data
files, or lists of your favorite Web sites
with friends and family alike. It's simple
to create your personal Home Page.
▸ Create a home page with Family Tree
Maker or view your existing Family Tree
Maker home page.

My Virtual Cemetery
▸ Catalog every tombstone photo you
contribute to the online Virtual Cemetery.
Click below to add one now or take a tour
of those contributed by others.
View All | **Contribute** | **Search**

May We Suggest...

Family Tree Maker 2005:

Family Tree Maker 2005

• Easiest to use
• #1 selling and rated
• Customizable printouts
• Updated Pedigree Views

More Details

Brush-Up Your Family-Finding Skills:

Ellis Island Name Changes: Could it really be
true? Explore the truth behind the myth.

Cousins: What Does "Removed" Mean?

Join the Genealogy Community
▸ GenForum Message Boards
allow you to read and share
all kinds of information with
other family researchers. You
can easily find the messages
you need by creating your
own My GenForum page.

The success of genealogy sites has meant that there is now a high perceived value in the material contained in archives. So those who are used to the free (and some might say, anarchic) nature of the Internet might be in for some surprises. Access to many archive sites (whether through direct access or via a portal) is often on a pay-per-use basis. You might be charged for accessing the data and (in some cases) charged for printing out that data. If you request a hard copy to be sent to you from the originator, you will almost certainly be charged. If you think this unfair, consider for a moment the position of the originators of this data. They do not have to place this data on the Web; in doing so they are making the work of professional researchers easier. We, as the amateur sleuths of genealogy, have to work under the same rules. And you wouldn't begrudge paying to see the real records, would you?

If you find that you are making regular visits to information resources you might find it easier to subscribe to one of the portal organizations. These charge monthly or annual subscriptions and provide unlimited access to a set or collection of databases. There are no further fees to pay. Similarly, the vendors of many family-tree software applications provide the option of purchasing their products with the bonus of subscriptions to certain databases.

Family Tree Maker—the product we discussed on page 232—includes a three-month subscription to Genealogy Library with one of its packages. This gives access to a range of researched family histories, marriage records, census indexes, and more. For a higher premium, you can include subscriptions to further databases, such as the 1900 Census and even International and Passenger Records—a vast collection of passenger lists, international censuses, and land records. But one note of caution. When you subscribe, do take care to check that those directories and databases to which you'll have access stand a good chance of being relevant. It may be of little value gaining access to the UK National Census of 1901 if your ancestry is entirely in Milwaukee, or the New York State Records if your family hails from London!

One particularly useful database to include in any subscription is World Family Tree. This is a vast searchable repository of family trees that researchers like you and me have contributed. You may be lucky and find several arms of your family already compiled in one of the trees here. Otherwise, paste yours and hope that it galvanizes others into action.

Cumberland Family Software

http://www.cf-software.com/

Cumberland Family Software
Family History Software for Beginners and Professionals!

Products | Orders / Support | Miscellaneous

▶ Cumberland Family Tree | ▶ Other Products | ▶ Freeware

FREE!
45-Day Trial Version of Cumberland Family Tree Pro

Current Version Pro

Discussion Group (Mailing List)
technical support and product discussion

To contact Cumberland Family Software:
ira.lund@cf-software.com

Professional Genealogy Research Assistance

Danish Research... Kay Lund Clark now does Danish Research. She reads and speaks Danish and lives in Rexburg, Idaho near a large LDS Family History Library on the Ricks College Campus. If interested please contact her at familysearch@ida.net

enealogy Software: Index"

Q- Google

place
RS.

u want to provide a link to Cumberland Family Software?
e freely copy the gif banner below and include it on your
pages with a link to this page. Thanks for your support!

Deluxe Edition
Order your personal copy of Legacy Family Tree 5.0 Deluxe Edition for only $19.95 (download only) or $29.95 plus shipping and get the book and CD. more info

Buy Now

Legacy Family Tree

Editor's Choice Award PC Magazine

September 17. 2002
Legacy Family Tree 4.0
Deluxe Edition
Millennia Corporation

Upgrade to the Deluxe Version
Those who purchased Legacy 4.0 Deluxe Edition can upgrade to the New 5.0 Deluxe Edition for just $14.95

Buy Now

Cumberland Family Tree
Genealogy Software
For Beginners & Professionals

art Computing.
In Plain English
SMART CHOICE

helps you track, organize, print,
ts, merging, To Do list, slide

THE TRUTH IS OUT THERE

The Internet is a superb resource for gathering information, images, official documentation—you name it. "Links" are what make the Internet function: billions of web pages are linked to billions of others, so your search could be literally endless. But it is also a useful way of "following the scent" of an information lead, or tracking down loads of software packages that you might not find in the shops. But do a little research on what you're buying or downloading first. Is there a discussion board elsewhere on the Internet that rates the software? You'll almost certainly find that there is. And if the package you're considering using has hundreds of online critics complaining that it doesn't work, think twice before using it yourself. But most of the ones out there are fine—things don't last long online if they don't work. The Internet is good at "regulating" itself in this way.

Once you've done your research and built the outline family tree, you can look at embellishing the material. Photographs begged, stolen (surely not!) or borrowed (of course!) from relatives will need to be copied. As you'll remember, a simple flatbed scanner will be sufficient for digitizing most conventional photographs. But also remember that many of these pictures—especially the older ones—will be quite fragile, so it's important to handle them with care. If the photos are mounted in an album and can't easily be removed, scan the whole album page and trim out any superfluous material later.

Time has two principal effects on your photos. It flattens the contrast through fading (which can occur even if the photos are stored in an album, away from the light), and also through the action of residual chemicals. Second, over long periods, it is almost inevitable that your photos will have suffered some physical damage. The corners get dog-eared, folds and creases develop, and, in the most severe case, the print gets torn. Fortunately, all these problems can be sorted digitally! You can boost the contrast (and, on old color photos, even restore faded color) and fix all those handling marks. You can finish with a photo that is better than the original!

THE FRUITS OF THEIR LABORS

Photographs are an important element of any family tree. We compiled an illustrated family tree for this project—and we've been fortunate to discover photographs of the great-great-grandparents of the children shown in the tree (who, we suspect, might have grandchildren of their own by now, looking at their photographs!). We've even identified all the relatives in the intervening generations. When using specialist family-tree software, you'll often find that it's sufficient to save a photo to have it included in the tree. The software handles all the sizing, cropping and placement. And notice the structure of this family tree. We could call it a "descendant" tree, as it illustrates all the descendants of the original couple, Joseph Reardon and Mary Hopkins. But you could base your tree on a selected child, for example, and trace their ancestry backwards.

Once you've created your tree, you won't want to keep your research to yourself—and no doubt those curious relatives from whom you've extracted information and ephemera will be keen to see the results. Printed family trees are fine, but a family website will be much more dynamic and can grow as more and more information comes your way. Like real trees, your family tree will never be "finished!" And it will withstand the ravages of time, thanks to the digital skills you've acquired in this book. You've truly made something for future generations to enjoy.

A family website need not be just a collection of data, or a place that family members visit once to discover their own past; it can be an energetic forum through which far-flung relations can communicate, share stories, and develop a greater sense of belonging. Your website will rapidly become a family resource. It will be a place where news is shared; marriages and births announced; and biographies added. That's what digital scrapbooking is all about: sharing, preserving, editing, growing... giving a new lease of life to your precious memories.

JOB DONE!

This Constance-Barry family tree website is the result of a substantial amount of research. George and Susan Barry spent three years researching their ancestry, in the course of which they discovered a great deal about their ancestors and items important to their lives.

They've avoided the pitfall of merely pasting the family tree online, instead grouping the material into sensible sections. In this way, relations can find out more by exploring the site in different ways. For example, they could use the linear family tree as the start point, then branch off to discover more about particular relations. Or they could choose (by clicking on one of the "saplings") to explore a selected time period, discovering more about the lives and times of their ancestors.

It's a site that's fun to visit and encourages people to visit again, and even add their own stories, anecdotes, and photos. Inspired?

Across the Pond

Families are fascinated by their roots, and when those are in another country, the story is more intriguing. Although the Constance-Barry ancestors were English, their descendants ended up in the US, where the family tree was compiled. Within the website, a short biography along with a few illustrative pictures brings each person to life. Visitors can click on each photo and see it enlarged, or even print off a high-quality copy for their own album.

the Constance-Barry family tree

Home ➡

● *Alfred George Barry 1892-1947*

Alfred Barry was born on the 6th of July and lived for the first past of his life in Rochester, Kent, England. He attended Sir Joseph Williamson's Mathematical School until the outbreak of the first World War, then became a junior medical officer in France until 1918.

After the war he married Victoria Hoskins and moved to Maidstone, Kent. Victoria gave birth to May in 1921 and Elizabeth in 1923. A son, Charles, was born in 1926 and emigrated to the USA in 1947. *More*

Alfred Barry

Victoria Hoskins aged 9

Pictures:

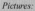1800-1900

Tea party

St Luke's

Victoria's home

Alfred's Aunts

Reginald Barry

Victoria aged 19 years

Welcome to the
Constance-Barry
family tree

Home page

Site Plan

Family Tree

Album

Surnames

News

Heirlooms

Feedback

We've spent three years researching the Constance-Barry family tree and we think that the results so far have made it all worthwhile. We hope that you agree, and if you can help us further with our searches please don't hesitate to contact us.

Some links are still nebulous but we are progressing steadily and will endeavour to update the site at least bi-monthly.

We look forward to hearing from you,

George and Susan Barry

Home ➡) 1900-2000

the
Constance-Barry
family tree

Heirlooms

Just for fun we've included some pictures of the many artefacts handed down to us over the years. They're not particularly valuable as antiques but they mean a lot to us.

*Every item has its own little story to tell and there's a brief description accompanying the photos. If **you** have anything of interest that you would like us to feature, please don't hesitate to get in touch.* More

Richard Constance

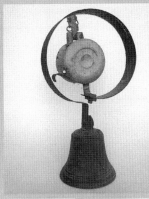

1800-1900

May Barry

Peter Barry

Reginald Barry

Jack Constance

Keep it Light

There's a tendency for genealogy to become ponderous and academic. While some of the material may demand this, don't make it totally humourless. Here the Barrys have included a page of family heirlooms (one selected by each family member) that say more about the character of each person than they define the wealth of the family!

T-Shirts

This project demonstrates how easy it is to print and then transfer an image to a t-shirt or other fabric.

The image is first printed onto a special transfer paper. This is then ironed onto the fabric. Due to the heat involved, you should use a fabric with at least 50% cotton content. The transfer process will mirror the image, so the image needs to be flipped horizontally in your image-editing program to maintain the original view. If you prefer to have your t-shirt printed professionally, the box below gives some guidelines.

what you need

- transfer paper
- inkjet printer
- household iron
- scissors
- a flat surface to work on
- a t-shirt

→ tip

Using a professional printing service

A quick search of the internet will reveal many custom t-shirt printers that will print single t-shirts or short runs. They typically require an image that is less than 2MB in size, usually in JPEG format, and possibly PNG and TIFF. The project on this page is suitable and can easily be converted to JPEG format. You will not need to worry about mirroring the image – your printer will do that.

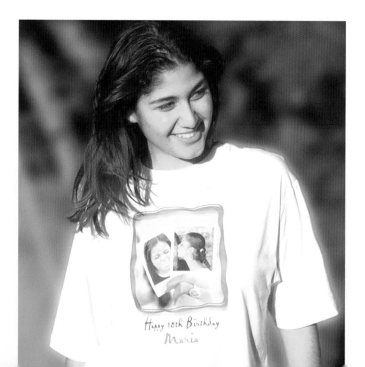

CREATING THE TRANSFER

Open a new A4 document in Elements. Create two new text layers and type in the name and message of your choice. Here the word "Maria" is in red, a color that we will use on the frame later on. The font is Pablo. You will have to substitute it with a font available on your own computer.

2 Select the *Custom Shape* tool from the *Tools* palette. From the flyout menu, select *Frames* and choose *Frame 19*. Click at the position top left. Holding the cursor down, drag it to the bottom right position of the frame shape. Don't worry if you don't get it right first time, as you can edit the shape subsequently.

3 When you draw with the *Custom Shape* tool, a new shape layer is created. To convert this to a regular Layer on which you can apply effects, click on the *More > Simplify Layer* button on the layers palette. The *Layer* icon now has a chequerboard background indication that it is transparent.

4 With the Shape 1 Layer still selected, choose *Wow Plastic > Red* from the *Layer Styles* palette. This effect is now applied to the frame.

5 Paste in the photo to be used within the frame. Use the *Transform* handles to rescale and position it so the area to be shown within the frame is correct.

6 Once you are satisfied with the position of the photo, reselect the Shape 1 Layer. Using the *Magic Wand* tool, click in the area outside the frame. Now return to the Photo Layer and hit the *Delete* button. This removes the unwanted portion of the photo.

7 Select the topmost Layer. From the *Select* menu, choose *All*. Then choose *Copy Merged* from the *Edit* menu. This action makes a copy of all the visible layers, including the background. Again from the *Edit* menu, select *Paste*. The new Copy merged Layer is now at the top of the order.

8 From the *Image* menu, select *Rotate > Flip Selection Horizontal*. This converts it to the mirror image that is necessary for the image to appear correctly when it is transferred onto a t-shirt.

9 Steps 7 and 8 can be ignored if your own printer is able to print a mirror image. The option may not be on the *Main* options tab. Follow the transfer paper manufacturers' instructions before starting to print. Usually the best quality is the suggested option.

→ tip

Use the template instead

You can download the Tee Shirt.psd document from the web-linked website *(see page 166)* and simply add your own text and photo.

ironing the print-out onto the t-shirt

These instructions are for a typical transfer paper, Epson Iron–on Cool Peel Transfer Paper. Other makes may be different, so read the instructions carefully before proceeding. Although transparent, the unprinted background will be apparent where the texture of the fabric has been ironed. If your image is an irregular shape, you may prefer to trim the print back to within a quarter of an inch of it so that this is less noticeable.

❶ Make sure the t-shirt is free from wrinkles. Place it face up on a hard, flat surface that is able to withstand heat, such as a sheet of wood or a laminate worktop.

❷ Place the transfer print-out face down on the t-shirt in the position that you want it to appear.

❸ Ensure that the steam setting is turned off. Heat the iron to high/max temperature – usually between 350 and 390° F (180 to 200° C). Cordless irons may not retain heat long enough to complete the process.

❹ Apply steady pressure and heat as you iron over the surface of the print-out. This will take between 45 seconds and 1 minute. If you have some spare fabric, it is sensible to do a test transfer with a spare print-out.

❺ Leave to cool for a couple of minutes and then carefully peel away the transfer paper, leaving the image imprinted on the garment.

10 To convert to JPEG format, select *Save As* from the *File* menu and choose *JPEG* from the drop-down menu. Leave the options as default, which should be *Quality* at 12 Maximum. The resulting file will be about 1.6MB. If you reduce the quality setting to 6 Medium, the file size will be considerably smaller without much loss of quality.

11 A typical online print service has a browse button to enable you to select the image to be uploaded to the online printer.

Water Slip Decals

For this project, you will need a white ceramic plate on which to apply your decal. The area for your decal should be flat to avoid creasing when the decal is applied.

what you need

- water slip decal paper
- inkjet printer
- lint free cloth
- dish of water

Any subject can be suitable, but this plate is intended for mounting on a wall, so it is best to choose something that you are unlikely to tire of – like our dog, Monty.

1 Open a new document in Elements. It can be any size as long as it is not smaller than the area of the plate that you intend to fill. We chose 12 x 12in (30.5 x 30.5cm).

2 On a new Layer, use the Elliptical Marquee tool to define a circle. Choose *Inverse* from the *Select* menu and fill the circle with white using the *Paint Bucket* tool.

3 On a Layer below, paste in your photo. Use the *Transform* handles to rescale the image. The image that we chose has an obvious space for the title; your image needs to be carefully chosen with this in mind.

4 Duplicate the Layer created in step 2. Use *Adjust Color > Hue/Saturation* from the *Enhance* menu. Select a color for the image's border. Drag this new Layer below the white one. It will temporarily disappear.

5 With the image still selected, use a corner *Transform* handle to reduce the size of the image. It will now become visible beneath the Layer above. Hold down the *Shift* and *Alt* keys together while you do this so the image will rescale from its central point.

6 Use the *Magic Wand* tool to make a selection within the circular window. Choose *Inverse* from the *Select* menu. Again from the *Select* menu, choose *Feather*. The actual amount will depend on the size of your image. Between 16 and 64 should be fine.

7 With the selection still active, change to the photo layer and hit the *Delete* key. This will remove the background of the image, leaving it with a soft (feathered) edge.

8 On two new layers above the others, type in the title and subtitle. We used Caslon semi-bold small caps and italic; you will have to use fonts available on your computer.

printing and applying the decal

Follow the water slip decal printing and application instructions supplied with the paper. They are likely to be similar to these.

❶ Make sure the paper is placed in the printer tray correctly and print with high-quality setting.

❷ Leave the print to dry for a few minutes and then spray with a clear varnish. Several coats will be required. Leave each to dry before applying the next. This is important beacause the varnish fixes the inkjet print-out, which would otherwise run in contact with water.

❸ Cut out the circular image with scissors or a craft knife. Place it in a dish of water for about 30 seconds, or until you can feel the thin membrane slipping away from the backing paper.

❹ Apply some watery glue (diluted PVA) to the area where you are going to place the decal. Then slip off the design from the backing paper and onto the plate. Drain off the water. Smooth out the design with a lint-free cloth to remove the air bubbles. When thoroughly dry, you can spray-varnish the completed design if you wish.

Save an image to include in a Web page.
Save photographs as JPEG and images with limited colors as GIF.
The image preview shows how your image will look using the current settings.

OUTPUT IDEAS

OK

Cancel

Help

Settings: Custom

JPEG Optimized

Maximum Quality: 84

Progressive

ICC Profile Matte:

Email Your Photos

Sending your digital photos by email is fine as long as you abide by email etiquette. The recipient normally has no way of stopping an email downloading to their computer, so you must consider whether or not to send an unsolicited email, particularly if it has an attachment.

Even when you are sending something to a friend or relative, it is courteous to email them ahead to say that you are going to send an attachment. Make sure the attached image has been optimized to the smallest possible file size. Many people do not have a broadband connection and it is very irritating to see your email software endlessly awaiting an incoming message. Always type a descriptive phrase in the message subject box. If you do decide to send an unsolicited email and it is to multiple locations (a Christmas card, for example), use the BCC (Blind Carbon Copies) option to hide other recipients' email addresses.

EMAIL PHOTO MESSAGE

1 Open a new document 500 x 350 pixels with *Resolution* set to 72 pixels/inch.

2 Paste in the photo and use the *Transform* handles rescale to fit the area required.

3 Select the Background and use the *Paint Bucket* tool fill with a color of your choice. Here, we have matched the rim of Jim's cap.

4 On a new layer above the others, select the *Horizontal Type* tool and type in the headline. We have used a funky font called Pompeia. Repeat this process, this time with the main message; you should use a smaller font size than that used for the headline.

5 From the *File* menu, select *Save for Web* and choose *JPEG*. We left the settings as default except for *Quality*. A level of 84 was necessary to avoid degrading the text, but the resulting file size was still below 72KB.

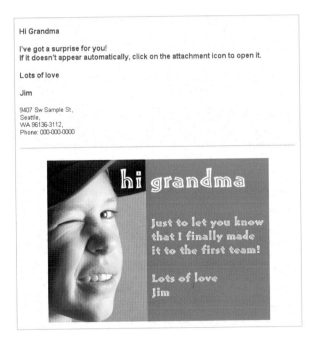

6 Now the JPEG file has been Optimized, it is ready to attach to an email message; here Jim is emailing his grandma with some special news that is contained in the image created in steps 1 to 5. He is using MS Outlook Express and has personalized the background selecting *Maize* from the *Format > Apply Stationery* menu.

Trimming, Mounting, and Sticking

Although this book is primarily concerned with digital solutions to the presentation of your photos, there may come a time when old-fashioned cut-and-paste will provide just the finishing touches that you need. By pasting together prints, you will be able to breach the size limitations of your desktop printer. Why not try a Hockneyesque montage of overlapping prints, or a panoramic montage that is pasted together rather than digitally stitched?

You can also stick your digital images directly on to household surfaces. For example, you could put a puppy border around the nursery wall, or party photos on an old cupboard door. As most inkjet prints are made from water-soluble inks, it is essential to first apply fixative coating spray like Jet Coat. The list below shows some equipment that might be useful. Preparation as well as creativity is usually the key to success.

Cutting
• A craft knife with sharp blade; more accidents occur using blunt instruments than sharp ones.
• A purpose-made cutting mat is preferable, but if you have only a sheet of stout card that will do.
• A steel rule is essential as a guide to cutting straight lines with a craft knife.
• Slender scissors for cutting round shapes; dressmakers' pinking shears for cutting wavy edges.

Pasting
• Adhesive sprays are best for mounting photographs. However, they are not sold in some areas due to the heath risk if they are inhaled.
• PVA water-based adhesive is good for sturdier materials.
• Double-sided tape is effective but doesn't offer a second chance if an element of your presentation is incorrectly placed.
• Adhesive sticks are difficult to control and can leave globules of unwanted glue.
• Glue guns are great for really chunky objects.

Pens and paint
• As most of your imagery will be digital, concentrate on pens that leave a three-dimensional trail, like gel and glitter pens. Nail varnish can also be use to create blobs.
• Acrylic or even oil paint can be used to create a textured surface, but be prepared to allow for the drying time.
• Gold or other metallic paints create a finish that the computer cannot truly replicate.
• Gilt wax can give many surfaces a touch of splendour.

Papers and cards
Often left-over paper can be really effective. Old greetings card can be used for decoupage; doilies are good for decorative borders; and even wallpaper can be used if the pattern is small enough. Tissue paper, marbled paper and various hand-made papers are also useful to have in your creative arsenal.

Miscellaneous
Use a roller rather than pressing glued surfaces together by hand.

framing your photos

Some of the projects in this book demonstrate how a virtual frame can be created directly from software like Elements, or how real-world frames and borders can be either photographed or scanned to enhance your digital photographs. However, there will also be times when you will want to mount your photos in a real frame.

It is sensible to make or purchase the frame (and liner or mat if necessary) first and then to arrange the project so that it fits within the frame when printed. With rectangular frames, this is straightforward, but with some highly decorative frames – for example, an Art Nouveau design – the image may appear behind an irregular shape. If you buy a new frame, it will almost certainly have a sample print inside that can be used as a guide. If this is not the case, try scanning the frame, scale the image to match it and then discard the scanned frame before printing.

If your skills extend to making things, why not buy the mouldings and make the frames yourself? Make sure that you cut the corners with a mitre saw. You could also decorate a plain, unmoulded frame, with sea shells, for example, or your own creations made from modelling clay or salt dough.

A few rules of thumb:

❶ Don't put a project that uses a virtual frame into a real one: frames within frames look a mess. Use a borderless glass frame instead.

❷ Match the character of the image with a suitable framing material; for example, dignified hardwood for seniors; silver for newlyweds; plastic for kids.

❸ Use a multi-opening frame to record events like a wedding or phases of a child's life such as new-born, first day at school, and receiving a sports award or school prize.

❹ Always match the print to the actual frame size. An oversized image shoe-horned into a small frame or a small image lost in a vast frame look equally bad.

glossary

Adobe Inc. Software developer whose products are widely used by professionals and amateurs for many creative tasks such as Web design, graphic design and video editing. Photoshop, Photoshop Elements, Photoshop Album and the video-editing package Premiere are some of its most successful products.

alpha channel While each color channel defines the level of a certain color for each pixel, this channel defines the level of transparency for each pixel, allowing you to create images with objects of varying levels of transparency.

anti-aliasing The smoothing of jagged edges on diagonal lines created in an imaging program, by giving intermediate values to pixels between the steps. This is especially common around text.

application Software designed to make the computer perform a specific task. For example, Photoshop is an image-editing application, whereas Windows is an operating system.

artefact Any flaw in a digital image, such as "noise." Most artefacts are undesirable, although adding "noise" can create a desirable grainy texture if an image is appropriate.

back-up A copy of either a file or a program created in case the original file becomes damaged (corrupt) or lost.

bit depth The number of bits per pixel (usually per channel, sometimes for all the channels combined), which determines the number of colors that pixel can display. Eight bits-per-channel are needed for photographic-quality imaging.

bitmapped graphic An image made up of dots, or pixels, such as those produced by digital cameras, scanners and software like Photoshop. It is distinct from the vector images of "object-oriented" drawing applications.

browser/Web browser Program that enables the viewing or "browsing" of World Wide Web pages across the Internet. The most widely used browsers are Netscape Navigator and Microsoft Internet Explorer.

burn(ing) The act of recording data onto a CD using a CD burner (a recordable CD drive). Software such as Ahead Nero (PC) or Roxio's Toast (Mac) is often used for this task.

byte Eight bits. The basic data unit of desktop computing.

CCD (Charged Coupled Device) The name given to the component of a digital camera which "sees" and records the images, like film does in a traditional camera. The CCD is made up of a grid of tiny light sensors, one for each pixel. The number of sensors, and the size of image output by the CCD, is measured in megapixels.

CD-ROM CD (Compact Disc) Read-Only Memory. An evolution of the CD that allows the storage of up to 600 megabytes of data, such as images, video clips, text and other digital files. But the discs are "Read only," which means the user can't edit or overwrite the data.

CD-R/CD-RW CD Recordable/CD-ReWriteable. CD-Rs are inexpensive discs on which you can store any digital data, or roughly 77 minutes of audio (on a hi-fi CD recorder). But once written and finalized (fixed), the data cannot be erased, edited, or modified. Similar to the above, CD-RW discs can be "unfinalized" then overwritten, in part or entirely, any number of times. However, CD-RWs will not play on all CD drives, so they are primarily used for storage.

channel Images are commonly described in terms of channels, which can be viewed as a sheet of color similar to a layer. Commonly, a color image will have a channel allocated to each primary color (red, green and blue in a standard RGB image) and sometimes an alpha channel for transparency, or even an additional channel for professional printing with special inks.

clone/cloning In most image-editing packages, clone tools allow the user to sample pixels (picture elements) from one part of an image, such as a digital photograph, and use them to "paint" over another area of the image. This process is often used for the removal of unwanted parts of an image or correcting problems, such as facial blemishes. In Photoshop, the tool is called the *Clone Stamp* tool (sometimes known as the rubber stamp).

CMYK The standard primary colors used by professional, or "process," printing: cyan, magenta, yellow and key (black). These colors are mixed according to "subtractive color,", meaning that white appears where no color value is applied.

color depth See *bit depth*

color gamut The range of color that can be produced by an output device, such as a printer, a monitor, or a film recorder.

color picker An on-screen palette of colors used to describe and define the colors displayed and used in an application or on a computer monitor. Color pickers may be specific to an application such as Adobe Photoshop, a third-party color system such as PANTONE, or to the operating system running on your computer.

compression The technique of rearranging data so that it either occupies less space on a disk or transfers faster between devices or over communication lines. For example, high-quality digital images, such as photographs, can take up an enormous amount of disk space, transfer slowly, and use a lot of processing power. They need to be compressed (the file size needs to be made smaller) before they can be published on the Web: otherwise they take too long to appear on screen. But compressing them can lead to a loss of quality. Compression methods that do not lose data are referred to as "lossless," while "lossy" describes methods in which some data is lost.

continuous-tone image An image, such as a photograph, in which there is a smooth progression of tones from black to white.

contrast The degree of difference between adjacent tones in an image from the lightest to the darkest. "High contrast" describes an image with light highlights and dark shadows, but few shades in between, while a "low contrast" image is one with even tones and few dark areas or highlights.

copyright The right of a person who creates an original work to protect that work by controlling how and where it may be reproduced.

copyright-free A misnomer used to describe ready-made resources, such as clip art. In fact, these resources are rarely, if ever, "copyright free." Generally it is only the license to use the material that is granted by purchase. "Royalty free" is a more accurate description, as you don't have to pay per copy used.

digitize To convert anything—text, images, or sound—into binary form so that it can be digitally processed. In other words, transforming analog data (a traditional photograph or an audio tape, for example) into digital data.

dithering A technique by which a large range of colors can be simulated by mingling pixels. A complex pattern of intermingling adjacent pixels of two colors gives the illusion of a third color, although this makes the image appear grainy.

dots per inch (dpi) A unit of measurement used to represent the resolution of output devices such as printers and also, erroneously, monitors and images, whose resolution should be expressed in pixels per inch (ppi). The closer the dots or pixels (the more there are to each inch) the better the quality. Typical resolutions are 72 ppi for a monitor, 600 dpi for a laser printer, and 1440 dpi for an inkjet pritnter.

download To transfer data from a remote computer, such as an Internet server, to your own. The opposite of upload.

DVD (Digital Versatile Disc). Similar in appearance to CDs and CD-ROMs, but with a much greater storage capacity. Although store-bought movie DVDs hold up to 18Gb you can only burn around 4–5Gb on the various home formats. Like CD-R and CD-RW you can get blank discs that can be written once or re-written repeatedly. Unlike CDs, however, there are competing formats that look the same but cannot write to each other's discs. These are DVD-R/RW, DVD+R/RW, and DVD-RAM. When buying blank discs be sure to get the correct sort. The write-once discs from both DVD-R and DVD+R can be read by most modern DVD players so, with the correct software, you can make DVDs of photo slide shows or digital videos at home.

EPS (Encapsulated PostScript) Image file format for object-oriented graphics, as in drawing programs and page-layout programs.

extract A process in many image-editing applications whereby a selected part of an image is removed from areas around it. Typically, a subject is "extracted" from the background.

eyedropper tool In some applications, a tool for gauging the color of adjacent pixels.

file extension The term for the abbreviated suffix at the end of a file name that describes either its type (such as .eps or .jpg) or origin (the application that created it, such as .qxp for QuarkXPress files). Extensions are compulsory and essentially automatic in Windows, but not on Apple computers, so Mac users should add them if they want their files to work on Windows computers.

file format The way a program arranges data so that it can be stored or displayed on a computer. Common file formats include TIFF (.tif) and JPEG (.jpg) for bitmapped image files, EPS (.eps) for object-oriented image files, and ASCII (.txt) for text files.

FireWire A type of port connection that allows for high-speed transfer of data between a computer and peripheral devices. Also known as IEEE-1394 or iLink, this method of transfer – quick enough for digital video – is employed by some high-resolution cameras to move data faster than USB.

frame A single still picture from a movie or animation sequence. Also a single complete image from a TV picture.

font Set of characters sharing the same typeface, these are stored by your computer and made available to applications where text is edited. There are two varieties of font; vector fonts like TrueType which can be printed at any size with no loss of quality, and bitmapped fonts which cannot be scaled.

GB (GigaByte) Approximately one billion bytes (actually 1,073,741,824), or 1024 megabytes.

GIF (Graphics Interchange Format) One of the main bitmapped image formats used on the Internet. GIF is a 256-color format with two specifications, GIF87a and, more recently, GIF89a, the latter providing additional features such as the use of transparent backgrounds. The GIF format uses a "lossless" compression technique, which handles areas of similar color well, and allows animation. It is therefore the most common format for graphics and logos on the Internet, but JPEG is preferred for photographs.

gradation/gradient The smooth transition from one color or tone to another. Photoshop and other programs include a Gradient tool to create these transitions automatically.

histogram A "map" of the distribution of tones in an image, arranged as a graph. The horizontal axis is in 256 steps from black to white (or dark to light), and the vertical axis is the number of pixels, so in a dark image you'll find taller bars in the darker shades.

HSL (Hue, Saturation, Lightness) A way of representing colors based upon the way that colors are transmitted from a TV screen or monitor. The hue is the pure color from the spectrum, the saturation is the intensity of the color pigment (without black or white added), and brightness representing the strength of luminance from light to dark (the amount of black or white present). Variously called HLS (hue, lightness, saturation), HSV (hue, saturation, value) and HSB (hue, saturation, brightness).

hue A color found in its pure state in the spectrum.

icon An on-screen graphical representation of an object (such as a disk, file, folder or tool), tool, or feature, used to make identification and selection easier.

interface A term used to describe the screen design that links the user with the computer program or website. The quality of the user interface often determines how well users will be able to navigate their way around the pages within the site.

interpolation Bitmapping procedure used in re-sizing an image to maintain resolution. When the number of pixels is increased, interpolation fills in the gaps by comparing the values of adjacent pixels.

ISP (Internet Service Provider) An organization that provides access to the Internet. At its most basic this may be a telephone number for connection, but most ISPs provide email addresses and webspace for new sites.

JPEG, JPG The Joint Photographic Experts Group. An ISO (International Standards Organization) group that defines compression standards for bitmapped color images. The abbreviated form gives its name to a "lossy" (meaning some data may be lost) compressed file format in which the degree of compression, ranging from high compression and low quality, to low compression and high quality, can be defined by the user.

KB (kilobyte) Approximately one thousand bytes (actually 1024).

lasso A selection tool used to draw an outline around an area.

layer One level of an image file, separate from the rest, allowing different elements to be moved and edited in much the same way as animators draw onto sheets of transparent acetate.

lossless/lossy Refers to the data-losing qualities of different compression methods. "Lossless" means that no image information is lost; "lossy" means that some (or much) of the image data is lost in the compression process (but the data will download quicker).

luminosity Brightness of color. This does not affect the hue or color saturation.

mask A greyscale template that hides part of an image. One of the most important tools in editing an image, it is used to make changes to a limited area. In Photoshop Elements a mask can only be applied to an adjustment layer, but in Photoshop masks can be applied to all layers.

MB (megabyte) Approximately one million bytes (actually 1,048,576).

megapixel This has become the typical measure of the resolution of a digital camera's CCD. It is simply the number of pixels on the CCD, so a size of 1280 x 960 pixels is equal to 1,228,800 pixels, or 1.2 megapixels.

memory card The media employed by a digital camera to save photos on. This can be Compact Flash, Memory Stick, SD Cards or Smart Media – all store images which can then be transferred to the computer.

menu An on-screen list of choices available to the user.

midtones/middletones The range of tonal values in an image anywhere between the darkest and lightest, usually referring to those approximately halfway.

noise Random pattern of small spots on a digital image that are generally unwanted, caused by non-image-forming electrical signals. Noise is a type of artefact.

pixel (picture element) The smallest component of any digitally generated image. In its simplest form, one pixel corresponds to a single bit: 0 = off, or white, and 1 = on, or black. In color or greyscale images or monitors, one pixel may correspond to several bits. An 8-bit pixel, for example, can be displayed in any of 256 colors, a 24-bit pixel (8 bits per channel) can display any one of 16.8 million colors.

pixels per inch (ppi) A measure of resolution for a bitmapped image.

plug-in Subsidiary software for a browser or other package that enables it to perform additional functions, e.g., play sound, movies or video.

PNG (Portable Network Graphics) A file format for images used on the Web, which provides 10–30% "lossless" compression, or a "lossy" option. It was created as an alternative to the GIF and JPG file formats, but has not yet displaced either.

RAM (Random Access Memory) The working memory of a computer, to which the central processing unit (CPU) has direct, immediate access. The data here is only stored while the computer is switched on, and more RAM can dramatically improve a computers performance.

raster(ization) Deriving from the Latin word "rastrum," meaning "rake," this is the method of displaying (and creating) images on a television or computer screen. It is commonly used to mean the conversion of a scaleable vector graphics image into a bitmapped image.

resolution (1) The degree of quality, definition or clarity with which an image is reproduced or displayed, for example in a photograph, or via a scanner, monitor screen, printer or other output device.

resolution (2) Monitor resolution, screen resolution. The number of pixels across by pixels down. Common resolutions are 640 x 480, 800 x 600 and 1024 x 768, with 800 x 600 the size most Web designers plan for.

re-sampling Changing the resolution of an image either by removing pixels (so lowering the resolution) or adding them by interpolation (so increasing the resolution).

RGB (Red, Green, Blue) The primary colors of the "additive" color model, used in video technology, computer monitors and for graphics such as for the Web and multimedia.

ROM (Read-Only Memory) Memory, such as on a CD-ROM, which can only be read, not written to. It retains its contents without power, unlike RAM.

Rubber stamp Another word for a clone tool (see *cloning*).

software Programs that enable a computer to perform tasks, from its operating system to job-specific applications such as image-editing programs and third-party filters.

thumbnail A small representation of an image used mainly for identification purposes in a file browser or, within Photoshop, to illustrate the current status of layers and channels.

TIFF (Tagged Image File Format) A standard and popular graphics file format originally developed by Aldus (now merged with Adobe) and Microsoft, used for scanned, high-resolution, bitmapped images and for color separations. The TIFF format stores each pixel's color individually, with no compression, at whatever bit depth you choose. That means they can be black and white, greyscale, RGB color or CMYK color, can be read by different computer platforms, but can be very large files. For example, an image of 640 x 480 pixels (just 0.3 megapixels) at 8 bits per channel CMYK (32 bits per pixel) is 1.2Mb.

tile, tiling Repeating a graphic item and placing the repetitions side-by-side in all directions so that they form a pattern.

toolbox In an application, an area of the interface that enables instant access to the most commonly used commands and features. Unless switched off by the user, the toolbox is always visible onscreen.

transparency A degree of transparency applied to a pixel so that, when the image or layer is used in conjunction with others, it can be seen through. Only some file formats allow for transparency, including TIFFs which define transparency as an alpha channel, or GIFs, which allow only absolute transparency (a pixel is either colored or transparent).

TrueType A type of font or typeface composed of vector graphics which can be scaled up or down without any loss in quality.

USB (Universal Serial Bus) An interface standard developed to replace the slow, unreliable serial and parallel ports on computers. USB allows devices to be plugged and unplugged while the computer is switched on. It is now the standard means for connecting printers, scanners, and digital cameras.

vector graphics Images made up of mathematically defined shapes, such as circles and rectangles, or complex paths built out of mathematically defined curves. Vector graphics images can be displayed at any size or resolution without loss of quality, and are easy to edit because the shapes retain their identity, but they lack the tonal subtlety of bitmapped images. They are used in illustrations for their accuracy and clarity, and employed by Photoshop's text handling and shape tools.

webpage A published HTML document on the World Wide Web, which when linked with others, forms a website. The HTML code contains text, layout and navigational instructions, plus links to the graphics used on the page.

Web server A computer ("host") that is dedicated to Web services.

website The address, location (on a server), and collection of documents and resources for any particular interlinked set of webpages.

Windows Operating system for PCs developed by Microsoft using a graphic interface.

World Wide Web (WWW) The term used to describe the entire collection of Web servers all over the world that are connected to the Internet.

253

adhesives 248
airbrushing 136–9
analog-to-digital converter 202
Ancestry.com 230–1
animals 70–3
　pet calendars 164–71
animation 223, 224
Animation Shop 223
aperture 38–9, 40
Apple computers 23,
　28–9, 156
Archer, Frederick Scott 9–10
aspect ratio 97
automobiles 76–7

background
　catalog photos 216–17, 219
　removal 126–7, 166–7, 195
　webpages 180
Background Eraser 166–7, 195
banding transients 222
Barnack, Oskar 11
binding 152
bits 14–15, 16, 20
Black Pencil 116
Blur 108
blurring 112–13, 166
　soft focus 124–5
brightness, adjustment 90–3
Brightness/Contrast 83
browsers 156, 163
Brush Strokes 117
buildings 55–9
Burn tool 98
businesses 182–91

cages 72–3
calendars, pets 164–71
caloytpes 9
camera obscura 8
candid shots 46–7, 50–1
cataloging 212–25
CCD 14, 38, 39
CDs 222
　covers 209
　kids' parties 210
　music copyright 211
　video 206–7
Clarify tool 85
clip-art 178–9, 184
Clone tool 87, 135,
　196, 219

close-ups 37, 41, 45,
　62–5, 145
　buildings 55
　catalogue photos 219
　pets 167
CMYK 43
collages 149
collection records 212–25
color 42–3
　adjustment 88–9
　casts 67, 88, 94–5
　grayscale images 132–3, 148
　monitors 188
　removing 134–5
Colored Chalk 116
combining images 106–7
　see also panoramas
CompactFlash 24–5
composition 34–5
compression 20–1, 86,
　87, 160
computers 11, 28–9,
　30–1, 143, 192
Constance-Barry family tree
　238–9
contrast 82–3, 88–9, 236
copyright 174, 211
Corel Knockout 166
cropping 100–3, 190
cropping mask 103
cutaways 194
CuteFTP 162
Cyndi's List 228, 229

Daguerre, Louis 9
daguerreotypes 9
databases 214, 216, 230
depth of field 38–9, 41,
　49, 125
　cages 73
　close-ups 64, 65
desktop publishing programmes
　170, 179, 182
diffusers 216
diopter rating 63
distortion 97, 108–9
Dodge tool 98–9
downloading pictures 23, 26–7, 146
downloading webpages 180
Dreamweaver 156
dust removal 148
DVDs 206

Eastman, George 10, 11
Elliptical Marquee 115, 168, 209,
　244
email, photos 246–7
enlargements 17, 62–3, 96–7
EV compensation 45, 55, 66, 90,
　91, 98
Excel 168–9, 170, 184,
　214, 215
exposure 38, 54–5, 66,
　88, 90–1, 196
　close-ups 167
　correction 98–9
　Histogram 93
　locking 53, 90
Extensis Portfolio 215
Extract 166, 216
Extrude 118
eye contact 49

Family Tree Maker 232, 234
family trees 226–39
Feather 113, 114, 115,
　137, 168
Fetch 162
file sizes 160, 161, 180
FileMaker Pro 214
fill-in flash 45
Final Cut 202, 204–5
FireWire 23, 27
flash 44–5, 60, 63,
　167, 198
flipping images 240, 242
focal points 52
focus 40–1
　auto-focus 22, 40–1
　close-ups 65
　locking 41, 75
　selective 49, 84–5
　soft 124–5
fonts 180
Fox Talbot, William Henry 144
frames 130–1, 249
framing shots 51, 53, 60–1
FrontPage 156
FTP software 162

Gamma Correction 92
gardens 66–8
Genealogy.com 232–3
GIFs 20, 21, 160,
　180, 223

GoLive 156
Grain filter 166
Grayscale filter 111
grayscale images 42, 43,
　98–9, 134–5
　airbrushing 138
　coloring 132–3, 148
　noise 110, 111

Healing Brush 196
Hemera BizArt 184
highlights 99
Histogram 93
histograms 99
holding cameras 36–7
home offices 182–91
HotDog 156
hotspots 198–9
house moving 172–81
HTML 154, 156
Hue/Saturation tool 88–9

image size 96–7
iMovie 200, 202–3, 204
InDesign 170
interiors 60–1
Internet
　see also webpages
　family trees 226, 228–35
　online photo printing 201
　photo galleries 201
Internet Explorer 156, 163
InterNIC 162
interpolation 17, 96–7
inventories 224
iPhoto 184
iView Media 215

JPEGs 21, 160, 161,
　180, 191, 200
　artifacts 86, 87
　email 247
　t-shirts 243

Keynote 182, 188

landmarks 49, 56–9, 176
landscapes 52
Lasso tool 90, 134,
　166, 167
layers 126–7, 134
LCD screens 23, 50, 64

lighting 35, 59
see also flash
catalogue photos 216, 218
close-ups 65
interiors 60
sun 45, 52, 53, 66, 158
lighting cove 216
links 180, 201
Liquid Edition 204
Liquify 117
logos 182, 186

macro photography
see close-ups
Maddox, Richard 10
Magic Wand 107, 242, 245
Magnetic Lasso 166
maps 174–7, 179
Marquee tools 106, 115,
168, 209, 244
Median filter 110
memory cards 24–5, 31, 146–7
memory sticks 25
metatags 228
metering, electronic 39
midtones 92, 93, 99
montages 106–7, 120–3,
136–9, 249
Moonfruit 156, 163
mosaic effect 118
Motion Blur 113
motion effects 112–13, 124
mounting 248
Movie Maker 200, 202
multimap.com 174–5

Namo WebEditor 156, 201
negatives 9–10
NetObjects Fusion 156
Netscape Composer 156
Netscape Navigator 156, 163
newspapers 148
Niepce de Saint-Victor, Abel 9
Niepce, Joseph Nicephore
8–9, 144
noise 86–7, 110–11

Ocean Ripple 118
Office 154, 168, 182,
184, 210
old photos 146, 236
Opera 156

Paint Shop Pro 29, 81, 82–102,
110–11, 116–17, 143
animation 223
catalogues 215
cropping 100–3
frames 130–1
red-eye 140, 141
panning 39, 74, 112–13, 124
panoramas 120–3, 152, 220–1,
222, 248
paper 150, 248
iron-on transfers 243
water slip decals 245
parallax error 64
parallel connections 27
parties, kids 208–11
PCMCIA cards 25
PCs 23, 28–9
PDF format 170, 171
Photoshop 29, 80, 166, 216
Photoshop Elements 80–1, 88–9,
98–9, 107–9, 114–15, 117–19,
120–7, 134–5, 143, 195
brightness 90–1
calendars 164–7, 171
catalogs 215
cropping 100–3
image size 96–7
motion effects 112–13
panoramas 220
red-eye 140–1, 198–9
slideshows 184, 188–90
t-shirts 240–3
text 128–9
water slip decals 244–5
web photo galleries 201
PhotoVista Panorama 220
Pinch 109
pixels 15, 16–19, 63, 82
planning 212, 218
PNGs 21, 180
polarizing filters 72
portraits 46–51, 63, 114–15, 216
ports 26, 27
Powerpoint 182, 184–8, 191, 210
Premiere Elements 202
presentations 184–90
printers
computerless 31
paper 150
resolution 151
props 48

QuarkXPress 170
QuickTime 201
QuickTime VR software 222

Ready,Set,Go! 170
records 212–25
red-eye 45, 140–1, 198–9
reflections 72
reflectors 45, 65, 198
removing objects 87, 196–7, 219
resolution 14, 16–19, 151
printing 179
webpages 179
RGB 43
rotation 101, 102
RS232 connection 26
rule of thirds 34, 53

Safari 156, 163
Salt and Pepper filter 111
sand 58
saturation 88–9
scale 174, 188, 219
scanners 146–7, 148, 149, 236
scrapbooks 144–53
screen grabs 158, 174
seasons 35, 54–5
sepia toning 114–15
serial connections 26–7
Serif PagePlus 170
shadows 45, 54, 66, 93,
99, 218
sharpening 82–5
Shear 109
shutter speed 38–9
slideshows 23, 182, 184, 186,
188–90, 210–11
SLRs 10, 36, 40
SmartMedia 24–5
snow 35, 55, 66, 69
soft focus 124–5
software 29, 80–1
see also individual types
soundtracks 210, 211
souvenirs 146, 148
Spherize 109
sports shots 74–5
spreadsheets 168–9, 170, 184,
214, 215, 216
storage see CDs; memory cards
straightening images 102
street maps 174–7

t-shirts 240–3
Talbot, William Henry 9
text 128–9, 169, 218
texture 55, 58, 59, 110–11,
116–19, 152, 166
Texture Preserving Smooth 111
Texturizer 119
TIFFs 20, 21, 160, 180, 190
timeline 202
Transmit 162
transport pictures 76–7
trimming 248
tripods 61, 65, 72, 75
Turing, Alan 11

Ulead GIF Animator 223
Ulead Video Studio 202
Unsharp Mask 84–5
USB 23, 26–7

vacations 49, 55, 59
album 144–53
verticals, converging 57, 61, 108
video 222–3, 224, 226
CDs 206–7
editing applications 200
memory 204
online movies 201
VideoWave 200, 202
viewpoints 37, 50, 51, 52, 55,
144, 158
vignettes 102–3, 114–15, 166,
168–9, 209
virtual reality 222–3, 224
Von Neuman, John 11

water slip decals 244–5
webpages 154–63
see also Internet
collections 224
design software 143, 156, 200
family trees 228, 238–9
wedding photos 200–1
wedding photos 192–207
white balance 42–3, 45, 55, 69, 98
wide-angle lenses 60, 73, 77, 219
Wind filter 119
Word 154, 156, 170, 180
WordArt 169
World Family Tree 234

zoom lenses 22–3, 41, 73, 77, 219